Landscape and Infrastructure

Landscape and Infrastructure

Reimagining the Pastoral Paradigm for the Twenty-First Century

MARGARET BIRNEY VICKERY

BLOOMSBURY VISUAL ARTS

LONDON • NEW YORK • OXFORD • NEW DELHI • SYDNEY

BLOOMSBURY VISUAL ARTS
Bloomsbury Publishing Plc
50 Bedford Square, London, WC1B 3DP, UK
1385 Broadway, New York, NY 10018, USA

BLOOMSBURY, BLOOMSBURY VISUAL ARTS and the Diana logo are trademarks
of Bloomsbury Publishing Plc

First published in Great Britain 2020

Cover design: Eleanor Rose
Cover image © Elizabeth Felicella

A catalogue record for this book is available from the British Library.

A catalog record for this book is available from the Library of Congress.

ISBN: HB: 978-1-3500-7108-7
ePDF: 978-1-3500-7109-4
eBook: 978-1-3500-7110-0

Typeset by Newgen KnowledgeWorks Pvt. Ltd., Chennai, India
Printed and bound in Great Britain

To find out more about our authors and books visit www.bloomsbury.com
and sign up for our newsletters.

Contents

Illustrations

Acknowledgments

I want to begin with thanks to my editor at Bloomsbury, James Thompson, whose request for a proposal led me to craft my ideas into these pages. I am incredibly grateful to the faculty in the History of Art and Architecture Department at the University of Massachusetts, Amherst: Laetitia la Follette, Tim Rohan, Karen Kurczynski, Nancy Noble, Monika Schmitter, Sonja Drimmer, Gülru Çakmak, Walter Denny, Christine Ho and, of course, Regina Bortone de Sa. Their support and encouragement have meant a great deal to me, and they are the best of colleagues. Professor Christy Anderson has been an inspiration with her energy and exciting teaching and research. Thanks to Jesper Gottlieb and Sten Søding for a glorious day of infrastructure in Copenhagen, and Sune Scheibye for a trip to the top of Amager Bakke, hardhat and all. Dr. Alan Plattus, Ken Smith, Chris McVoy, Dan Wood, Julian Weyer, Scott Wolf, Walter Hood, Kristen Lees, and Andrew Usher took time away from their busy lives to talk with me about their projects, as did Emmanuel Pratt. Michael Singer and Jason Bregman have been steadfast in their support as we all work to weave a new approach to infrastructure into society. Thanks to Professors Michael Davis and Bettina Bergmann for their ideas about Virgil and medieval infrastructure. As I tackled another book project, my long lunches with Jill Shulman and Carol Sharick gave me the confidence boost I sometimes needed to push on. Professors Carol B. deWet and David M. Birney have inspired me with their strong work ethic and intellectual approaches to understanding the world, even in very different disciplines. My father, Scott Birney, has taught me to have a sympathy for the natural world that is at the very heart of this book. Finally, I want to thank my children, Oliver, Bethany, and Arthur, for the joy they have brought me—may their world continue to be a place of natural beauty and diversity. I am grateful for them every day. To Peter Vickery, the best of husbands, go my thanks for our discussions, your helpful edits, and your love and support. Without you, none of this would have happened. I dedicate this book to the memory of my mother, Jane Birney, whose grace, gentle humor, and goodness inspire me every day.

Introduction: Infrastructure, Landscape, and the Pastoral Paradigm: A Tale of Two Projects

This book is about landscape painting in the Netherlands, England, and North America and recent infrastructure projects around the globe. These seemingly disparate subjects are united by a shared concern for the pastoral middle ground, a traditionally productive landscape. By focusing an art-historical lens on preindustrial productive systems and the effects of the Industrial Revolution on the pastoral landscape tradition, we can gain a better understanding of how to weave new approaches to productive infrastructure systems (such as power generation, water filtration, and food production) into our contemporary landscapes. With rising demand for clean energy, clean water, and locally grown food, this study offers a historical perspective on how such systems can be integrated into our suburban and urban areas. Vestigial elements of the pastoral tradition have long held aesthetic sway in our suburbs, cities, and national parks, both in Britain and America. Now, as new energy- and water-related projects encroach on these spaces, remnants of the pastoral play a crucial role in convincing neighborhood residents, municipal leaders, and energy companies or water authorities of the benefits of a neighboring infrastructure. This book investigates the history of that tradition and highlights the advantages it brings as we reimagine infrastructure in the twenty-first century.

A Tale of Two Projects

In 1996, the South-Central Connecticut Regional Water Authority informed residents in the town of Hamden that it planned to replace the local—and defunct—water treatment plant, which happened to border on an affluent neighborhood. Lake Whitney had been a source of drinking water for the area since 1906, and an older plant had closed in 1991. Residents were unhappy about the prospect of a new water treatment plant on the edge of their suburban streets and public park, fearing that such a plant would hurt property values and become an eyesore amid an otherwise woodsy and bucolic landscape. Hamden is a wealthy suburb of New Haven with many Yale professors living nearby, and residents had both funds and intellectual expertise to object to the plans. In the face of opposition, the engineers for the Authority presented a plan to put the plant in a building that resembled a modified house.[1] When residents rejected this somewhat feeble attempt at camouflage, a design committee consisting of thirteen members of the community chose Steven Holl Architects and Michael Van Valkenburgh Associates, a well-known landscape architecture firm, to design the project. The two firms drew up plans that excited the committee but raised cost concerns from the Water Authority. At a final meeting to decide the fate of the plans, Dr. Alan Plattus, a professor of Architecture and Urbanism at Yale, used the example of how the nearby Merritt Parkway, with its picturesque features and beautifully designed bridges, may have cost a bit more but made for a very different driving experience. He argued, "They were facing a decision about making something mundane and undistinguished, or something that would give character to the area and be beautiful." And he reminded them "that their mission was to do more than simply provide a water supply, but also involved place-making and community identity. The example of the Merritt Parkway seemed to effectively sway those members."[2]

The resulting filtration plant (Figure 0.1) is an exquisite marriage of utility and beauty, functionality and nature. Much of the plant itself is tucked below ground, out of sight of the neighbors. But the processes that go on below are articulated in the design of landscape architect Michael Van Valkenburgh. He divided the plot into six sections, "each devoted to a stage in the purification process."[3] These spaces include what Van Valkenburgh titled a Bubbling marsh, which sits atop the plant itself, a Filter court, a Chlorophyll garden,

[1]Chris McVoy, interview with the author, Mar. 8, 2018.
[2]Alan Plattus, interview with the author, Apr. 27, 2018.
[3]Mark Alden Branch, "Water Shed: A Water Purification Plant and Park by Steven Holl and Michael Van Valkenburgh Is a Model of Sustainable Infrastructure," *Architecture*, vol. 94, no. 10 (Oct. 2005): p. 35.

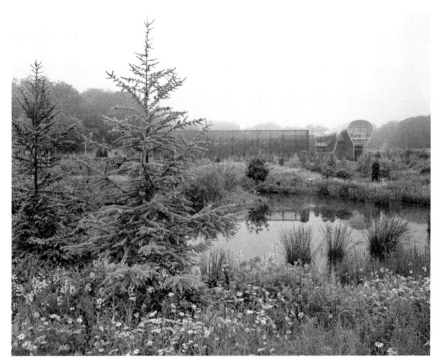

FIGURE 0.1 *Steven Holl Architects, Michael Van Valkenburgh Landscape Architects, Lake Whitney Water Purification Facility, Hamden, Connecticut, 2005. Photo credit: Elizabeth Felicella.*

and Turbulent lawn. Using fill from the excavation of the building, he created small-scale topographies within these sections. Just beside the plant is what he labeled the Mountain and Stream. The tallest feature on the site, this spiral-pathed mound metaphorically begins the hydrologic process of water through the site. The Chlorophyll garden he labeled agricultural, and the lower valley and stream feed water down into the ponds at the edge of the site. With a range of plantings, from sedum on the roof garden to native wildflowers and reeds and cattails in the marsh and stream areas, the site is a microcosm of nature's hydraulic processes. Yet the geometries of the pathways and the plantings make clear that this is a constructed and designed space, there is no attempt to hide the hand of the landscape architect.

Architecturally, Steven Holl and the principal on the project, Chris McVoy, created "a fusion of technology and land art."[4] While most of the structure sits below grade, the building emerges up out of the landscape like a sliver of silver. Designed in the shape of an inverted teardrop, it references the watery

[4]Chris McVoy, interview with the author, Mar. 8, 2018.

functions[5] while creating an elegant tubular intervention in the landscape. Inside, elegant curves and shadows play across the white plastered walls, while a staircase extrudes from an upper story wall that seems as if it were pulled gingerly away from the base. Gentle, abbreviated S-shaped curves and soft lighting from skylights create sensuous and primal forms inside. It is a radical departure from the traditional language of infrastructure.

Below the area of the Bubbling Marsh, the process of ozonation happens. In a sweet design synergy, the round, tubular skylights of the green roof refer to the hydraulic processes within. Similarly, the belowground site of turbulent mixing is referred to in the landscape where "agitated grass mounds are penetrated by little streams."[6] Steel walls from the building occasionally erupt through the surface of the ground, interruptions in the landscape that slice and subtly divide spaces. According to Chris McVoy, the project realized several key concepts/ideas. It

> creates a public park for the community: infrastructure as a destination; reflects a close collaboration with engineers to fully understand the engineering aspects of the project and work within those parameters; is a pioneer in environmental design with a green roof, restored wetlands, reuse of discharged water to charge the wetlands, lower energy use by means of gravity bringing the water to the site, and geothermal heating and cooling.[7]

An aerial view of the site gives a good sense of its surroundings. The Eli Whitney Museum sits across the street from the plant and the original plans included an open visitors' center for the public to learn about the water purification process. Since 9/11 although the landscape remains open for visitors, the plant itself has been fenced in. However, even the fence has been planted with vines that wind through the apertures and appear to soften the security barrier.

Just beside the plant lies Edgerton Park. This was designed in 1909 by Robert Storer Stephenson for the industrialist Frederick F. Brewster in the manner of an eighteenth-century English Garden,[8] a much more traditional pastoral landscape. Like many such parks, though modeled on a productive pastoral tradition, it was designed as a bucolic escape from the urban bustle, a salve to the spirit, but no longer a site of productive prosperity. Instead, it is

[5]Ibid.

[6]"Whitney Water Purification Facility and Park," Steven Holl Architects, http://www.stevenholl.com/projects/whitney-water-facility. Accessed Aug. 2018.

[7]Chris McVoy, interview with the author, Mar. 8, 2018.

[8]"Park History and Facilities: About the Park and Its Scope," Edgerton Park, http://www.edgertonpark.org/history–scope.html. Accessed Aug. 2018.

now the water treatment plant next door that offers what an English landscape park of the eighteenth century once did: a productive landscape that is a recreational destination and a source of regional civic pride. The Whitney plant offers the pastoral middle ground reimagined and made manifest, pointing toward new infrastructural paradigms for the twenty-first century.

In the late 1990s in the small town of Amherst, Massachusetts, a group of developers began building houses in a relatively new neighborhood called Amherst Woods. The majority of housing stock in the town consisted of small houses, such as the traditional Cape or Ranch. This new development included much larger homes, typical of the building boom of the 1990s—not McMansions exactly, but not modest saltboxes either. Significantly, as it turned out, many of the houses encircled an old municipal landfill, which had been closed and covered in 1985. Since then grasses and wildflowers had sprung up and grown over the cap so that the surface of the landfill came to resemble a pasture. Deciduous trees and evergreens surrounded the site, and gentle slopes, where the landfill ends, created perfect hills for winter sledding. Residents walked their dogs across the landscape secure in the knowledge that this now pastoral idyll would remain open and bucolic as developers could never build atop a landfill.

In 2011, however, the town announced plans to erect a large photovoltaic array on this old landfill. The site had ideal solar orientation and was owned by the municipality. The director of public works assembled a small committee to choose the solar provider. The committee interviewed several firms, decided on one, and then the town announced the project. With no period of public comment and no neighborhood involvement, what had appeared to be a simple project to produce clean energy for Amherst's public buildings became a fraught and vitriolic issue, pitting neighbor against neighbor and town government against residents. This proposed use for an otherwise unusable plot of land sparked a storm of outrage from residents whose houses bordered the site. Proposed sheep grazing between solar panels met with similar outcry. The reaction led to lawsuit and in 2015 the town abandoned the project. The neighbors continue to look out across the pastoral landscape that has grown up atop the rotting trash and rusting cars buried below (Figure 0.2). This outcome is not uncommon: zoning ordinances and bylaws often compel the segregation of infrastructure and natural landscape, strictly forbidding the overlap of infrastructure and residences.

The two tales told above illustrate key issues facing us in the twenty-first century. As our power production becomes more localized through solar and wind energy, and infrastructure projects such as waste water treatment plants or agriculture are increasingly crowding into our cities and suburbs, we will need to think carefully about how such productive processes are integrated into our landscape. Including community voices and the design

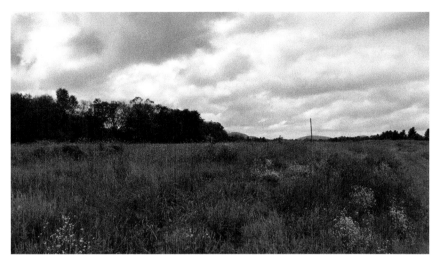

FIGURE 0.2 *Old Landfill, Amherst, Massachusetts. Photo by the author.*

skills of artists, architects, and landscape architects is crucial to weaving new infrastructural systems into our streets, neighborhoods, and parks. Yet the integration of productive landscapes, community pride, and recreation (those features that the Whitney Plant included, and the Amherst plan did not) is not new. As the following pages illustrate, the pastoral tradition (as identified by the likes of Virgil, William Kent, or Frederick Law Olmsted) was once celebrated for its productivity as well as its recreational connection to the landscape. By looking back to the older pastoral tradition, we can begin to understand how productivity, landscape, and community pride were once wedded seamlessly together. Only since the Industrial Revolution have we frayed those ties by separating our landscapes from productivity, legally, physically, and mentally cordoning them off, one from the other. *Landscape and Infrastructure: Reimagining the Pastoral Paradigm for the Twenty-First Century* identifies the historical marriage of the two within the Anglo-American tradition. The book concludes with contemporary examples of infrastructure projects from around the globe that once more unite the landscape with productive systems, creating places that, like the Whitney Water Purification plant, invite and educate, while honestly illustrating the processes of energy production, water treatment, or food production within a pastoral scaffold.

The term infrastructure is relatively new. For many, the word conjures only images of bridges and highways, railroads and utilities. Its origins were military, but it is often identified with governmental public works projects. Most dictionary definitions define the term as a series of systems and facilities that are needed for a country, state, or region to operate successfully. Scholars such

as Mitchell Schwarzer are increasingly interested in digital infrastructure and how systems of communication, transportation, and connective networks are shifting in the digital age. This solitary term has been co-opted to describe a wide range of different systems, but in this case *Landscape and Infrastructure* focuses on *productive* systems, those which produce energy, clean water, and food.

Since the nineteenth century, infrastructure and industrial systems that power society have frequently been confined to isolated, specifically zoned areas, with a deleterious impact on the fence-line communities, usually home to low-income, under-served populations, disproportionately consisting of people of color. This infrastructural apartheid is part of a wider trend to categorize and compartmentalize humans, things, and places and to define humans and nature as separate entities. Yet this isolation is a relatively new phenomenon. Historically, productive infrastructure projects such as windmills or mills, bleaching fields, or pumping stations were often represented as symbols of civic pride and progress and featured in paintings, landscape architecture, or cityscapes.

Landscape and Infrastructure explores the representation of landscapes in the Western tradition since the seventeenth century, illustrating periods when productive infrastructures or landscapes and the community embodied a unified symbol of society's progress. Such examples usually relied on the pastoral tradition wherein productive systems were key elements in a pastoral middle ground, uniting wealth, civic pride, and nature. By the nineteenth century, with the Industrial Revolution, such systems were often grouped with industry and were both celebrated and reviled, disparaged for their pollution and poor working conditions by the likes of William Morris, and praised for their sublime power and modernity by Turner and the Impressionists like Monet. We examine how and why this triad of infrastructure, landscape, and community divorced, only to reunite again in the twentieth-century projects such as the Tennessee Valley Authority and its massive river and land reclamation work.

Chapters 1 and 2 investigate how landscape paintings and design from the seventeenth and eighteenth centuries included elements of production crucial to society, such as windmills, mills, bleaching fields, sheep and cattle, and forests for timber production. Those elements were a source of civic pride and recreation. Chapters 3 through 5 focus on the nineteenth and twentieth centuries, wherein infrastructure systems such as the railroad, factories, and power stations were admired for their powerful forms and promising production of goods and services. Yet such infrastructure became one branch of a growing duality which pitted progress against nature and what was considered the purity of an untamed wilderness. The productivity within the landscape was slowly erased and replaced with either a wild nature *or* an industrial urban scene. The bucolic pastoral wended its way into suburban

enclaves and urban and national parks, designed for recreational pleasures. As the character of industry, agriculture, and infrastructure changed, such productive systems have been zoned into separate spheres and decoupled from the pastoral landscape. Chapter 6 provides a discussion of the City Beautiful Movement and twentieth-century approaches to infrastructure, landscape, and nature. While the City Beautiful Movement sought to reweave infrastructure projects into an urban fabric dressed in historical garb, Frank Lloyd Wright's vision of Broadacre City integrated orchards, industry, and residential neighborhoods. But on the whole the separation of productive systems and the landscape prevailed.

With an art historical lens focused on the art and landscape architecture of the seventeenth through the twentieth centuries, this book provides a vantage point from which to investigate the work of contemporary architects, artists, planners, and engineers who seek to reintegrate infrastructure projects into our landscapes and communities. The final four chapters offer examples of infrastructure projects that remarry productive systems with public spaces, offering education and recreation with vestiges of the pastoral tradition. From Michael Singer and Linnea Glatt's Phoenix Transfer Station to Bjarke Ingels's waste-to-energy plant hidden under a ski slope, these projects highlight the promising ways in which architects, artists, and designers are creating infrastructure projects that are not only productive but also socially beneficial, inviting, historically resonant, and often considered beautiful. Leaders in this movement are invested in creating an infrastructure that is once again pleasing to the eye and welcomed by the people who live alongside it. As energy sources are increasingly found on rooftops, mountain tops, or local fields, integrated with the suburban and urban landscapes, and as farms rise in cities and waste and water are processed in parks, the projects featured here provide inspiring examples of community involvement and ingenious engineering solutions. In his foreword to *Public Natures: Evolving Infrastructures* by Weiss Manfredi Architects, Barry Bergdoll praises the architects for their work blurring the "divisions between nature and building that craft the public realm."[9] Yet he intimates that such integration is a recent phenomenon, crediting Weiss and Manfredi with opening "the issue up to others."[10] And in their text Weiss and Manfredi ask, "What if a new paradigm for infrastructure exists? What if the hard lines between landscape, architecture, engineering, and urbanism could find a more synthetic convergence?"[11] *Landscape and Infrastructure*, by tracing the history of productive landscapes and how they united landscape,

[9]Barry Bergdoll, "Forward," in *Public Natures: Evolutionary Infrastructure*, ed. Marion Weiss and Michael A. Manfredi (New York: Princeton Architectural Press, 2015), p. 6.
[10]Ibid.
[11]Ibid., p. 9.

architecture, and community, highlights the intersections and separations of these elements over the past four hundred years. Such a contextual offering enriches the current debate and opens our eyes to a new vision of infrastructure and the landscape, one that often resides in the pastoral middle ground offering recreation, education, and productivity in inspiring new ways. Such an overview, while it cannot be comprehensive, offers a historical perspective on how productive landscapes have been represented in the social and physical fabric of British and American history, which in turn, contributes to the contemporary discussions about infrastructure, landscape, architecture, and community.

1

Landscape Painting and the Productive Pastoral Tradition

For many of us today, the term "pastoral" evokes images of verdant fields and copses of trees with the odd shepherd or shepherdess and a small flock of sheep. Such scenes are understood as bucolic idylls and enjoyed for their beauty as a relaxing escape. Thus, the term "productive pastoral" can seem a contradiction. Productivity in the landscape often evokes images of grey industrial expanse, smokestacks belching black plumes or vast agricultural fields. Such images can have little in common with a Virgilian idyll of orchards and bees, shepherds and goats—what we often associate with the pastoral. Yet, as will become clear in the following pages, the pastoral landscape represented a middle ground between wild nature and civilization. This middle ground featured the productive systems that were celebrated by society; it was a liminal place wherein the conflicts between civilization and wild nature were resolved harmoniously. In the poet Virgil's *Eclogues*, Tityrus and Meliboeus discuss the merits and benefits of the pastoral arcadia, one in which Tityrus basks amid his flocks, laboring yet taking time to rest in the shade and play on his pipes. In contrast, Meliboeus is exiled from his farm thereby facing the chaos of either the bustle of Rome or the dangers of wild nature which lie beyond the pastoral idyll. Thus, Virgil establishes in the first century BCE the key trope in the pastoral tradition: a balanced middle ground tied both to nature and to civilization and a resolution of the two.

The pastoral tradition has had a long and fruitful history in art, literature, and landscape design. Scholars such as Gail Crandell discuss its seminal role in the development of landscape painting and architecture influencing the likes of Claude Lorrain and much later, Frederick Law Olmsted and his designs for

Central Park[1] which we will examine in Chapter 5. Both the classicist Bettina Bergmann and the Americanist Leo Marx refer to David Halperin's definition of the pastoral to help define the term in the context of their work. In his book *Before Pastoral: Theocritus and the Ancient Tradition of Bucolic Poetry*, Halperin defines the pastoral according to four criteria:

1. Pastoral is the name commonly given to literature about or pertaining to herdsmen and their activities in a country setting; these activities are conventionally assumed to be three in number: caring for the animals under their charge, singing or playing musical instruments, and making love.

2. Pastoral achieves significance by oppositions, by the set of contrasts, expressed or implied, which the values embodied in its world create with other ways of life. The most traditional contrast is between the little world of natural simplicity and the great world of civilization, power, statecraft, and ordered society—established codes of behavior, and artifice in general.

3. A different kind of contrast equally intimate to pastoral's manner of representation is that between a confused or conflict-ridden reality and the artistic depiction of it as comprehensible, meaningful, or harmonious.

4. A work which satisfies the requirements of any two of the three preceding points has fulfilled the necessary and sufficient conditions of pastoral.[2]

The definition above is helpful in its expansiveness. At the time of writing his *Eclogues* or *The Georgics*, Virgil's pastoral landscape included the shepherd and his flocks, pastures, orchards, vineyards, and beehives. While a place of refuge and peace, it was also a place of vital production, harvest and milking, slaughter, and honey. Such production fueled Roman society. While both poems may veil commentary about Roman politics, they celebrate the productive systems that power it. Thus, Virgil's work most clearly adheres to Halperin's first definition with the shepherds in the landscape. But equally, his writings meet the requirements of number two with the contrasts between the wilds of nature and the exhausting intricacies of Rome. Nature is tamed by human labor while the soul is restored by an escape into the rural pastoral,

[1]Gina Crandell, *Nature Pictorialized: "The View" in Landscape History* (Baltimore, MD: Johns Hopkins University Press, 1993).
[2]David Halperin, *Before Pastoral: Theocritus and the Ancient Tradition of Bucolic Poetry* (New Haven, CT: Yale University Press, 1983), pp. 70–1.

a peace not found in the urban streets. And finally, Virgil's pen artistically resolves the two conflicting realities of city and nature into a bucolic ideal from which Meliboeus has been banished.

In her study of Roman wall paintings and the sacred groves they often included, Bergmann references the importance of this pastoral system. The agricultural scenes with their pasturage and fields were highly valued: "cultivation threatened the grove.... Accordingly, the paintings of quiet scenes with grazing sheep and cows omit any sign of danger from the plow; wool and meat accompany signs of piety, implying that peace with nature and the gods produces fertility and wealth."[3] And she cites the example of Varro's writings on the ownership of private villas and the monetary and symbolic valued placed on the agricultural infrastructure they entailed. The Roman wall paintings, Bergmann argues, offered elevated perspectives across landscapes "in which the sight of family tombs and honored old trees were a reminder of the owner's genetic ties, privately employed fishermen and shepherds of their self-sufficiency, and shrines and votives of the god's protection of their proud possessions. Horace said that the happy man spent his days surveying his grazing herd and pruning his trees."[4] Roman pastoralism included many elements but key among them were the systems which brought wealth, civic pride, and recreation: the pastoral landscape of sheep and cows, fields and vineyards, and fishponds and aviaries.

Medieval Infrastructure

In her section on "Cloistering the Spectator: The Middle Ages," Crandell argues that the medieval landscape was more a place of fear and hard labor than a pastoral idyll. While the pastoral with its harmonious balance of work and rest, nature and civilization, was not classically represented in medieval paintings and illustrated manuscripts, one need look no further than the celebrated *Tres Riches Heures* painted for the Duke of Berry in *c.* 1412 to see that agriculture and the landscape played very important roles in providing wealth, pride and even recreation in the fifteenth century. The "Labors of the Months" illustrate not only the duke's numerous chateaux but also his valuable woods used for timber and heat, his fields for plowing and pastures for grazing, the thrill of the hunt for venison, and serfs for laboring in the farmlands. If we understand infrastructure to mean a series of systems that power society, then the

[3]Bettina Bergmann, "Exploring the Grove: Pastoral Space on Roman Walls," *Studies in the History of Art*, vol. 36, Symposium Papers XX: The Pastoral Landscape (Washington, DC: National Gallery of Art: 1992), p. 33.
[4]Ibid., p. 41.

"Labors of the Month" most clearly illustrate an agricultural infrastructure that was vital to a prosperous existence. While Crandell is right to argue that there was not a medieval focus on the landscape for its aesthetic properties or as a pastoral idyll, I would argue that artists such as the Limbourg brothers and others contributing to similar books of hours, were keenly aware of and celebrated the agricultural landscape—both as a symbol of their patrons' wealth and prestige but also as a record of a landscape that sustained the community. Similarly, as we see in the months of April, May, and August, the landscape was a place of romantic love (in May), and of recreation in April and August. Leisure, wealth, pride, and sustenance are thus all associated with these agricultural infrastructural systems.

The medieval monastery was another site of productive synergies. Monasteries were often rural and self-sufficient and were planned to include orchards, fields, pastures, and vineyards. In some cases, complex infrastructural systems originating in the monastery yielded dramatic benefits for both the clergy and layman. Mickey Abel explores the waterworks and infrastructure of Maillezais Abbey in western France in her essay, "Water as the Philosophical and Organizational Basis for an 'Urban' community plan: The Case for Maillezais Abbey." While her general thesis asserts that the complex infrastructure of water systems which re-claimed land from the sea and marshes and provided transportation of goods helped to create an urban center around the Abbey, her discussion of the sophisticated system of canals, levees, dams, and aqueducts posits that this "was the circulatory system that linked the interdependent components and supported the corporate body's well-being."[5] Her research maps the rich and varied system of mills, rivers, canals, and levees that drained the land for agriculture while creating a transportation system. She concludes that "the monastic complex, working as a corporate enterprise with interests in agriculture, commerce, real estate, manufacturing, and construction, not to mention the service industries and transportation, all looked to the strong supporting infrastructure in order to prosper and grow stronger over the centuries."[6] In this case, the engineering success of fighting and organizing the sea and rivers made possible not only conurbations but also the agriculture and economic vitality that supported the community. Maillezais Abbey was widely recognized for its water-infrastructure and its enabling qualities. It can be argued that the monks of Maillezais, via their engineering might, created a pastoral middle ground as productive as Virgil described in *The Georgics*. While lacking classical allusions,

[5]Mickey Abel, "Water as the Philosophical and Organizational Basis for an 'Urban' Community Plan: The Case of Maillezais Abbey," in *Medieval Urban Planning: The Monastery and Beyond*, ed. Mickey Abel (Newcastle upon Tyne: Cambridge Scholars Publishing, 2017), p. 11.
[6]Ibid., p. 45.

the landscape surrounding the Abbey reflects the conflict between the monks who settled there and the watery power of the sea and rivers. By battling both, the monks created a productive middle ground—systems of water and land that brought prosperity to the area.

These early examples, from Ancient Rome and Medieval France serve to illustrate key elements of infrastructure and the landscape that we shall trace throughout this book. Beginning in the seventeenth century, artists began to look at specific landscapes for inspiration and landscape painting was born. Within these landscapes, the productive systems that powered society were included and celebrated. Claude Lorrain is touted as perhaps the greatest landscape painter in the Western tradition. He was a prolific painter who captured the romance and poetry of the Roman campagna with its ruins, lakes and rivers, and harbors and shepherds. Bathed in a soft golden light, these images did not depict specific sites but rather captured the essence of ancient Italy. His work was wildly popular, especially in Britain, and his influence on the design of landscapes there has been well documented. He included mythological and biblical characters set amid classical ruins or sparkling harbors. At times he painted simple pastoral landscapes with no specific literary narrative. The Claudian landscape was carefully arranged with trees framing a view into a distant landscape. Water, either the sea or river, snakes around a middle ground, leading the eye deep into the picture plane where mountains or rocky crags are suffused with a hazy light. Claude's pictures were a pastoral refuge from culture, set within a tamed and peaceful middle ground. Nature was not angry or threatening but provided a peaceful respite from the cares of the day. While Claude Lorrain's influence on the designed landscape stretches well into the twentieth century, his works and those of his followers are not featured here in the same detail as the Dutch landscape painters such as Jacob Ruisdael. This is because, while Claude has undoubtedly influenced the way we look at and design our landscapes, he painted imagined scenes. While including productive pastoral features such as herds of sheep and cows tended by shepherds, he did not celebrate or render specific infrastructure that yielded prosperity, civic pride, or even recreational activities. As we shall see, those inspired by his paintings, such as the Dutch landscape painters or the English aristocracy, modeled their landscapes on his imagery, but they framed real, productive landscapes that brought their culture wealth and prestige.

Hence, though landscapes by Claude, Poussin, Dughet, and others were widely collected and influenced the pastoral landscape tradition in art and design, they figure only peripherally in our discussion of the art of productive landscapes and infrastructure. In the following chapters, we will trace the ways in which the *productive* middle ground of the pastoral tradition became a cultural paradigm in art, landscape architecture, and architecture.

In the examples that follow, artists and architects have played crucial roles in translating and transforming infrastructure and productive landscapes into an art celebrated and enjoyed by the societies that created it. Such designers have mediated between the smelly reality of cows or smokestacks and the natural landscape. They created a liminal landscape which balanced the culture's need for power, land, or water with nature and the environment.

In his 1992 essay "Does Pastoralism have a Future?" Leo Marx points out that at the end of the twentieth century was a growing awareness that we as a species are no longer simply at the mercy of wild nature but we have actually begun to damage it, possibly beyond repair. He argues that "This wholly new conception of the precariousness of our relations with nature is bound to bring forth new versions of the pastoral. After all, pastoral always has served to represent humanity's awareness of its location on the thresholds between the complex and the simple, between art and nature."[7] His prescient assertion paves the way for the recent and contemporary works discussed in this book. From power stations to urban farms, they represent efforts to reconcile nature and society with a long-term concern for global climate change. Their promise lies in the unity of community, production, civic pride, and accessibility that weave sustainable prosperity, recreation, and education into society's needs for power generation, clean water, and food. Landscape painting and design in the seventeenth through the nineteenth centuries established a visual paradigm of productive, pastoral landscapes. This pastoralism, as explored through the lens of art history, has been rediscovered for the twenty-first century.

The Dutch Landscape

Art historians generally agree that a new typology of landscape painting emerged in the early to mid-seventeenth century in the Netherlands. This emergence has been carefully tracked by scholars such as Wolfgang Stechow, John R. Stilgoe, Peter Sutton, Svetlana Alpers, and Simon Schama among many others. These scholars' writings focus on a range of issues from formal analyses to provenance and politics. What all agree on is that Dutch landscapes in the seventeenth century introduced a break from the classical and narrative landscapes of the French and Italians that illustrated mythological and biblical subjects in idealized settings. Instead, the Dutch painters opted for landscapes of the everyday; scenes of dunes and country roads, farmers and ruined castles, and frequently, readily identified places. The

[7]Leo Marx, "Does Pastoralism Have a Future?" *Studies in the History of Art*, vol. 36, Symposium papers XX: The Pastoral Landscape (Washington, DC: National Gallery of Art: 1992), p. 222.

renderings of these specific sites were not always exactly true to reality, but the liberties taken were relatively minor. Stechow makes the point that the Dutch landscape painters "All selected from nature; but what counts in their selection is nature."[8] For our purposes here, what is also vitally important is *what* these artists chose to weave within their views of the natural world. Dutch landscape painters such as Jacob van Ruisdael, Jan van Goyen, Esaias van der Velde, Salomon van Ruysdael, Aelbert Cuyp, and Meindert Hobbema (among others) focused on contemporary views of the landscapes and cityscapes of the Netherlands. Included in those views are certain infrastructural systems that powered the Dutch economy and fostered civic pride.

While these artists also painted country roads and dunes, ruins and sublime waterfalls, or rocky crags, the inclusion of such preindustrial productive features in the landscapes such as windmills and watermills, bleaching fields and dairy cows, is significant as such works blur the modern distinctions between city and country, production and nature, and indicate that a "landscape" or *landshap*, was for the Dutch, more than simply a rendering of an untouched nature, but rather a site wherein the hand of man and the natural world are woven together. This unity is key in landscape painting—economic systems such as windmills and agriculture which powered Dutch society and helped it thrive were recorded in paint and print amid fields, dunes, rivers, and farmhouses. This fusion commemorated those systems and created a productive, pastoral middle ground—not the city or the wilds of the countryside, but a productive landscape. They were sites visited by travelers and the wealthy, tied to a burgeoning civic pride in Dutch achievements and were valued as a part of the landscape view that was in high demand across a wide socioeconomic spectrum of Dutch society. In the following pages we will look more closely at the rise of Dutch landscape painting and the role it played in Dutch society. We will then examine three particular economic infrastructures—windmills, bleaching fields, and agricultural systems—to better understand their role in the Netherlands and why they appear in this seminal landscape genre.

The seventeenth century was a heyday for the Dutch Republic. After a protracted separation from the Spanish Empire which was officially resolved in 1648, the Dutch Republic became known in Europe as a tolerant and relatively democratic society, welcoming Protestant and Catholic alike and encouraging immigration to assist in its economic boom. This prosperity was fueled by a burgeoning stock market, the founding of the Dutch East Indies Company and a growing international empire. The Dutch increased their landmass by about a third during this time via an intensive land reclamation program, fighting back the sea with polders and pumping stations powered

[8]Wolfgang Stechow, *Dutch Landscape Painting of the 17th Century* (London: Phaidon Press, 1966), p. 11.

by the iconic Dutch windmills. The textile industry, which, according to the economic historian, Fernand Braudel, "would bear comparison with coal mining,"[9] helped fuel the demand for high-quality linen bleached across the dunes and landscapes around Haarlem. Cities in the prosperous republics were in relatively close proximity with one another and were accessed via a network of efficient canals and barges. Even the dairy cows were renowned across Europe for their "prodigious milk production, and the cheese made from their milk."[10]

It was during the height of this Golden Age of Dutch culture that a new type of landscape painting, closely tied to a tradition of mapping and cartography, emerged. Both Schama and Sutton credit part of this emergence with a growing national pride in this prosperous and newly independent confederation.[11] Disengagement from Spain and fighting back the sea to create more landmass stimulated a civic pride and an inward focus on the Dutch world, its interiors and still lives, portraits of its merchants and their wives, and views of the landscape without allegorical figures or classical ruins, but with views of distinctively Dutch motifs.

The market for these landscapes was huge, and scholars agree that such landscapes were seldom painted on commission but were bought on the market by both those of modest means and the wealthy. Numerous artists made their livings painting landscapes of the Dutch countryside, and printmakers such as the famous Visscher family tapped into the hunger for landscapes and maps, producing visual records of the landscape, its productivity, its infrastructure, and its topography. Such prints, maps, and paintings appear in Dutch interior scenes documenting their popularity and ubiquity.

Scholars of Dutch art have laboriously traced and categorized these landscapes, and Svetlana Alpers's seminal book *The Art of Describing* convincingly blurs the boundaries between maps and landscapes for the seventeenth-century Dutch citizen.[12] All recognize and acknowledge various motifs within these landscapes, from country roads and watermills to bleaching fields, polders, and windmills. Some such as Bruyn find scriptural

[9]Fernand Braudel, *The Wheels of Commerce: Civilization and Capitalism, 15th-18th Century*, vol. 2 (New York: Harper & Row, 1979), p. 313.
[10]Ann Jensen Adams, "Competing Communities in the 'Great Bog of Europe': Identity and Seventeenth Century Dutch Landscape Painting," in *Landscape and Power*, ed. W. J. T. Mitchell (Chicago, IL: University of Chicago Press, 1994), p. 60.
[11]Peter Sutton, *Masters of 17th Century Dutch Landscape Painting*, ed. Peter Sutton (Philadelphia: University of Pennsylvania Press, 1987), p. 2; Simon Schama, "Dutch Landscapes: Culture as Foreground," in *Masters of 17th Century Dutch Landscape Painting* (Boston, MA: Museum of Fine Arts, 1987), p. 71.
[12]Svetlana Alpers, *The Art of Describing: Dutch Art in the Seventeenth Century* (Chicago, IL: University of Chicago Press, 1983).

readings[13] within the landscapes, whereas others such as Sutton and Schama interpret the plethora of ordinary scenes of Dutch life as symbols of civic pride in Dutch prosperity and their triumph over both Spain and the sea. Here is not the place to wrangle over this debate in great detail, but most scholars, while acknowledging the force of Bruyn's argument in places and with regard to certain images, generally agree that given the quantity, range of subject matter, and verisimilitude of the works in question, this landscape genre was probably enjoyed more for how it represented the familiar scenes enjoyed by the city dwellers who reveled in the rural escape of the painted landscape.[14]

Jacob van Ruisdael was one of the most prolific and acclaimed of the Dutch landscape painters. He painted a wide range of landscapes, from stormy seas and rocky waterfalls to country roads and blasted trees, cityscapes, and panoramas. We will focus on his oeuvre as it epitomizes many of the trends in seventeenth-century Dutch landscape painting. As we shall see, several of his most famous and revered works foreground productive Dutch infrastructure: windmills, bleaching fields, watermills, and agriculture. Given that scholars agree that Dutch landscapes are selectively composed, with artists occasionally omitting or moving motifs for compositional reasons, we can be assured that Ruisdael and his peers were purposeful in their choice to include such productive motifs.

Windmills appear frequently in Ruisdael's paintings and drawings. The Dutch windmill is, of course, a structure closely associated with the Netherlands. Stechow wrote in 1966: "the typical Dutch windmill is a feature fondly remembered by all travelers to Holland and trustingly accepted as characteristically Dutch even by those who know it from advertisements only."[15] He goes on to point out the crucial roles that windmills played in the water systems of the Netherlands. Windmills made the draining of polders possible and facilitated the reclamation of one-third of the Dutch land in the late sixteenth and seventeenth centuries. In his article about the transfer of windmill technology to Asia in the seventeenth and eighteenth centuries by the Dutch East India Company, Peter Boomgaard argues,

the windmill was an ally in the "battle against the water," probably from its introduction in the Netherlands, but after a number of adaptations it also started to play an important role in Dutch industrial development. Thus, by the 17th century, the windmill had become an important feature in the

[13]Joshua Bruyn, "Toward a Scriptural Reading of Seventeenth-Century Dutch Landscape Paintings," in *Masters of 17th Century Dutch Landscape Painting*, ed. Peter Sutton (Philadelphia: University of Pennsylvania Press, 1987), pp. 84–103.

[14]Walter Gibson, *Pleasant Places: The Rustic Landscape from Bruegel to Ruisdael* (Berkeley: University of California Press, 2000).

[15]Stechow, *Dutch Landscape Painting of the 17th Century*, p. 50.

Dutch landscape and in the Dutch economy. They were the main mechanical industrial establishments in seventeenth-century Holland ... In 1630, there were already 86 windmills in Holland for sawing timber alone ... Besides sawing timber, windmills were also used, among other activities, for the production of flour, vegetable oil, paper, tobacco, paint and hemp.[16]

As Boomgaard's research makes clear, the windmill was a crucial feature in Dutch economic prosperity. In the landscapes of Jacob Ruisdael and his peers, windmills are spotted in abundance. Some punctuate the horizon, their angular blades distinctive against the vast Dutch sky, while others are the central motif. Take, for example, Ruisdael's *Windmill near Fields* of 1646. Here the windmill is silhouetted against a late afternoon sky, one of its blades jutting into the soft greys of the clouds. It sits on a small hillock above the flat fields to the left, which are peopled by two walkers with bleaching fields and rustic cottages beyond. It is a scene typical of Ruisdael and his Dutch counterparts, a rustic scene capturing the peace and productivity of the Dutch landscape. One of Ruisdael's most famous works is *Windmill at Wijk bij Duurstede* (Figure 1.1) from around 1670. Indeed, Seymour Slive calls it his "most famous picture."[17] *Windmill at Wijk* brings together several classic motifs of the Dutch countryside, the ripples of the river and its wooden breakwaters, travelers walking along the river's edge, sailboats heading out, and civic and religious buildings in the distance. But it is the windmill that dominates the scene, with its strong stone circular base and wooden observation deck and its technologically refined vanes against the sky. Wind, the energy source for the mill, is suggested by the broken clouds, some kissed by the sun, others dark and more ominous, suggesting wind and change. Slive points to a possible allegorical meaning "between the natural forces that power what man has made and the divine spirit that gives him life."[18] Certainly the productivity of the windmills depended on those "natural forces." While the moralizing aspect of Ruisdael's windmill may be present, foregrounding it as the central motif in the painting highlights the importance of this preindustrial infrastructural system of power and productivity in the Dutch landscape and the key role it played in Dutch life.

Peter Sutton called the *Windmill at Wijk*, "more than a heroic motif, it serves as an icon of preindustrial Holland, an image rich with social, political, and spiritual meanings."[19] In the same exhibition catalogue, Simon Schama

[16]Peter Boomgaard, "Technologies of a Trading Empire: Dutch Introduction of Water- and Windmills in Early Modern Asia 1650s-1800," *History and Technology*, vol. 24, no. 1 (Mar. 2008): pp. 43–4.
[17]Seymour Slive, *Jacob van Ruisdael: Master of Landscape* (London: Royal Academy of Arts and Yale University Press, 2005), p. 39.
[18]Ibid.
[19]Peter Sutton, "Introduction," *Masters of 17th Century Dutch Painting*, p. 51.

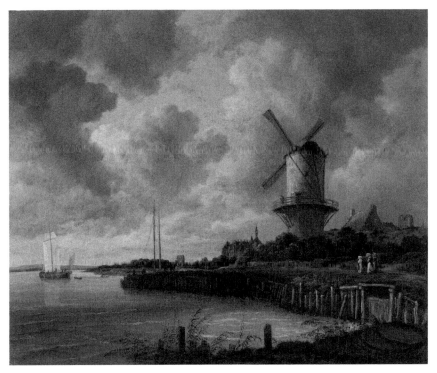

FIGURE 1.1 *Jacob van Ruisdael.* Windmill at Wijk, *c. 1670. Oil on canvas (Rijksmuseum, Amsterdam: on loan from the City of Amsterdam (A. van der Hoop Bequest)).*

convincingly connects the Dutch market for landscape painting of the everyday that typified the Dutch countryside with a new-found patriotism. Not only had the Netherlands rid themselves of Spanish rule, but they had fought back the sea and increased their land mass. Together with the prosperity of their businesses, there was a thriving Dutch market for images that celebrated the source of this new freedom, their landscape, and their subsequent financial success.[20]

The idea of civic pride, of lauding the sources of prosperity, explains the prevalence of infrastructure in Dutch landscape paintings. When Ruisdael painted panoramic views with cities in the distance and fields in the middle ground, windmills are a consistent feature, their vanes articulating the horizon. In *Extensive Landscape with a Ruined Castle and a Village Church*, the windmill is a small motif in the middle ground. But the clouds have parted and

[20]Simon Schama, "Dutch Landscapes: Culture as Foreground," in *Masters of 17th Century Dutch Painting*, p. 71.

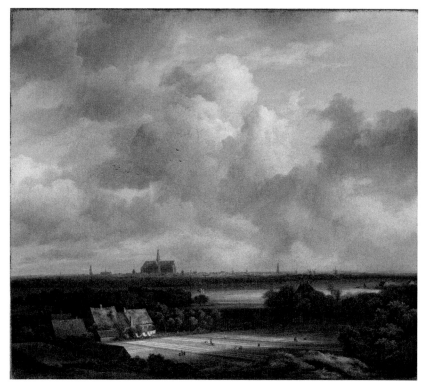

FIGURE 1.2 *Jacob van Ruisdael.* View of Haarlem with Bleaching Grounds, *1675. Oil on canvas (Mauritshuis, The Hague. Photography: Margareta Svensson).*

the sun shines down directly on the vanes of the windmill amid the field, a golden oasis frozen in time before the clouds scuttle across the sky. Whether monumentalized in the foreground of the *Windmill at Wijk*, or as one of a series of favored motifs such as churches and ruins, the windmill's inclusion points to its cultural importance in the seventeenth century.

Jacob van Ruisdael is also famous for his panoramic views of the Dutch landscape, a type Stechow calls, "Dutch through and through."[21] Here the vast expanse of sky dominates the composition, and the lack of traditional framing devices emphasize the open and flat landscape. Ruisdael painted a series of *Haarlempje*, little scenes of the city of Haarlem seen from afar. In *View of Haarlem with Bleaching Grounds* (Figure 1.2), Ruisdael's vast sky is interrupted on the horizon by the immense Church of St. Bavo. Smaller church spires and windmills rise above the landscape. In the foreground, the tufty

[21]Stechow, *Dutch Landscape Painting of the 17th Century*, p. 33.

brush of a hillock offers a higher vantage point from which to survey the view. Just below our viewpoint, bleaching fields of white strips of linen stretch across the land and are highlighted by the sun and the golden background of the fields.

Linda Stone-Ferrier has done extensive research on these scenes of bleaching grounds by Ruisdael and their wider context. She points out in her article "Views of Haarlem: A Reconsideration of Ruisdael and Rembrandt" that the bleaching industry was frequently illustrated in maps and prints in the late sixteenth century and on into the seventeenth. The prolific printer, Claes Jansz Visscher produced seven engravings of views of Haarlem, two of which focused on the bleaching industry in 1620. Twenty years later, Visscher engraved views by Jan van Velde II in which a rustic setting includes the work of linen bleaching together with wealthy visitors enjoying the view of the industrious workers. Other painters such as Jan Vermeer van Haarlem and Jan van Kessel also painted landscapes featuring the bleaching grounds. Rembrandt's etching, *The Goldweigher's Field* (1651) captures the local dunes, the city of Haarlem on the horizon, and linen fields reaching across the middle ground.

So why this interest in this localized industry? Stone-Ferrier convincingly weaves the production of these images with prosperity and civic pride. Bleached linen from the Netherlands was in huge demand and was considered the finest linen in the European market. The locale around Haarlem, with its easy access to water and stretches of sun-soaked fields, together with a thriving dairy industry and ready access to buttermilk, a key bleaching agent, combined to produce a highly sought-after product and to yield economic success. The plethora of images illustrating the process of bleaching attest to their popularity. The manufacture of such linen was also touted in literature and poems about Haarlem at the time, emphasizing its celebrated status. Such paintings were not commissioned by a specific guild or series of merchants but were available on the open market. In Stone-Ferrier's words, "These paintings commemorate the fame of a particular industry and its contribution to the economic well-being of Haarlem. If a didactic message is embodied in such images, it expresses the value and worth of a local community's industriousness."[22] Artists such as Ruisdael wove into these panoramic landscapes of particular regions in the Netherlands productive systems that powered society. Much like the windmills that dot the landscape and rise above the horizon line, strips of linen extend across the fields near Haarlem, integral to the regional landscape and celebrated for the role the industry played in Dutch culture and prosperity.

[22]Linda Stone-Ferrier, "Views of Haarlem: A Reconsideration of Ruisdael and Rembrandt," *Art Bulletin*, vol. 67, no. 3 (Sept. 1985): p. 422.

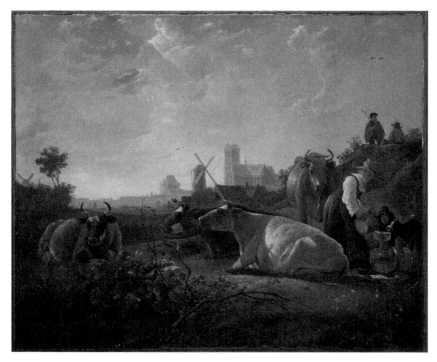

FIGURE 1.3 *Aelbert Cuyp*. A Distant View of Dortrecht (The Large Dort), *1650. Oil on canvas (The National Gallery, London).*

In addition to scenes of linen bleaching and windmills across the landscape, images of agriculture were often the subject of Dutch landscape painters in Dutch seventeenth-century paintings. Ruisdael's lyrical *Wheatfields* of 1660 is just one of a myriad of images celebrating the verdant and productive fields of the Netherlands. Ann Jensen Adams discusses the paintings of Albert Cuyp and the ways in which he monumentalizes Dutch cattle. His *View of Dortrecht with Cattle (the Large Dort)* (Figure 1.3) of the late 1640s is one such view wherein the "close visual juxtaposition of the historically important church with the economically important cows must have had strong resonances with national patriotic fervor in the Dutch viewer."[23] Thus, these robust and highly productive cows, as seen in the foreground of Cuyp's *Cattle in a River* or being milked among the ruins in his *Landscape with Cattle* (c. 1665) were symbolic of another important industry in the Dutch Netherlands.

The motifs in Dutch landscape paintings, windmills, agricultural lands, cattle, and bleaching fields, to name the most prevalent, are seamlessly woven into the natural world. As Stechow points out, "Dutch landscape painting represents a

[23]Adams, "Competing Communities," pp. 61–2.

phase which lies before, or in any case, outside, the 'sin' or 'tragedy' of making nature into either the superior or the handmaiden of man ... Here, nature and man were still completely apart—and still balanced in perfect harmony."[24] What is key here for our purposes is the "whole world of values and associations"[25] that accompany these motifs was a meaningful source of civic pride for the many Dutch who bought such works in the vibrant art marketplace. For the first time in Western art, the actual landscape became a subject of painting, joining the ranks of more traditional history, genre, and mythological subjects. Here is a productive pastoral vision, grounded in the actual landscape and infrastructural systems that brought prosperity. And collectors and artists in the eighteenth century, particularly in England, celebrated this pastoral unity of the natural world and infrastructural and industrial productivity. But it was not a landscape as we might understand it since the Industrial Revolution, where, as we shall see, nature is a subject of art, but is apart from humankind, divorced from the infrastructural systems that powered society. Here in the seventeenth century, Dutch artists celebrated their enormous skies and rolling dunes, their country roads and forests together with productivity. As Adams and other scholars point out, some landscapes are clearly nostalgic for an older time and the *trekvaarten*, the orderly system of canals that transported people and goods from city to city, were not often included in the landscape views. But overwhelmingly, Dutch landscapes featured motifs that represented key infrastructural systems that powered the prosperity and cultural success of the country. Their popularity attests to the significance of such features in the landscape—they were what people wanted to see.

[24]Stechow, *Dutch Landscape Painting of the Seventeenth Century*, p. 8.
[25]Schama, "Dutch Landscapes: Culture as Foreground," p. 72.

2

The Eighteenth-Century English Landscape: The Classic Pastoral and Its Productivity

By the late seventeenth century, the Dutch Netherlands experienced an economic downturn with greater competition in trade and struggling production after their financial and military struggles against England. This led some artists to emigrate to England, where an admiration for Dutch landscapes had been emerging since the Restoration. For a growing aristocracy, the Dutch emigrants found work painting genre scenes, manor house portraits, and landscapes. Their arrival and the work they produced can be seen as part of a burgeoning fascination with and passion for landscape in eighteenth-century England. Throughout this period poets, philosophers, painters, and landscape architects made the British landscape their subject. Even today, British tourism touts the classic landscape of rolling hills, expansive fields, quaint villages, and great country houses set within vast estates. We will turn now to these landscapes, both painted and designed to better understand their pastoral productivity and place within British civic pride and discourse in the eighteenth century.

David L. Solkin's exhaustive book on British painting in the eighteenth century begins with a look at painting from the 1670s onward. In terms of landscapes, the art of Claude Lorrain, Poussin, and Gaspard Dughet popularized the idyllic landscapes of Antiquity. In general, such works were set within an imagined, ancient natural world with temples or ruins, bucolic shepherds, or mythological or biblical figures. Illusionistic devices such as valleys and copses of trees, lakes or seas, and mountains in the far, misty distance created landscape tropes used by followers of Claude, Poussin,

and Dughet, such as Robert Agass in the 1670s and 1680s. But some Dutch emigrants, such as Jan Siberechts introduced a different sort of landscape to England in the late 1600s. Siberechts moved to England in 1672, where he developed a successful practice painting views of great, aristocratic houses, such as *View of Longleat House*, of 1678.

This early view of Longleat focuses in on the architecture of the house and the small, walled gardens before it, but by the 1690s his views of country houses became more expansive and inclusive of the wider landscape park. Historically, this trend parallels political shifts in England at this time, as the landed aristocracy were gaining power, influence, and land following the Restoration of Charles II in 1660, the downfall of James II, and the more stable reign of William and Mary. A good example is Siberechts view of *Wollaton Hall and Park* of 1697 (Figure 2.1). In this work, Siberechts provides a bird's-eye view to better capture not only the house but the landscape around it. While the house is in the center of the painting, our eyes are drawn outward to the formal geometric gardens just before the house, past the orchards, bleaching fields, and kitchen gardens and out into the fields and woodlands. The house is surrounded by a green and verdant nature tamed and cultivated for maximum pleasure and productivity. As Solkin points out, *Wollaton Hall* and the many other house portraits like it from this time, attest "to the willingness of Britain's landed gentry and nobility to fashion a mixed identity for themselves, as the culturally enlightened members of a leisured ruling class on the one hand, and as the pragmatically minded overseers of Britain's productive acreage on the other."[1] Such landscape paintings struck a pastoral balance between leisure and productivity, nature and commerce. Painting and prints such as *Wollaton Hall* reflect the idea that "private wealth played a key role in establishing a harmonious balance between nature and society."[2] That wealth came from the land, through agriculture and animal husbandry, through careful forest management and timber harvesting, and through roads, rivers, and canals that carried goods to burgeoning cities. It is the land that is portrayed in its verdure and variety, and thus celebrated as a source of wealth and prosperity.

It was not just the aristocrats who commissioned such portraits. Solkin identifies wealthy merchants who owned land outside of London who also commissioned Siberechts to portray their properties. *Landscape with Rainbow, Henley on Thames* was one of a number of such views he painted at the request of city merchants between 1692 and 1698. Positioned on a hillside looking down to the river Thames and the village of Henley, Siberechts recorded a bucolic scene with cattle and sheep grazing in the foreground and

[1]David L. Solkin, *Art in Britain 1660–1815* (New Haven, CT: Yale University Press and the Paul Mellon Centre for Studies in British Art, 2015), p. 64.
[2]Solkin, *Art in Britain*, p. 65.

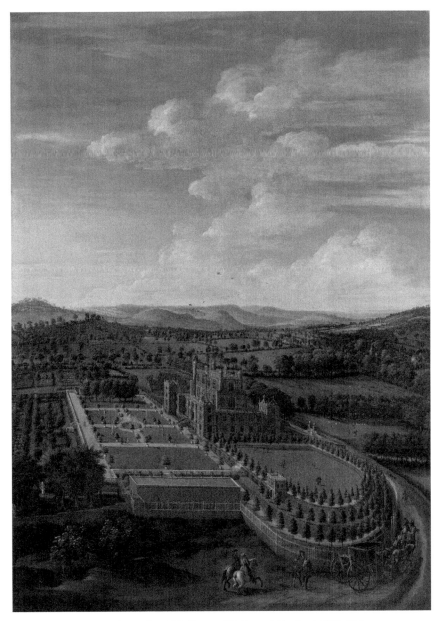

FIGURE 2.1 *Jan Siberechts*. Wollaton Hall and Park, *1697*. Oil on canvas *(Yale Center for British Art, Paul Mellon Collection)*.

a rainbow kissing the distant fields. Close inspection reveals a hive of activity, from workers in the field, and a barge hauling goods along the river, to neatly harvested fields on the distant hillsides. In this and Siberechts's *View of Henley from the Wargrave Road*, of 1698, the subject is more than the landscape: it is the productivity; the labor and abundance, that provided wealth to the landowners, be they aristocrats or wealthy merchants. And it is that balance of nature's bounty and human management that is celebrated in these images, the pastoral middle ground. While we, in the twenty-first century, see such images as quaint portrayals of a pastoral British idyll, for those commissioning the works, the views represented the productive systems on which society in the late seventeenth century flourished.

The idea of a synergy of landscape, recreation, and productivity was prevalent in the eighteenth century and was perhaps in part responsible for the plethora of landscape design, painting, and poetry from the period. In 1712, the poet, playwright, and politician Joseph Addison produced a series of essays in the newly founded *Spectator* magazine. Here, he expounded on a range of topics including the importance of imagination, taste, architecture, and nature. In an oft-cited passage he wrote in 1712 on Wednesday, June 25, "Nature and Art as Sources of the Pleasures of the imagination," Addison argued that while untouched nature is a source of pleasure, "We find the works of nature still more pleasant the more they resemble those of art."[3] Such art consists of a prospect "which is well laid out and diversified with fields and meadows, woods and rivers, in those accidental landscapes of trees, clouds, and cities."[4] In discussing the French and Italian gardens with their formal parterres and geometries he writes,

> our English gardens are not so entertaining to the fancy of those in France and Italy, where we see a large extent of ground covered over with an agreeable mixture of garden and forest which represent everywhere an artificial rudeness much more charming than that neatness and elegancy which we meet with in our own country. It might, indeed, be of ill consequence to the public as well as unprofitable to private persons to alienate so much ground from pasturage and the plow in many parts of a country that is so well cultivated to a far greater advantage. But why may not a whole estate be thrown into a kind of garden by frequent plantations that may turn as much to the profit as the pleasure of the owner.[5]

[3] Joseph Addison, "No. 414 [Nature and Art as Sources of the Pleasures of the Imagination] Wed. June 25, 1712," in *Essays in Criticism and Literary Theory*, ed. John Loftis (Northbrook, IL: AHM Publishing, 1975), p. 150.
[4] Ibid., 151.
[5] Ibid.

In polite prose, Addison suggested that the designers and consumers of the formal gardens of the French and Italians might be mistaken in not using their land more productively. And he calls for a garden that is as much about pleasure as it is about profit. Siberechts's paintings illustrate just such a balance of pleasure and profitable productivity and Addison's words codify the union.

As the eighteenth century progressed, such ideas persisted and relate to a fervent patriotism and civic pride. Carol Fabricant explored these issues in her 1985 essay, "The Aesthetics and Politics of Landscape in the 18th Century." She discussed how Addison admired variety and prospect in nature (as modified by man). Prospects (in the eighteenth-century understanding of the term as a view across the landscape) provided a sense of control, while nature in its variety and unpredictability offered the thrill of uncertainty. The tension between the control and ownership of nature and a loss of control and surrender to nature's caprices is one that continues to this day. The English countryside was considered to epitomize the perfect balance of variety, beauty, and industry. In Daniel Defoe's preface to his *A Tour through the Whole Island of Great Britain*, he waxed lyrical about the improvements in culture, commerce, and employment and posited that "the situation of affairs in this great British Empire gives such new turns, even to nature itself, that there is matter of new observation every day presented to the traveler's eye."[6] His tour documented the variety and richness of the British landscape stressing its productive output with a patriotic fervor.

Another vital thread was woven through the cultural ether of eighteenth-century Britain, beginning in the early years and stretching throughout the century. This was the influence and popularity of Virgil's poem *The Georgics* from 29 BCE. In this work, Virgil dedicates four books to agricultural endeavors, from animal husbandry and crop rotation, to vineyards and aviaries. This is a poem that praises the efforts of those who work the land, while critiquing the Roman political milieu. At its core is a recognition of the importance of farming, of tending to the earth. In 1697, John Dryden published a new translation of Virgil's poem and Addison wrote "Essays on Virgil's Georgics." These works ignited a passion for the landscape, a landscape both productive and aesthetic that continued through the century. As late as the 1780s, William Mason published his *English Garden*, a georgic-style poem in four books that praised the "*reunion* of beauty and utility."[7] Mason was primarily concerned with the *ferme ornée*, or ornamental farm that we will examine shortly. But as we delve into the eighteenth century, via paintings and landscape design,

[6]Defoe, *A Tour through the Whole Island of Great Britain*, p. 2, quoted in Carole Fabricant, "The Aesthetics and Politics of Landscape in the 18th Century," in *Studies on Eighteenth Century British Art and Aesthetics*, ed. Ralph Cohen (Berkeley: University of California Press, 1985), pp. 60–1.
[7]Laura B. Sayre, "Locating the Georgic: From the Ferme Ornée to the Model Farm," *Studies in the History of Gardens and Designed Landscapes*, vol. 22, no. 3 (July 2002): p. 172.

we shall see this concern with practical, productive landscapes, and cultured aesthetics surface regularly.

What is crucial here is that nature is understood as landscape. Landscape, in turn, is a nature that has been "improved" by man, tamed and harnessed to feed a hungry nation, grow timber for her naval ships, as transport for goods to an urban market, or barley for her ale. This is an organic and productive world that delights the eye and drives economic prosperity. The English landscape in the eighteenth century was celebrated in paint, print, and the design of the land itself, not merely for its aesthetic virtues and classical references but for the features included in those landscapes which produced wealth and prosperity.

These ideas took various shape throughout the eighteenth century. We can see them expressed in landscape painting, poetry, and the very popular design of landscape parks, both large and small. In painting, the landscape became an increasingly popular subject. During this period, there is a marriage of the French and Italianate style of landscape painting of Claude and Poussin, so popular throughout the century with its mythological or biblical subjects set in imagined arcadian landscapes, together with another strain of landscape that looked more carefully at the Dutch tradition of recording the landscape as pastoral records of the English countryside. Artists such as Peter Tillemans, a Flemish painter who relocated to England, recorded life along the Thames, where trade and commerce were interwoven with rural life and mansions of the elite.

For our purposes we will begin the work of the painter George Lambert. Lambert is considered a key figure in the history of British landscape painting. Art historians credit him with "groundbreaking steps"[8] in his landscapes. When commissioned to paint country seats, Lambert eschewed the tradition of Siberechts and his exacting bird's-eye views, instead capturing a more atmospheric rendering of landscape and great houses in the manner of Claude and Dughet. In 1733, Lambert painted two views of Box Hill, in Surrey in 1733. While he occasionally painted Claudian idylls, here Lambert borrows from the French tradition for the hazy sunlight that stretches across the pastoral and georgic hills of Surrey, bathing the scene in a warm summer haze. But there are several striking elements to this pair of images. They do not appear to have been commissioned by any particular patron, and they do not feature a great estate belonging to a wealthy landowner. Nor do they feature shepherds in classical dress or figures from mythology such as people in a Claudian landscape. Rather, Lambert captures the verdant fields of Surrey, laborers harvesting wheat, and wealthy gentlemen in the foreground finishing their

[8]Diane Perkins, "Tate Aquistition: Two Landscapes by Lambert" *British Art Journal*, vol. 1, no. 2 (Spring 2000): p. 87.

picnic, drawing and taking in the views. Here a party is enjoying their picnic on the hillside, looking out over carefully tended fields with sun-kissed Dorking in the distance, tidy haystacks, and grazing sheep. Such scenes illustrate the georgic or pastoral ideal of a productive and thriving landscape offering peace and recreation for the leisured classes. They celebrate the British countryside, its verdure and productivity. They pay homage to the land and to a balance between man and nature both pleasing to the senses and vital to the nation's prosperity.

This union of factors can be seen in Lambert's *View of Copped Hall, from across the Lake, Essex.* Here is the aging home of John Conyers, a Tory MP, who commissioned the painting in 1746. The house, while in the center of the painting, is surrounded by the landscape, a greensward just below the building includes deer grazing, alluding to a royal lineage, rustic fishermen hauling nets from the pond, and a small sluice in the distance that alludes to the productive bounty of the park. Such views of great country estates present an integration of nature and man's cultivation that was a source of individual and civic pride. Indeed, when Conyers had his portrait painted by Francis Hayman in 1747, Lambert's view of Copped Hall is placed just above the table beside which Conyers sits, a testament to his pride in his land and estate.[9]

Richard Wilson was another artist active during the mid- to late eighteenth century who prolifically drew and painted landscapes in England, Italy, and Wales. His *View on the Thames Near Twickenham* of 1762 continued this trend, illustrating the neoclassical Marble Hill house set within a riverscape with two men preparing to swim in the foreground, a barge hauling goods along the river, and laborers working on the far bank. Such scenes represent an idealized confluence of economic and pastoral concerns that make up the British landscape tradition.

Thomas Gainsborough is best known for his fashionable portraits of the English aristocracy and celebrities. But biographers and scholars record that he was an avid landscape painter who was influenced by the Dutch tradition of Ruisdael and Hobbema.[10] His early biographer, Philip Thicknesse, recorded, "Friendship there was between him and NATURE ... whether from the sturdy oak; the twisted eglantine; the mower wetting his scythe; the whistling plough boy; or the shepherd under the haw-thorn in the dale."[11] Though Gainsborough could not establish his career on landscape paintings alone, he painted many and introduced, both in style and subject matter, the tradition of the Dutch painters. With botanical accuracy and feathery strokes,

[9]Solkin, *Art in Britain*, p. 116.
[10]Susan Foister, "Young Gainsborough and the English Taste for Dutch Landscape," *Apollo Magazine*, vol. 146 (Aug. 1997): pp. 3–11.
[11]Philip Thicknesse, quoted in Ann Bermingham, *Landscape and Ideology: The English Rustic Tradition 1740–1860* (Berkeley: University of California Press, 1986), p. 59.

his landscapes rendered winding paths through woods, shepherds herding sheep, and rustics collecting firewood.

In his notorious portrait of *Mr. and Mrs. Andrews* dating around 1750 (Figure 2.2), Gainsborough united landscape with portraiture, siting the young couple just beside a field of hay, in the midst of harvesting. Sheep graze in the distance while fields and hills stretch out into the far distance. Here is a scene of rural harmony, the landowners sitting amid their fertile fields. There is no sign of hard, physical labor; instead, it is a georgic scene of verdure and paternalistic control.

We will return to the rendering of landscape in paint and ink shortly. But it is important to understand that while Siberechts, Tilleman, Lambert, Gainsborough, and others were capturing these georgic or pastoral landscapes on canvas, philosophers and gardeners were approaching the land itself, its hills and dales, farms and pastures with an eye toward recreating a classical idyll. Garden design in the seventeenth century in Britain owed much to the Dutch and French tradition with symmetrical beds, an ordered geometry and carefully tended topiaries. With the rising interest in Virgil's "Georgics" and a new patriotic stability after the political turmoil of the seventeenth century, eighteenth-century thinkers, poets, and gardeners began to look askance at such European formality, arguing for a more naturalistic landscape of winding paths, irregular water features, and variety in the "prospect" or view. Many scholars have pointed out that this was not an abrupt rupture in garden design,

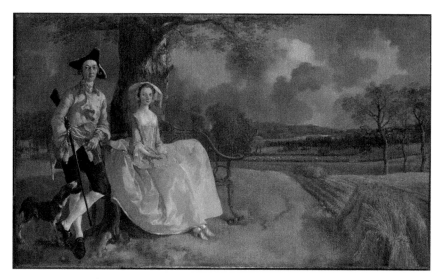

FIGURE 2.2 *Thomas Gainsborough.* Mr. and Mrs. Andrews, *1750. Oil on canvas (©The National Gallery, London).*

but it was a significant departure and one that had far-reaching consequences in landscape design.

As we have seen, Addison was calling for a landscape that was both productive and aesthetic as early as 1712, inspired by his study of Virgil. Also, in 1712, Alexander Pope "attacked the complex topiary and the predictable regularity of gardens and urged a return to the 'amiable simplicity of unadorned nature.'"[12] A return to a more naturalistic garden, one inspired by the ancients was a concept that gained traction, first among poets and painters and then translated into the actual landscape. In 1720, Pope designed his gardens at Twickenham with classical examples in mind, creating a grotto, and classically inspired landscape. This idea of a landscape evocative of the ancient Greek or Roman past, replete with classical allusions via statuary and architecture has fascinated landscape historians for centuries. We see it worked out in the gardens of Stourhead by Henry Hoare, with views inspired by Virgilian poetry and Claudian compositions, such as *Aneas at Delos*. But when one looks more deeply at the components of such landscapes within the context of Virgil's Georgics and the pastoral ideal, we find included in these landscapes a similar union of aesthetics and productivity that we saw in landscape paintings of Lambert or Wilson.

William Kent is frequently cited as the father of this new development in landscape design. For our purposes, we will focus on his designs for Rousham in Oxfordshire to illustrate the means by which the classical ideal was interwoven with a working and productive landscape. Kent began work on the house and gardens in 1738. The house dates from 1635 and is still owned by the same Dormer family. Such stability of ownership has ensured that the house and gardens have changed very little since the 1740s when Kent's plans were followed. While formal gardens with carefully trimmed boxwood remain within the kitchen or walled garden, Kent's designs reach out to the north and west of the house itself, winding through a narrow vale with serpentine walks that meander through the landscape and carefully arranged views of features such as Venus's Vale, Palladian Gate, or the Temple of the Mill. The sculptures that dot the garden are positioned looking out, directing our gaze toward borrowed views of fields and meadows, hills and distant villages. As Hal Moggridge discusses in his "Notes on Kent's Garden at Rousham," this countryside is divided into two distinct areas. "Around the southern side of the garden adjacent parkland reaches right up to the side of the house where cattle graze in the paddock beyond the HaHa. The hillside rises up from this paddock, ornamented with trees and farm buildings to a nearby

[12]Tom Williamson, *Polite Landscapes: Gardens and Society on Eighteenth-Century England* (Baltimore, MD: Johns Hopkins University Press, 1995), p. 48.

wooded skyline, all belonging to the Rousham estate"[13] while to the northeast views extend down toward the Cherwell river across other properties. Such "borrowed" views were common, especially on smaller estates.

Moggridge quotes a letter in the archives at Rousham, from the head gardener, John MacClarey, who wrote in about 1750 regarding the garden's views. These are worth recording here as they shed a spotlight on what particulars were valued in the landscape garden.

> From whence perhaps at this time you have the prettiest view in the whole World, Tho the most extensive part of it is but short, yet you see from hence five pretty Country Villages and the Grand Triumphant Arch in Aston field, together with the natural turnings of the Hills, to let that charming River down to butify our Gardens, and what stops our long view is a very pretty Corn Mill. Built in the Gothick manner but nothing sure can please the like our short view, there is a fine Meadow, cut off from the Garden only by the River Cherwell wherein all sorts of Cattle feeding, which looks the same as if they was feeding in the Garden.[14]

Included in these "prettiest" views are cattle and a corn mill (Figure 2.3). What is clear here, is that not only does the visitor to Rousham enjoy Kent's clever placement of classical sculptures and water features, but equally, with the Virgilian mindset, the bounty of the working landscape, from the mill and meadows to the grazing cattle. And while the classical allusions are important in the English landscape park, the georgic and pastoral traditions in poetry translate into an appreciation for and celebration of, the agriculture and animal husbandry that is woven into that landscape.

Such a synergy between a cultured aesthetic inspired by literary traditions and productive landscapes saw full realization in what was called the *ferme ornées* that were popular in the eighteenth century. The *ferme ornée*, or ornamental farm, is distinct from more traditional landscape parks in its emphasis on the active workings of agriculture and animal husbandry. The term first appears in Stephen Switzer's *Ichnographia Rustica* around 1729. Switzer was concerned that prosperity and aesthetics could be joined in the garden, and he worked out "grand formal designs [which] incorporated irregular woodlands, meadows, orchards, vegetable plots and even arable fields within their boundaries."[15] Sayre argues that these elements were persistent in garden design throughout the century, though the term has not been

[13]Hal Moggridge, "Notes on Kent's Garden at Rousham," *Journal of Garden History*, vol. 6, no. 3 (July 1986), p. 190.
[14]John MacClarey, quoted in Moggridge, "Notes on Kent's Garden," p. 190.
[15]Sayre, "Locating the Georgic," p. 168.

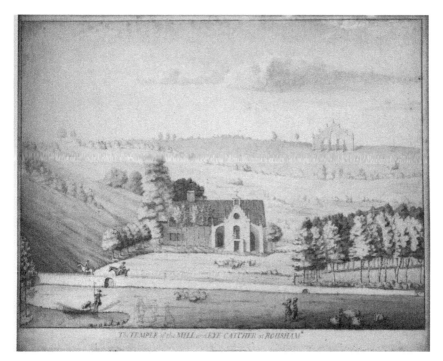

FIGURE 2.3 *William Kent.* View of the Temple of the Mill and Eye-catcher, Rousham, c. *1738–41. Pencil, pen and ink, wash. Private collection. From Susan Weber, ed. William Kent: Designing Georgian Britain. Yale University Press, 2013.*

used regularly. But she understands the genre to reflect the "extraordinary persistence of the georgic impulse to combine profit and pleasure in designed landscapes."[16]

Often cited as early examples of the *ferme ornée* are William Shenstone's Leasowes near Halesowen in the West Midlands and Philip Southcote's Wooburn Farm near Chertsey in Surrey (Figure 2.4). Shenstone developed his landscape in 1745–63. He was not particularly interested in incorporating arable land into his garden but instead focused on grazing together with meandering walks through woods and ruins. He was also a poet and established various benches, urns, and places where visitors could pause and read the verses or inscriptions that he dedicated to his heroes and friends.[17] Southcote began work on Wooburn Farm after his marriage to the Dowager Duchess of Cleveland. Here, he combined arable fields and grazing

[16]Ibid.
[17]Sayer, "Locating the Georgic," pp. 170–1.

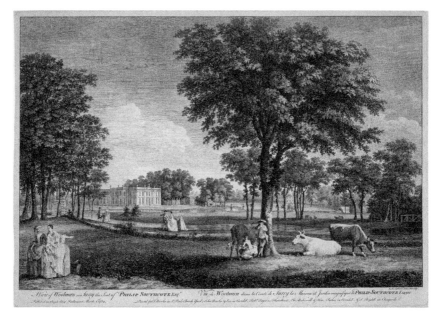

FIGURE 2.4 *Luke Sullivan.* Wooburn Farm, *1759. Engraving (©The Trustees of the British Museum. All rights reserved).*

pastures with sandy walks past "ornamental garden structures including a grotto, a gothic cottage, a poultry house, a menagerie, a ruined chapel and an octagonal temple."[18]

From the image above, it is clear that the *ferme ornée* is a place of recreation and pleasure, visited by the cultured elite. The labor of farm life is not included, but rather the georgic pleasure of carefully groomed landscapes with robust (and sometimes mischievous) cattle and sheep is part of an elite pastime celebrating the productive landscape. In 1770, the author Thomas Whately published his *Observations on Modern Gardening* in which he discussed the *ferme ornée*, which he "defined as an 'ornamented farm' as 'a walk, which with its appendages, forms a broad belt round the grazing grounds and is continued, though on a more contracted scale, through to the arable.' "[19] Whately praised the farms as a welcome escape for the owner of the estate, a retreat to a simpler and quaint rusticity. Brown and Williamson tie the *ferme ornée* to a long tradition of landscape gardening. In their words,

[18]Ibid., p. 169.

[19]Thomas Whately, *Observations on Modern Gardening: An Eighteenth-Century Study of the English Landscape Garden*, introduction and commentary by Michael Symes (Woodbridge: The Boydell Press, 2016), pp. 146–7.

But even in the 1740s landscapes like Woburn had not merely been about the creation of Arcadian scenes in the English landscape. They were more than ribbons of shrubbery, decorated urns and root houses, scattered through the fields… They drew on the notions of rural retirement so prominent in the writings of Pliny and Virgil, and were landscapes in which agricultural improvement, botanical experimentation, philosophic speculation, rural retirement and arcadian landscape come together in the recreation of an Augustan ideal.[20]

Sayre makes the point that these ornamental farms continued to be designed and enjoyed well into the nineteenth century when they became known as Model Farms. We will look at their legacy later both as it emerged in the nineteenth century and how it affected the Jeffersonian landscape.

The Landscape Park

The British landscape park is perhaps the most famous and widely recognized contribution to landscape design. The park differs from a garden in terms of scale and plantings, and a *ferme ornée* in its recognition of and integration with agriculture. In the 1750s Capability Brown emerged as a key figure in the design of the landscape park. There is no simple lineage here: as we have seen, Rousham Park was designed to include agricultural views with a classical overlay. Stourhead in Wiltshire was modeled on the landscape paintings of Claude and Poussin, and included views of pastureland with grazing sheep and cattle. Brown's landscape parks tended to be more expansive and focused on an opening up of the landscape, reducing plantings and follies and instead focusing on a naturalistic landscape of undulating swards of grass, carefully arranged copses of trees, and irregularly shaped ponds and lakes. The whole was often encircled by a belt of woods for privacy. Tom Williamson and David Brown trace the development of this landscape park back to the elite deer parks of the monarchs and aristocracy and chart the growth of these landed estates throughout the eighteenth century. They focus on the development of the Brownian landscape within the larger economic context of the landed estate. Key to our purposes here is their assertion that some of the vital elements of the park, the wide expanses of lawn, the wooded plantations, the distance agricultural fields, were all part of "the economic life of the estate, as well as expressing the owner's wealth and taste."[21]

[20]David Brown and Tom Williamson, *Lancelot Brown and the Capability Men: Landscape Revolution in Eighteenth-Century England* (London: Reaktion Books 2016); Brown and Williamson, *Lancelot Brown*, p. 211.

[21]Brown and Williamson, *Lancelot Brown*, p. 27.

Croome Court (Figure 2.5) was Brown's first major commission, and Richard Wilson's record of it gives a useful insight into how it would have appeared to Lord Coventry and his family and visitors. The view focuses first on the newly renovated neo-Palladian house the façade of which Brown had designed in 1751, upgrading the Jacobean house with a modern classical look. While sunlight directs our eye to the white stone façade in the middle distance, we soon take in a myriad of features carefully situated by Brown for maximum effect. To the left of the house, a stone bridge brings the visitor to the house, the culmination of Brown's characteristic winding path around the lake. Two large trees frame the view toward the house and a mother and child sit on the bank beside two men fishing. Across the lake from them a cow drinks from the lake, its haunches warmed by the sun. In deeper shadow, a herd of deer graze behind them, while sheep are spotted in the meadow to the far right. A classical rotunda sits atop a small hill on the far right—an eye catcher which invites exploration. Just to the left of the house in the far distance, a church tower signals the presence of a small village in the distance. The view is one of bucolic harmony, a peaceful pastoral essay wherein "nature" spreads out

FIGURE 2.5 *Richard Wilson.* Croome Court, c. *1759. Oil on canvas (©National Trust/Peter Moore).*

before the house, verdant and productive, restorative and evocative of an arcadian idyll.

This is typical of a Brownian landscape, its vast open swards, framed and enclosed by trees with classical references judiciously placed throughout. Embedded in such views are expressions of wealth, prosperity, and productivity, which the twenty-first-century viewer might miss. Such pastoral landscapes with their undulating topography, winding paths, and water features have become familiar, naturalistic tropes in our public parks and suburbs. But for the eighteenth-century visitor to such parks, or the collector of painted landscapes, such views played an economic and patriotic role. The peacefully grazing sheep and cows were a "gentlemanly form of agricultural production."[22] Not only were the sheep and cows picturesque, they were useful in maintaining the grounds before the advent of lawnmowers, and the meat and wool they produced were key to the owners' wealth. The deer in the shadowy glen of Wilson's painting suggest royal patronage, as deer parks were associated with royal privilege and tradition. The woods that ring the park were plantations for harvesting timber that could be used for naval ship building. The demands of time and space for such plantations were obvious symbols of wealth and privilege that only the elite could afford. Not included in Wilson's view, but frequently integrated into the Brownian landscapes via walks were the kitchen gardens which grew the vegetables, fruit, and herbs for the household.

Additionally, Brown and Williamson point out,

The networks of drives that made their appearance in the parks of Brown and other improvers through the 1760s represented, in an important sense, an extension of the new, improved road network. Of particular significance are the bridges that were a central feature of many park designs. Most were gratuitous, unnecessary adornments: Brown, and to some extent his contemporary designers, went out of their way to carry approaches across rivers or lakes, even where other routes would have been possible and easier. A passion for bridges cannot be seen in isolation from the sudden upsurge of bridge building that occurred in the wider countryside: they were symbols of modernity. And the very importance of drives and rides reflected new possibilities of, and new attitudes toward, travel in horse-drawn vehicles.[23]

Thus, the landscape park, as designed by Brown and recorded here by Wilson, expresses more than an idyllic pastoral retreat. Rather, it celebrates

[22]Brown and Williamson, *Lancelot Brown*, p. 124.
[23]Ibid., p. 193.

the modern: new approaches to agriculture and animal husbandry, advances in infrastructure systems such as roads and bridges, and, at its very core, a productive landscape that not only brings wealth to the owner but provides food and timber to the nation and recreation to visitors of "Taste."

As Britain prospered, wealth in trade and commerce grew, those who grew rich in the urban centers, such as London or Manchester, also wanted their country estates. These were often developed nearer to such urban centers and their owners had closer ties to industrial and commercial wealth than to agriculture. And the

> landscape they created around them reflected and expressed this fact. It was partly a desire to signal their difference from the farmers and other agricultural producers in the surrounding countryside – to affirm, very publicly, their membership of the polite – which encouraged landowners to clear away the barns, yards, and orchards from the immediate vicinity of their homes … but it was also because such things seemed offensive, uncouth, dirty.[24]

With the Industrial Revolution, and greater wealth in urban centers, the landscape parks, especially the smaller ones, became less productive, though sheep and cattle, even today in Britain, continued to help manage the land.

This union of productivity and aesthetic beauty did have its cost. What is not seen in Wilson's paintings or Brown's landscapes are the residents of a village displaced by a park's "improvements" or the widening disparities of wealth as the acts of enclosure shifted the agricultural landscape and deprived the poorest from a long tradition of grazing rights. As Carole Fabricant points out, "the aesthetics of landscape during this period was as much dependent upon what was *not* seen as on what was."[25] The issues surrounding the poor and social justice will continue to appear throughout this study. But of crucial concern here is the visual power these parks had. From Addison to Brown, the productive systems were included in landscape painting and design and celebrated not only for their beauty but for the prosperity they yielded. What is also crucial is the eighteenth-century belief that this controlled and productive nature was the privilege of the elite. Addison's essays in the *Spectator* of 1712, set the stage for the century:

> A man of polite imagination is let into a great many pleasures that the vulgar are not capable of receiving. He can converse with a picture and find an agreeable companion in a statue. He meets with a secret refreshment

[24]Brown and Williamson, *Lancelot Brown*, p. 168.
[25]Fabricant, "The Aesthetics and Politics of Landscape," p. 65.

in a description and often feels a greater satisfaction in the prospect of fields and meadows than another does in the possession. It gives him indeed a kind of property in everything he sees and makes the most rude, uncultivated parts of nature administer to his pleasures, so that he looks upon the world, as it were, in another light and discovers in it a multitude of charms that conceal themselves from the generality of mankind.[26]

Fabricant refers to this as a "hierarchic chain of seeing"[27] in which only an elite few can truly appreciate the "charms" of nature as ordered and shaped into the landscape. As the landscape park became less productive, this arranged nature became something to be consumed by the cultured elite. This is an important thread that runs throughout this book. Since the end of the eighteenth century, the "natural" landscape, the middle ground between the city and the wilderness as created by the likes of Kent and Brown, became a privileged place that slowly lost its productivity and became instead a place of leisure, recreation, and status.

[26]Addison, "Pleasures of the Imagination," no. 411, *Essays in Criticism*, p. 140.
[27]Fabricant, "The Aesthetics and Politics of Landscape," p. 70.

3

The Industrial Revolution and Its Intrusion on the Landscape

While Brown, Wilson, and their contemporaries were rendering the landscape park for the enjoyment of owners and tourists, innovators such as Edmund Cartwright, Joseph Arkwright, and Abraham Darby were refining new technologies that would completely change the nature of productivity in Britain and the globe. Technological advances in the manufacture of iron, textiles, and steam engines would transform the landscape and a traditional way of life. As textile mills and iron foundries began to proliferate in the countryside where there was easy access to raw materials, artists and landscape designers were faced with a new challenge: how to incorporate these productive systems into the landscape. For example, Paul Sandby was landscape painter who exhibited regularly at the Society of Artists and then at the Royal Academy. A map maker and prolific painter of landscape views, he often painted estate portraits which he exhibited at the Society of Artists. His *Northwest View of Wakefield Hall in Whittlebury Forest, Northamptonshire*, of 1767 shows a Brownian landscape in the manor of Wilson's at Croome Court. His *A Distant View of Maidstone, from Lower Bell Inn, Boxton Hill* of 1802 (Figure 3.1) illustrates the bucolic scenery of the English countryside with men herding cattle and sheep in the foreground, a woman and child walking along a path, and a gentleman and lady seated to the left, watching the scene. The middle distance shows a modest house of the gentry, in red brick with a horse and carriage waiting in the drive. But in the valley in the distance, vapors of smoke billow over the town of Maidstone, a growing industrial site of paper making at the turn of the nineteenth century.

Sandby had recorded industry in greater detail during his travels in Wales and England in the 1770s. His *Iron Forge between Dogelli and Barmouth*, of

FIGURE 3.1 *Paul Sandby.* A Distant View of Maidstone, From Lower Bell, Boxley Hill, *1802. Gouache and watercolor (Yale Center for British Art, Paul Mellon Collection).*

1776, shows the forge set within the Welsh landscape, with the river and hills beside it. Sandby's use of etching and aquatint helps to increase the deep shadows of the façade of the forge that frames the right side of the image. A tall outcrop of rock frames the image on the left, its features also in deep shadow. But the rugged yet peaceful setting of the Welsh landscape and the small scale of the industry with the shepherd in the middle distance, creates a nonthreatening image of industry and nature working together. Similarly, Joseph Wright of Derby's 1782 painting of *Arkwright's Cotton Mills by Night*, rendered the mill tucked snugly in the valley, glowing from within thanks to the modern gas light. There is no sense of danger or foreboding, rather the scene sets nature and industry together with a similar harmony as we have seen in the earlier agricultural pastoralism.

But as the eighteenth century drew to a close and the nineteenth century dawned, we can chart a growing unease over or ambivalence toward productive industry within the landscape. Sandby's *Bedlam Furnace, Madley Dale, Shropshire*, 1803 (Figure 3.2) shows industry on a larger scale. The foreground has none of the bucolic peace of his view of Maidstone. Rather, framing trees and herds of sheep and cattle have been replaced by more downtrodden figures and remnants of industry. Bedlam Furnace glows in the

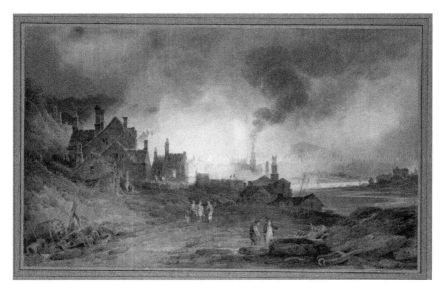

FIGURE 3.2 *Paul Sandby.* Bedlam Furnace, Madeley Dale, Shropshire, *1803. Watercolor (photo © Tate, London).*

center, its heat emitting an eerie, unnatural light, while the billowing smoke blends with ominous clouds. Like Philippe de Loutherbourg's *Coalbrookdale by Night* of 1801, there is a new sublimity to the productive landscape one that holds a certain fascination and curiosity, but one that is divorced from the traditionally productive countryside of animal husbandry, timber, and agriculture. Indeed, by the turn of the century, landscape painters were struggling with how to reconcile this new industrial productivity with nature and agriculture. The authors William Blake and Anna Sewell were adamantly against such industry, with its "dark Satanic mills"[1] and belching chimneys, but for painters of the landscape, tourists, and landscape gardeners, these new systems were both fascinating and troubling.

As early as the 1780s, Anna Seward's poem, *Coalbrookdale* describes the invasion of industry into the pastoral landscape around Coalbrookdale, a small village in Shropshire that was the site of dramatic industrial change. It was here where Abraham Darby first smelted iron in viable quantities and it became known as an industrial hub, painted by the likes of Turner and de Loutherbourg. Engineers Pritchard and Abraham Darby III's Ironbridge at Coalbrookdale of 1799 has long been lauded as an early triumph in iron construction. While "progress" developed there apace, Seward saw the

[1] William Blake, "And Did Those Feet," in *Norton Anthology of English Literature*, vol. 2, 6th edition, ed. M. H. Abrams (New York: W. W. Norton. 1993), p. 70.

changes as a violation: "Amid thy grassy lanes, thy wildwood glens,/Thy knolls and bubbling wells, thy rocks, and streams,/Slumbers!- while tribes fuliginous invade/The soft, romantic consecrated scenes."[2] She goes on bemoaning the intruding machines and smelters, "while red the countless fires,/with umber'd flames, bicker on all thy hills,/Dark'ning the Summer's sun with columns large,/Of thick, sulphurous smoke, which spread, like palls,/"[3] Throughout the poem, Seward warns of the power of Science and commerce that will spread its polluting clouds across all of England. She shares a mistrust of industrial development with William Blake, whose poem, *And Did Those Feet in Ancient Times* has the oft used reference to England's "Dark Satanic Mills"[4] of 1808.

Not surprisingly, the development of the picturesque in landscape painting arose just as the Industrial Revolution was taking shape in the late eighteenth century. William Gilpin, famous for his writings on picturesque views throughout Britain, did much to encourage domestic tourism, urging his readers to venture into the countryside to enjoy the irregular, varied, and wilder landscapes of England and Wales. Once there he offered advice on how to frame views to their most picturelike advantage. On subject matter, he advised, "From scenes indeed of the *picturesque kind* we exclude the appendages of tillage, and in general the works of men; which too often introduce preciseness, and formality."[5] These ideas were condensed and further articulated into the theory of the picturesque by figures such as Uvedale Price and Richard Payne Knight. The picturesque, as understood at the time, eschewed the pastoral views of bucolic fields and grazing sheep. Instead, it endorsed a wilder, less cultivated nature that still included rustic peasants at work, somewhat derelict mills and canals, and views that hinted at the passage of time and a pre-enclosure past. In her analysis of the picturesque, Ann Bermingham argues, "The anti-industrialism implicit in the picturesque grew out of the split between agrarian and industrial capitalism, which would widen considerably after the Napoleonic wars, and the nostalgia of the picturesque anticipated and compensated for the resulting shift of power away from the countryside after Waterloo."[6]

Advocates of the picturesque such as Gilpin and Price argued that the utilitarian had no place in our views of the landscape. As Stephen Daniels points out, "Enclosed fields, textile mills, and flaring furnaces appeared

[2]Anna Seward, *The Poetical Works of Anna Seward; with Extracts from her Literary Correspondence*, ed. Walter Scott Esq, vol. 2 (Edinburgh: James Ballantyne. 1810. Reprinted New York: AMS Press, 1974), p. 314.

[3]Ibid.

[4]Blake, "And Did Those Feet," p. 70.

[5]William Gilpin, *Three Essays: On Picturesque Beauty; on Picturesque Travel; and on Sketching Landscape: To Which Is Added a Poem, on Landscape Painting* (Cambridge: Chadwyck-Healey, 1999), p. iii.

[6]Bermingham, *Landscape and Ideology*, p. 83.

unambiguously functional and were looked down upon with disgust."[7] Others such as William Marshall continued to praise the inclusion of small-scale industry and agrarian activity for its productive and beneficial qualities, but increasingly the scale and magnitude of the industry made it a controversial aspect of the landscape. Artists and designers at the turn of the century were wrangling with ways to reconcile the two into a pleasing and inspiring whole. For example, Humphry Repton's commission for Benjamin Gott's estate, Armley Park, is indicative of this emerging tension. Repton's client, Benjamin Gott made his fortune in the textile business in Leeds. Gott began as a cloth merchant and moved into manufacturing as his business grew. He built the largest mill in Leeds, Bean Ing, in 1792–3. He bought the Armley Estate in 1803, with an existing house and seventy-three acres. While he originally lived in Leeds close to his work, his sister and mother-in-law lived in the house until he moved there in 1816. He hired Repton in 1809 to improve his estate. Repton was famous for his Red Books, in which he created before and after images of landscapes which, together with extensive descriptive text, outlined his plans for improving the house and landscape. For Gott, he renovated the house, opening up the eastern views with larger windows and a terrace framing the vista. For this view Repton arranged the foreground to include the terrace with flower beds, and green swards of lawn with cattle and sheep grazing. The middle distance featured the Leeds-Liverpool canal and the Armley Mill, and in the distance the city of Leeds with Bean Ing and other factories are misty in the industrial haze.

Thus, like the landed gentry before him, Gott could look out from his house and survey the productive landscape that brought prosperity to him and the local workforce. There is little doubt, according to Daniels that Gott took great pride in his business and enjoyed the views of it. He quotes Gott in a letter to his son, " 'we have had Burley Mill illuminated by Gas from Coal for ten days past and a beautiful and interesting object it is, the shade of light so pure – and the quantity so great and at so small a price—I have ordered similar apparatus for Armley Mill.' "[8] Armley Mill was a water-powered mill, which Gott updated with the latest amenities, such as gas light, steam heat, and spacious work spaces. Located in the middle distance from the Armley estate, it was situated in a rural environment and thus retained a more harmonious relationship with the land.[9] But Bean Ing, the large mill in Leeds, only hovers in the distance, its view softened by its smoky industry.

[7]Stephen Daniels, "Landscaping for a Manufacturer: Humphry Repton's Commission for Benjamin Gott at Armley in 1809–10," *Journal of Historical Geography*, vol. 7, no. 4 (Oct. 1981): pp. 380, 381.
[8]Daniels, "Landscaping for a Manufacturer," p. 390.
[9]Ibid., p. 390.

Daniels suggests in his article that Repton was deeply ambivalent about this commission. In general, together with Price and Gilpin, he was uncomfortable with the social and aesthetic changes that the Industrial Revolution was creating. He never mentioned the Gott commission in his other writings. In his last book, *Fragments on the Theory and Practice of Landscape Gardening* (1816), he praised views which included agricultural laborers, but warned against those that worked in manufacturing:

> Manufacturers are a different class of mankind to husbandmen, fishermen or even miners; not to speak of the difference in their religious and moral characters. The latter from being constantly occupied in employments which require bodily exertion, and their relaxations being shared with their family and friends, become cheerful and contented; but the former lead a sedentary life, always working at home and seeking relaxation at their clubs, the birthplace and cradle of equality, discontent and dissatisfaction.[10]

This passage highlights Repton's paternalistic yearning for an agricultural past; a time he understood as simpler in which laborers in fields and farms, even in mines, were of sounder moral character than those who worked in industrial cities. It illustrates a growing unease with industry and the social shifts that accompanied it.

Repton's attitude offers a wider lens onto the subject of productive infrastructures and the landscape. Increasingly, artists, thinkers, poets, and designers in the nineteenth century would react against the rise of industry, in part because of growing labor unrest, shifting patterns of social hierarchy, extreme poverty, and poor working conditions. Burgeoning industry sparked a growing divide between the landscape and productive, wealth-producing industry and we see that emerging in the work of Repton and others at the turn of the century. This shift is, of course, due to changing economic picture. Brown and Williamson discuss this shift in the context of the landscape park. They point out that landowners in the early to mid-eighteenth century depended on the production of their land for their wealth. But with the rise of industry by the 1770s and 1780s, the economic engine of the country's wealth became largely urban, with wealth the product of trade, industry, and commerce. This meant that the landowners took less pleasure in viewing the productive qualities of their properties and more pleasure in the recreational and pleasurable aspects of a house in the country as an escape from the city. The new, more urban culture "was above all, a culture of fashionable *consumption*, not of production: hence ... the rejection of orchards, fishponds, vegetable gardens and nut grounds as a setting for the homes of the polite.

[10]Repton, quoted in Daniels, "Landscaping for a Manufacturer," p. 393.

Hence, too, the increasingly elaborate displays of flowers and flowering shrubs in the gardens and pleasure grounds."[11]

This idea of consumption versus production in the landscape is crucial to our understanding of how we have viewed infrastructural systems in the twentieth and early twenty-first centuries. With the advent of the Industrial Revolution and the introduction of large-scale fossil fuel use, the "machine in the garden," as Leo Marx called it, the georgic idea of utility and beauty within the landscape fades. Instead, the landscape, from the wilderness to the garden bed is consumed as a pleasant pastime, a place of recreation, or spiritual retreat, but no longer of productivity, where man and nature ideally lived in sustaining balance.

One of England's best-known landscape painters is Joseph Mallord William Turner. He spent his early years in London, but by the 1790s traveled throughout Britain sketching. His topographical scenes were popular and printed in the *Copper Plate Magazine* published by John Walker in the late 1790s, which included text discussing each view. This was an early means of disseminating Turner's work and he continued to sketch urban and rural landscapes for publications such as Walkers's. In Stephen Daniels's analysis of Turner's landscapes, he points out that Turner's images, whether rural or more urban, celebrated waterways, roadways, and, toward the end of his career, the railroad. These landscapes highlight the bustle and productivity of the scene, whether it be timber production as in his views of Harewood Park, or mills and canals such as in his print of Pembury Mill of 1808. Turner produced several watercolors intended for T. D. Whitaker's *History of York*. For our purposes, we will look at Turner's image of *Leeds*, of 1816 (Figure 3.3). Here Turner depicts a growing industrial town. In this image, Turner captures, in an almost encyclopedic manner, the bustle and industry of the burgeoning city. Leeds lies in the distance, set in a valley with hills behind it. Church spires and factory chimneys dot the skyline bathed in a misty blur from the productive smokestacks. We can see the city spreading, with a smaller conurbation in the middle ground and a mill to the right of center. In the foreground, Turner emphasized the importance of the road leading into the city with laborers setting stones in place, milk carriers, and factory workers.[12]

To the left, the land and valley stretch out, providing a space for drying cloth and grazing cattle. This is a landscape of busy industry, celebrating well-traveled roads, flourishing industry, and verdant countryside. There is none of the sublime awe of industry that Sandby and de Loutherbourg suggested, rather what Turner chose to document suggests a productive balance. This is

[11]Brown and Williamson, *Lancelot Brown*, p. 168.
[12]Stephen Daniels, *Fields of Vision: Landscape Imagery and National Identity in England and the United States* (Princeton, NJ: Princeton University Press, 1993), p. 119.

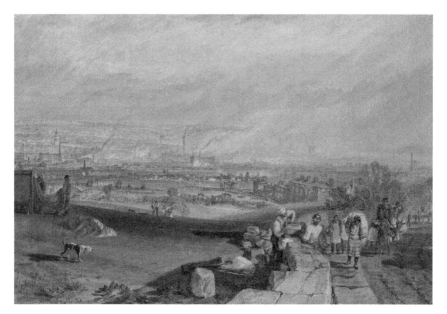

FIGURE 3.3 *Joseph Mallord William Turner.* Leeds, *1816. Watercolor (Yale Center for British Art, Paul Mellon Collection).*

somewhat ironic given that Turner's greatest patron and critic, John Ruskin, positioned his work to reflect Ruskin's own vehemently anti-industry views, but at least in this and other early works, Turner renders such scenes without doom or vitriol. Indeed, Daniels points out, it was not illustrated in Whittaker's *History of Leeds,* suggesting that "Turner's view of Leeds may have been too progressive for the text it was intended to illustrate … Whitaker's text deplores the effect of industrialization on the landscape and the culture of Leeds and its environs."[13] But in Turner's work, such condemnation is not clear and that may be why it was not published.

One of Turner's most famous paintings *Rain, Steam Speed: The Great Western Railway* of 1844 (Figure 3.4) suggests his ambivalence toward new infrastructural systems of production and transportation continued through the 1840s. In this iconic image, the Great Western Railway comes charging toward the viewer, the light from the furnace and cars contrasting with the dark black of the chimney stack. It is crossing Brunel's Maidenhead Railway Bridge, a feat of engineering in and of itself, and is part of the widely celebrated Great Western line that traveled from London to Exeter where it met the steamships heading for America. It was a symbol of a new great power, of British engineering and advanced technology. Turner included the

[13]Daniels, *Fields of Vision*, p. 123.

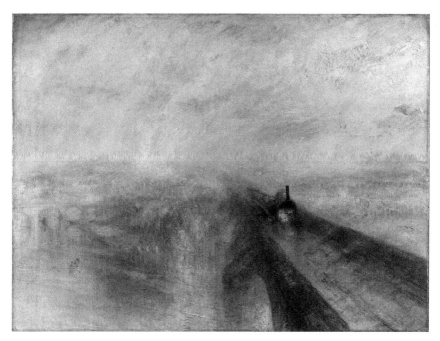

FIGURE 3.4 *Joseph Mallord William Turner.* Rain, Steam, and Speed, *1844. Oil on canvas (©National Gallery, London).*

old bridge across the Thames to the left, its stone arches hazy in the mist and clearly set apart from the steam and furor of the train and new bridge. A small wooden boat is glimpsed near the old bridge, afloat and alone, rowing slowly away. Turner sets up a series of contrasts of old and new which compel the viewer to reflect on the changes wrought by the railroad. But it is not clear whether Turner is protesting against those changes or celebrating them for their sublime energy and power. This is not a balanced, bucolic landscape but it does suggest a fascination and celebration of this new infrastructural system that French Impressionists such as Monet and Pissarro would also pursue in the 1870s and 1880s. What is significant here is the sense that landscape and industry are divorced in the view. This is a painting about the railroad, its power, speed, and revolutionary nature. Whether it celebrates or condemns that power, it does not try and wed it to nature. Indeed, the small hare, so hard to see, darts away from the tracks, one small vestige of the natural world fleeing the industrial.

In his *Art and the Industrial Revolution*, Francis Klingender tracks the representation of industry and infrastructure in the nineteenth century. In the context of the growth of the railroad, he mentions the work of J. C. Bourne, a watercolorist and engraver whose early work focused on the construction

of the railroads. "He was enthralled by the masterpieces of engineering and architecture that were hoisting themselves out of the sticky London clay. He was convinced that faithful delineations of their construction would 'gratify both the lover of the picturesque and the man of science,' as well as 'all persons who derive pleasure in contemplating the increasing importance of the commerce, manufactures and arts of Great Britain.'"[14] But his close observations of construction sites and railway bridges had limited appeal and, while published in collections such as *Drawings of the London and Birmingham Railway* of 1839, their audience was limited to engineers and railway enthusiasts.

John Constable vies with Turner for Britain's most famous landscape artist status. Much has been written about Constable and his devotion to the landscape where he grew up, around East Bergholt, Suffolk, and his landscapes are considered quintessentially English, capturing the rural countryside and quiet scenes of work on the land. Constable was a great admirer of both Gainsborough and Jacob Ruisdael and studied and copied both artists' works as models of landscape painting. Thus, his art developed out of a long tradition of the georgic landscape, capturing the rural life which he knew and loved. Like Ruisdael, he painted the productive landscape of wheat and cornfields, mills and canals, sheep and cattle that helped England prosper. But after the Napoleonic Wars, wheat prices plummeted, and an agricultural depression ensued. Concurrently, money and wealth increasingly came from the textile and iron industry, lessening the economic importance of land. These economic forces have led many to see Constable's works as nostalgic, both on a personal level, for the land of his childhood, and on a national level for a way of life that was fast declining. Constable's nostalgia was for an agricultural, productive landscape. It was a landscape appreciated by an increasingly urban painter whose father had owned and managed the mills, canals, and landscape he painted. He claimed this backward-looking view as his own, and by the 1880s, the English tourist celebrated Constable country as his or her own as well.

The rupture of productive systems that accompanied the Industrial Revolution, divorced the landscape from productive infrastructure. As we saw with Sandby and de Loutherbourg's images of the blast furnaces of Maltby and Coalbrookdale, nature increasingly had no role to play in industry. The pastoral landscape was to be enjoyed for recreation, as a balm to the spirit, subject of the Romantic poets, such as Wordsworth. But it was no longer productive. Thus, what we see in Constable's work, such as *The White Horse* (Figure 3.5) is a fading vision of the traditional, georgic landscape. In these

[14]Francis Klingender, *Art and the Industrial Revolution.* Edited and revised by Arthur Elton. (Chatham: W & J Mackay, 1968), p. 155.

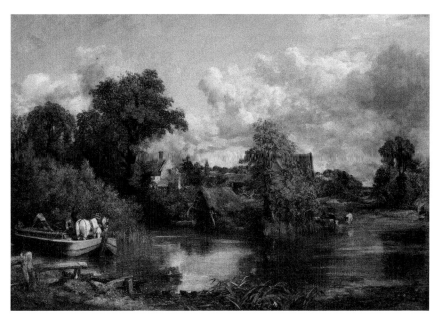

FIGURE 3.5 *John Constable.* The White Horse, *1819. Oil on canvas (purchased by the Frick Collection, 1943).*

larger works, Constable paints a world of work, with canals hauling goods to London or bringing night soil back from the city. There is prosperity and hard labor. But the workers are woven into the views as part of the landscape. Ann Bermingham points out,

> This blending has two effects: it naturalizes the labourer's presence in the landscape, and, by extension, it naturalizes the work they are shown performing there. Not only men and nature are shown in harmony but also industry and nature. The land is formed for cultivation and the river for navigation: work is the natural attitude in such a place where man's commercialization of nature comes to signify his oneness with nature.[15]

This is not to suggest that the laborers felt at one with nature—work was hard and long and economic shifts were causing great hardship and poverty among the rural poor. But Constable's landscapes perpetuated the tradition we have seen since the Dutch landscape painters wherein labor, prosperity, and civic pride were integral to the appreciation of the landscape. Constable painted a system that was rapidly disappearing. The Industrial Revolution, with its railways and factories, powered by coal and steam not only changed the

[15]Bermingham, *Landscape and Ideology*, p. 139.

face of cities and towns across Britain. It brought about a massive shift in our relationship with nature. As we shall see in the following chapters, in the nineteenth and twentieth centuries, nature is consumed, by tourists, painters, photographers, and industrialists mining its resources. But its productive value in the middle ground is lost.

4

A Growing Divide: Landscape and Infrastructure in Victorian Britain

John Ruskin, the prolific art critic and author, is often credited with securing Turner's place as Britain's most eminent landscape artist. In his multivolume *Modern Painters*, Ruskin argues in support of Turner, praising both his imagination and veracity in paint. As we saw above, Turner's interest in modern features of the landscape, such as the railroad and factories, suggests an appreciation of these new productive systems, as he wove the old with the new. His *View of Conventry* of 1832 typifies this integration: cows graze in pastures in the foreground while in the city in the distance, church spires and smoking chimneys punctuate the skyline within a misty atmosphere. While Turner wrangled to integrate industry into the traditional pastoral landscape and Constable ignored it altogether, focusing on a nostalgic look to the past, many Victorians were disturbed by the effects of industrialization.

William Wordsworth, one of the best-known Romantic poets, had dire misgivings about the growing industrialization of England. For Wordsworth, nature was a pastoral retreat, his imaginative muse. In his lengthy, somewhat autobiographical poem, *The Prelude,* shepherds and farmers, laboring in the hills of the Lake District where he was born and lived for much of his life, people the verses, their nobility emphasized by their simple yet inspiring connection to the land. Such a pastoral landscape was the source of his imagination and a balm to his soul. He too railed against the growth of cities and industry as is clear in his poem *The Excursion* in which he describes a large town whose growth has hidden "the face of earth for leagues" and "o'er which the smoke of unremitting fires/Hangs permanent, and plentiful as wreathes/Of vapours

glittering in the morning sun."[1] Klingender points out in the context of this poem, that Wordsworth is offended by industry primarily for moral reasons. He sees the rapid growth of cities and the ensuing poverty and hardship of laborers as one of the key problems with industry. Wordsworth's quarrel is with the "ill-regulated and excessive application of powers so admirable in themselves."[2]

In Wordsworth's poetry we can trace two key strands that shaped the nineteenth century's attitudes toward nature and new industrial systems. The first is Wordsworth's love of a pastoral nature, which was, of course, shared by eighteenth-century landowners and landscape painters and designers. But key here is Wordsworth's private and personal response to nature. While the shepherd combs the hills looking for his sheep, Wordsworth too wanders the vales: "Beauteous the domain /Where to the sense of beauty first my heart /Was opened."[3] Wordsworth's heart is opened to the beauty of the natural world, to a landscape both wild and tamed. This is a key shift and reflects the Romantic poets' interest in nature as a place of retreat, a salve to the soul. This is not to suggest that the pastoral tradition had not included such retreat before; indeed, the dialectic relationship between city and country is long. But this individualized, spiritual connection to nature is part of what defines the Romantics and influences writers and artists such as Ruskin in Britain and the Transcendentalist Ralph Waldo Emerson and the Hudson River school painters in America.

The second thread highlighted here in relation to Wordsworth is his concern with the social ills that were the result of industry. For many in Britain in the nineteenth century, industrialization was linked to social unrest and exploitation, and the sociopolitical issues surrounding the machine were of the greatest concern to many, above the effects on the landscape. Indeed, in his early essay "Signs of the Times," Thomas Carlyle expressed his misgivings about the "Machine Age" of the late 1820s. In this essay, he refers not only to the industrial machines changing the methods of production and transportation but also to shifts in larger social structures which he understands as also mechanized and dehumanized. His tone is ultimately optimistic, believing that man will in time, reconcile himself and society to the machine age with happy results; "Therein let us have hope and sure faith. To reform a world, to reform a nation, no wise man will undertake; and all but foolish men know, that the only solid, though far slower reformation, is what each begins and perfects

[1]Quoted in Francis D. Klingender, *Art and the Industrial Revolution*, ed. and rev. Arthur Elton (Chatham: W & J Mackay, 1968), p. 117.
[2]Ibid.
[3]William Wordsworth, *The Prelude 1805*, ed. James Engell and Michael D. Raymond (Boston, MA: David R. Godine, 2016), p. 142.

on *himself.*"[4] Thus moral reform of society must start with the individual. For both Wordsworth and Carlyle, machines and industry needed to be tamed and controlled, much like the wilderness or "wastelands," in order to reach a comfortable balance and a healthy society.

Man's personal relationship to nature and his wider concerns for the social ills caused by industry are manifested in art, architecture, and landscape design throughout the nineteenth century. In A. W. N. Pugin's classic *Contrasts* of 1841, he compares a "Catholic" town of 1440 with the same town in 1841.[5] The medieval town has a myriad of church spires silhouetted against the sky, and verdant fields harvested in the foreground. In the town of 1840, in contrast, smokestacks outnumber the church spires, and a Benthamite workhouse or prison has replaced the pastoral landscape. For Pugin, this contrast was laden with religious import and was for him, a call to return to a more benign Catholic past. Nature was not for Pugin so much about an arcadian ideal, but rather a symbol of healthier work in the fields under the shadow of the Catholic church. Significantly, Pugin's nature is productive; life-giving fields and orchards (as seen in his image of the medieval poorhouse, set within a monastery) are symbols of a healthy body and soul. For Pugin, as for Wordsworth and Carlyle, the moral fiber of British society had suffered under the yoke of industry and the subsequent race for wealth and material goods.

Pugin's legacy lay primarily in the development of the Gothic Revival in architecture and design, so representative of the Victorian era. In landscape painting after Turner and Constable, Ann Bermingham has noted that as England's landscape changed with the growth of the railroad and canal system, and landowners were increasingly making their money through commercial and industrial enterprises, interest in nature was shifting as well. As the middle and upper middle classes moved into developing suburbs, they grew less dependent on a rural economy. People were disconnected from the rural landscape; nature became either a destination for a holiday or day trip via the railroad, or an object of scientific study. Bermingham points out that "the growth of naturalist societies in 19th century England reveals that nature itself was falling increasingly outside quotidian experience and becoming the subject of specialized investigation."[6] She also notes that in the eighteenth century land was seen as a source of capital and with industrialization it had become a source of raw materials. In art, these shifts are expressed both in the development of amateur watercolor societies and naturalist societies. These

[4]Thomas Carlyle, "Signs of the Times," in *A Carlyle Reader: Selections from the Writings of Thomas Carlyle,* ed. G. B. Tennyson (Cambridge: Cambridge University Press. 1984), p. 54.
[5]A. W. N. Pugin, *Contrasts: Or, a Parallel between the Noble Edifices of the Middle Ages, and Corresponding Buildings of the Present Day; Shewing the Present Decay of Taste,* intro. H. R. Hitchcock, 2nd ed. (Leicester: Leicester University Press, 1971).
[6]Bermingham, *Landscape and Ideology,* pp. 159–60.

societies grew up in the wake of research and writings of the geologist Charles Lyell, and the explorer Alexander Humboldt. Their writings are emblematic of a new, methodical, and empirical study of nature and its geology and climates. Amateur scientists went into nature to carefully study, document, and categorize. Similarly, amateur watercolor societies encouraged day trips to the countryside to paint the scenery. In both, the landscape is valued now less for its productivity and more for its escapist attractions. England's civic pride may still, in part, have been based on the rural landscape as part of its picturesque image, but that was becoming a mythologized landscape far removed from the experience of most suburbanites.

John Ruskin, perhaps the most prolific and influential art critic of the mid-nineteenth century, urged artists to carefully understand and record nature. His, *Modern Painters*, consisted of five volumes written between 1843 and 1860. While much of his writing promotes the work of Turner as England's finest landscape painter, he offers advice and moral guidance to his audience and counsels them about the sacredness of the natural world. His writings inspired artists to paint carefully from nature, putting science and careful study in the service of the Divine. When science is understood within the context of beauty and spiritual health, "the simplest forms of nature are strangely animated by the sense of the Divine presence; the trees and flowers seem all, in a sort, children of God; and we ourselves, their fellows, made out of the same dust."[7] Thus for Ruskin and others, careful study of the natural world could bring Victorians closer to an understanding of life and God.

In art, this interest in scientifically recording nature, together with the country excursion for the urbanite or suburbanite, can be seen in the work of the Pre-Raphaelite Brotherhood (PRB). The three leaders of the PRB, Dante Rosetti, John Everett Millais, and William Holman Hunt, were based in London. While Rosetti is not known for his landscape paintings, both Hunt and Millais garnered attention and critical praise for their renderings of nature. Both men's art was influenced by the popularity of the natural sciences and Ruskin's call to study nature in detail and with great honesty. We will discuss Ruskin's ideas in greater detail later, but his writings such as *Modern Painters* had a profound influence on the PRB in their subjects and style. In the famous *Ophelia* by Millais of 1851, critics noted the exquisitely detailed rendering of the flora surrounding the drowning Ophelia. Indeed, so accurate was the rendering of each plant and flower, that Millais's son recounted the story of a botany professor who, when a field trip with his students was stymied, brought his students to see the plants surrounding Ophelia which "were… as instructive

[7] John Ruskin, *Modern Painters*, vol. 3, part IV. Edited and abridged by David Barrie (New York: Alfred A. Knopf. 1987), p. 423.

as nature herself."[8] This exacting naturalism is no longer a georgic celebration of the life-giving bounty or agricultural wealth of the country. Rather, for Pre-Raphaelites such as Millais, nature represented scientific discovery, the intense details illustrative of how their "vision was radical in that it was optical and investigative."[9] Taken as a whole, the viewer engages with Ophelia and her literary plight. But upon close examination of the painting, the viewer can slowly and carefully identify plant after plant on the canvas with encyclopedic precision. According to Bermingham, this is part of a wider trend wherein "In both the suburb and the laboratory, we experience the natural specimen, not nature; we observe the example of the larger phenomenon."[10]

This detailed exploration of nature is typical of much of the work of the Pre-Raphaelites and their followers. While one can make the case that William Holman Hunt's *Our English Coasts (Strayed Sheep)* of 1852, with its recognizable landscape and grazing sheep, has patriotic elements, others have read religious themes into it. The precarious cliff on which the sheep graze and the abrupt drop to the lower pasture and cliffs have none of the gentle pastoral nature of a Gainsborough landscape, nor is the scene sublime with raging seas or stormy mountains. It is also highly detailed with readily identifiable thistles and bracken on which the sheep are grazing. *Our English Coasts* is something of an outlier both in Hunt's oeuvre and in the works of most Pre-Raphaelite painters. In general, landscape is a backdrop for figurative scenes, such as Ford Maddox Brown's *The Pretty Baa Lambs* of 1851–9. This also features a highly detailed nature, where every blade of grass is rendered with excruciating detail.

These artists ventured from the city and captured rural scenery as an escape from city life. Some, like Ford Maddox Brown, remained closer to the city when they painted. Brown's *An English Autumn Afternoon* of 1852–5 captured the scene from his window in Hampstead. This suburban view looks out across Hampstead heath toward London, even including a wisp of smoke on the distant horizon. But in general, the mid-century Pre-Raphaelites were interested in landscape scenes of labor and community, a "repository of ideals through which urban experience both was perceived and found its ultimate truth. Objectified as spectacle or science, the countryside took on an ideal form and performed the ideological function of providing urban industrial culture with the myths to sustain it."[11] Brown's painting entitled, *Work* focuses on the changing nature of industry and urban life. Together with William Bell Scott's *Iron and Coal* of 1861, these paintings capture the crowded chaos of

[8]Alison Smith, "Ophelia," catalogue entry in *Pre-Raphaelite Vision: Truth to Nature*, ed. Allen Staley and Christopher Newall (London: Tate Publishing, 2004), p. 34.
[9]Alison Smith, "The Enfranchised Eye," in *Pre-Raphaelite Vision*, p. 14.
[10]Bermingham, *Landscape and Ideology*, p. 182.
[11]Ibid., p. 193.

labor and the disruptions of industry on the urban fabric. But both artists focus on the workmen themselves, their activity, strength, and hardships. Industry and infrastructure are the background context for the plight and challenges of industrial labor.

In the Tate's exhibition, *Pre-Raphaelite Vision: Truth to Nature*, the authors catalogued many lesser-known artists in the Pre-Raphaelite circle whose landscapes generally follow a similar trajectory to those we have looked at thus far. Nature is rendered within a longer pastoral tradition, and agriculture included in the views. But infrastructure and industry, such as the railroads, canals, or factories do not appear. Occasionally, as in William Davis's *Old Mill and Pond at Ditton*, of 1860–5 (Figure 4.1), older infrastructural systems are rendered in states of decline and decay, moss-covered and patched, as echoes of an earlier productivity. Such views ignore the contemporary industry or transportation systems, focusing instead on an older, pastoral tradition.

Conversely, wilder landscapes such as Gustave Dore's *Landscape in Scotland* of 1872 capture the wilderness of the Scottish Highlands, a wild and rugged land, offering an escape from urban civilization. Such a view, with its billowing clouds and gnarled branches, contrasts with Dore's better-known etchings of London that he published in conjunction with Blanchard Jerrod in the 1872 publication *London: A Pilgrimage*. London, or cities in general by this time, were often viewed as places of poverty and moral deprivations. While this publication focused on and exaggerated the close and harsh living conditions of the urban poor, a print such as *Row Houses*, effectively illustrates what by then was an understood divorce between nature as seen in the wilds of Scotland and an industrialization stripped of nature with its cramped quarters and blackened skies.

The ominous quality of industrialization was realized in the hyperbolic images by John Martin. Martin was best known for apocalyptic paintings recording the despair and destruction of ancient civilizations. He was a prolific and populist artist who showed his enormous works to large crowds. His final triptych, *The Last Judgment*, includes *The Last Judgment, The Great Day of His Wrath* (Figure 4.2), and *The Plains of Heaven*. Completed in 1853, these huge canvases illustrate the apocalypse as forecast in the Book of Revelation. While not critically acclaimed, their popularity was undeniable, and they were shown across England and America through the 1870s. According to his son, Leopold, the *Great Day of His* Wrath was inspired by a trip through the West Midlands, often referred to as "The Black Country." This was an area of intense industrialization with coal mines, smelting furnaces, brickmaking, and steel mills. His son wrote that as Martin passed through the region at night:

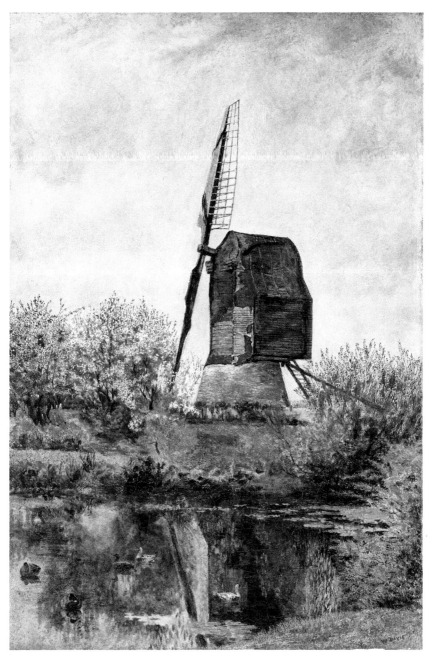

FIGURE 4.1 *William Davis.* Old Mill and Pond at Ditton, *c. 1860–5. Oil on canvas (Walker Art Gallery, Liverpool, The Atheneum).*

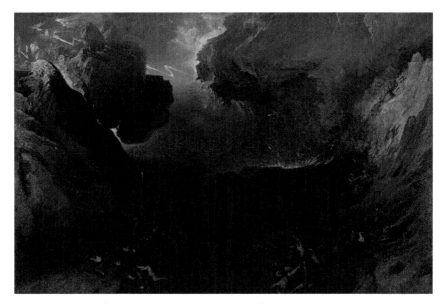

FIGURE 4.2 *John Martin.* The Great Day of His Wrath, *1853. Oil on canvas (photo © Tate, London).*

> The glow of the furnaces, the red blaze of light together with the liquid fire, seemed to his mind truly sublime and awful. He could not imagine anything more terrible even in the regions of everlasting punishment. All he had done or attempted in ideal painting fell far short, very far short, of the fearful sublimity.[12]

Such images of industry, belching black smoke, darkening the skies and scaring the earth became the image of industrial productivity.

The middle ground then, as painted by the likes of Brown, Davis, and Hunt, retained echoes of the pastoral with nostalgic twists indicative of the urbanites' understanding of it. It was to be enjoyed on a Sunday trip to the country, or as a view from the train. But its value was now psychological or spiritual. Within that middle ground, productive and infrastructural systems that played such a key role in the prosperity of the seventeenth-century Dutch society or in eighteenth-century England are now divorced from the pastoral landscape. While agriculture still played a role in England's economy, as the century wore on and the empire expanded, it was no longer the driving economic force. In light of this, we can see the landscape art of Brown, Hunt, Davis, and others as celebrating fading traditions and quaint rustic life. By the mid-nineteenth century, infrastructure and industry, that which produced England's prosperity and helped grow the Empire, was urban and separate from nature.

[12]Leopold Martin, quoted in Klingender, *Art and the Industrial Revolution*, p. 132.

We see this clearly in the writings and admonitions of John Ruskin. Throughout his long and voluminous writing career, Ruskin touched on subjects ranging from painting and landscapes to religion, domesticity, and education. Throughout all his writings, the theme of nature and a love of the natural world runs strong. In *Modern Painters*, volume 3, he describes how he came to love the countryside, and the joy he felt amid mountains and valleys. There was for him "a continual perception of Sanctity in the whole of nature, from the slightest thing to the vastest; -an instinctive awe, mixed with delight; an indefinable thrill."[13] Increasingly as the century continued, Ruskin's delight in nature was tinged with foreboding and he railed against the industrial machine. Sometimes considered as the father of twentieth-century environmentalism, Ruskin warned of the dire consequences of unchecked industrial pollution.

David Carroll's essay, "Pollution, Defilement and the Art of Decomposition" discusses Ruskin's ideas as expressing a deep belief in nature's covenant and a profound worry that "the covenant is being progressively and violently broken in the second half of the nineteenth century. The profane forces that invade the sacred [i.e. the natural world] come from the world of utility."[14] As early as 1849, in the *Seven Lamps of Architecture*, Ruskin warns against the railroads as they increasingly traversed the country. He understood them as dangerous and a symbol of the greed and pollution of the industrial era. If railroads had to be constructed, he recommended they be kept "out of the way, take them through the ugliest country you can find, confess them the miserable things they are, and spend nothing on them but for safety and speed."[15] From factories to the railroads, Ruskin saw industry as the great defiler of England and, increasingly, the globe.

In 1884, Ruskin delivered two lectures he titled "The Storm-Cloud of the Nineteenth Century." Delivered to the London Institution, he outlined how he had studied clouds with careful observation and had noticed how they had changed over the past forty years. Referring to the "plague-cloud" he noted that it was a new phenomenon that has emerged only relatively recently. Reviewing his diaries from years past Ruskin recounts his observations. For example, in 1871, "For the sky is covered with gray cloud; – not rain-cloud, but a dry black veil which no ray of sunshine can pierce."[16] And in June of 1876,

[13]Ruskin, *Modern Painters*, vol. 3, p. 416.

[14]David Carroll, "Pollution, Defilement and the Art of Decomposition," in *Ruskin and Environment: The Storm Cloud of the Nineteenth Century* (Manchester: Manchester University Press, 1995), p. 63.

[15]John Ruskin, *Seven Lamps of Architecture* (8.159–60) quoted in Jeffery Richards, "The Role of the Railways," in *Ruskin and Environment: The Storm Cloud of the Nineteenth Century*, ed. Michael Wheeler (Manchester: Manchester University Press, 1995), p. 134.

[16]John Ruskin, *The Storm Cloud of the 19th Century: Two Lectures Delivered at the London Institution, February 4th and 11th, 1884* (New York: John Wiley, 1884), p. 34. https://play.google.com/store/books/details?id=iR1FAAAAYAAJ&rdid=book-iR1FAAAAYAAJ&rdot=1. Accessed March 20, 2018.

he recorded the following: "Thunderstorm; pitch dark, with no *blackness*, – but deep, high, *filthiness* of lurid, yet not sublimely lurid, smoke-cloud; dense manufacturing mist."[17] In his second lecture on the subject, Ruskin, again discussing the weather, argued that with the pall of pollution across the country, earlier skies in paintings would not have been painted:

> Had the weather when I was young been such as it is now, no book such as *Modern Painters* ever would or *could* have been written; for every argument, and every sentiment in that book, was founded on personal experience of the beauty and blessing of nature, all spring and summer long; and on the then demonstrable fact that over a great portion of the world's surface the air and earth were fitted to the education of the spirit of man as a schoolboy's primer is to his labor, and as gloriously as a lover's mistress to his eyes.
>
> That harmony is now broken and broken the world around.[18]

Together with this recognition of the effects of polluting smoke from industry is Ruskin's stark delineation between nature, a sacred place even after his religious faith weakened later in life, and productive, yet polluting industry. Prior to the Industrial Revolution in the late eighteenth century, what brought prosperity and wealth, national pride, and prestige was the productive infrastructure of the landscape. With ties back to Virgil's *Georgics*, as we have seen, the pastoral vision exemplified a balance between man and nature. By the 1870s and 1880s as Ruskin makes clear, this was no longer the case. Nature and productivity through infrastructure and industry were divorced from one another.

Ruskin's proposed remedy for this divorce involved a backward look toward historical precedents. His proposed Guild of St. George, offered the means to restore art and handicraft, nature and morality to working people. As its name suggests, The Guild looked to medieval examples, encouraging members to return to the land and live a healthy life free of the corrupting influence of greed and industry. Founded in 1871 and incorporated in 1878, his aim was "to increase, the buying and securing of land in England, which shall not be built upon, but cultivated by Englishmen, with their own hands, and such help of forces as they can find in wind and wave."[19] By encouraging small-scale, cottage industries, Ruskin hoped to "make some small piece of English ground, beautiful, peaceful and fruitful."[20] His efforts were realized

[17]Ibid., p. 38.
[18]Ibid., p. 96.
[19]Ruskin, quoted in Edith Scott Hope, *Ruskin's Guild of Saint George* (London: Methuen, 1931), p. 18.
[20]Ibid.

in the Ruskin Linen Industry, under the guidance of a Miss Twelves who founded a small linen manufacturing group with local women who learned the traditional trade of linen making. Such efforts were part of a larger Arts and Crafts ideology pursued by William Morris and later C. R. Ashbee to restore dignity and pride in manual labor within a restorative, pastoral landscape. We will look at Morris's ideas further on, in the context of his brand of Socialism and productive infrastructural systems.

Ruskin believed that education was also the key to a healthier world. He lamented the intrusion of people on the landscape, and complain they litter and foul spaces they visit or inhabit. But concurrently he believed that nature was improved by man, that there was a "cleanliness of rural labor"[21] that benefited the land. He argued that "a natural environment, freed from the destructive effects of industrialization and economic competitiveness, would provide not only the best context for a system of national education but also part of the programme."[22] Ruskin's ideas are often fraught with contradictions. While he believed environmental conservation should come from education and immersion in nature, he also objected to the intrusion of the railroad into the Lake District, campaigning against such proposals on the grounds that this would ruin the natural beauty of the area by bringing tourists, cheap hotels, and litter. His and others' efforts to protect the Lake District from rail lines was tied to a deep mistrust of the working classes whose access to these landscapes, it was feared, would ruin them. Throughout his writings on landscapes, Ruskin complains of litter left behind, and takes the elitist view that only those educated to fully understand and appreciate nature can properly care for and respect it. This view was not only that of Ruskin. Wordsworth as well protested against the intrusion of the railroad into the Lake District and was "accused in the national press of snobbery and a 'spirit of exclusiveness' a charge that was to be laid regularly against the conservationists."[23]

This idea of nature as the preserve of the middle and upper middle classes who are understood to be better educated and therefore better able to appreciate nature is a thread that runs through environmental conservation since Ruskin's time. It is manifest in various ways; entry fees for national parks or some sites owned by the National Trust, for example. But on a deeper level, it reflects the "great divorce" of industry and nature. As we shall discuss in the following chapter in more detail, and as is highlighted in Gustave Dore's views of London, it is the poor who are destined to live in or near the blighted landscapes of industry. Increasingly in the nineteenth century, the middle and

[21]Keith Hanley, "The Discourse of Natural Beauty," in *Ruskin and Environment: The Storm-Cloud of the Nineteenth Century*, ed. Michael Wheeler (Manchester: Manchester University Press, 1995), p. 17.
[22]Ibid., p. 19.
[23]Richards, "The Role of the Railways," p. 125.

upper middle classes had the means to move out of the bustle and pollution of the city and into the sanitized suburban pastoral. Implied within this shift is the presumption that the poor do not appreciate or understand nature, and therefore do not *need* even the green lawns or shade trees of the suburban street. Such attitudes furthered segregation of rich and poor, and landscape and industry.

So how and when did these suburbs develop? The subject has been exhaustively addressed by scholars, from Dolores Hayden to Olmsted scholars. For our purpose, it is useful to look at the work of another towering figure in the nineteenth century, Joseph Paxton. Paxton is perhaps best known for designing the Crystal Palace, the home of the Great Exhibition of 1852, which was a remarkable feat of organization, prefabrication, and engineering. He was born in 1803, on the edge of the Duke of Bedford's Woburn Estate that was designed by Humphrey Repton in the same year. This was also near Battlesden Park, another estate laid out by Repton for Sir Gregory Osborne. Thus, from his earliest years, Paxton knew of, wandered through, and worked on the estates of the aristocracy. At the age of fifteen, he went to work at Woodhall, an estate in Hertfordshire as a gardener and later moved to the Horticultural Society at Chiswick where he became head gardener in 1826. Not long afterward he moved north to work at Chatsworth for the Duke of Buckingham. This was to be a crucial move for him. He developed a deep and close friendship with the Duke, and his work at Chatsworth and its greenhouses was to lead to his work on the Crystal Palace.

But it was also his profound understanding of estate planning, of the layout and workings of landscapes, such as Chatsworth, that would result in his work in park design. In the early 1840s, Paxton was introduced to Richard Vaughan Yates, an industrialist in Liverpool, who invited Paxton to help him develop land. Yates bought ninety-seven acres and planned to build terraces and villas on it. Forty acres would be set aside for a park for residents, to be called, Prince's Park. This was Paxton's "first essay in municipal design."[24] As Victorian cities grew, residents had less and less access to parks and nature. In London, Regent's Park, laid out by John Nash, restricted public access. Vauxhall Public Gardens was the only real public park, offering walks, entertainments, and gardens. Prince's Park was not intended for the public, rather only for the residents of this new development. But its layout, with "wide open, undulating grass parkland, planted with informal groups and single trees,"[25] and with paths and carriageways throughout was inspired by eighteenth-century parks such as Chatsworth.

[24]Kate Colquhoun, *The Busiest Man in England: A Life of Joseph Paxton: Gardner, Architect and Victorian Visionary* (Boston, MA: David R. Godine, 2006), p. 109.
[25]Ibid., p. 110.

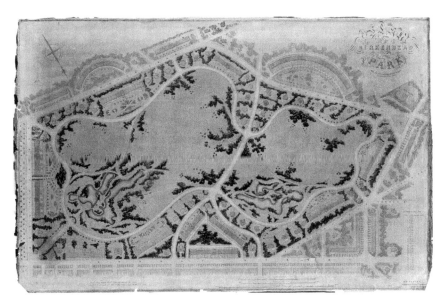

FIGURE 4.3 *Joseph Paxton. Plan of Birkenhead Park, 1844 (Williamson Art Gallery Birkenhead).*

In 1843, the growing City of Birkenhead, across the Mersey River from Liverpool, hired Paxton to lay out Birkenhead Park (Figure 4.3), the first publicly funded park in the country. Here again, Paxton drew on his experiences at Repton's parks and Chatsworth, to create a landscape for the people. As is clear from the plan, the park consisted of meandering paths and carriageways with a lake and copses of trees, an undulating landscape offering views and vistas. Around the perimeter were residential terraces. Ann Bermingham points out in *Landscape and Ideology* that the suburb arose from a "new perception of land,"[26] wherein land was no longer a source of capital as much as it was a source of materials for industrialism. "Suburban development joined the exploitation of the land with an appreciation of its natural rustic beauties ... The more rustic-looking a suburb, in fact, the more prestigious it was to live there."[27] She goes on to trace the evolution of suburban tracts, from workers housing such as Cromford for Joseph Arkwright's mill workers, to Loudon's *Suburban Gardener and Villa Companion* of 1838 which he based on some of Repton's ideas. And she makes clear that "Large-scale landscape design survived in the laying out of the suburban tract."[28] Thus, Paxton's design for Birkenhead Park, relied on the undulating landscape, carefully arranged views

[26]Bermingham, *Landscape and Ideology*, p. 166.
[27]Ibid., p. 167.
[28]Ibid., p. 172.

and meandering paths and carriageways of estates such as Chatsworth. In such parks, sheep grazed within the park's boundaries, a practical vestige of the pastoral tradition. Indeed, in Charles Allston Collin's *May, in the Regent's Park*, of 1851, the view into the park includes a herd of sheep enclosed in the pastoral landscape of the park. But by this point in the mid-nineteenth century, views across such parks celebrated a natural escape from the bustle of city life, a retreat for picnics and walks. It is a passive nature, consumed for pleasure not enjoyed for its productivity. And this is crucial for our understanding of nature, landscape, and infrastructure. The nature of public parks and suburbs (which will be discussed more in the next chapter) is a nature reduced to a scenic commodity.

But not all were comfortable with this division between landscape and industry. William Morris, the iconic figure of the Arts and Crafts whose influence was felt both in Britain and America, dreamt in his writings and projects of a reunion of labor, landscape, and industry. Morris is best known for his entrepreneurial Morris & Co., his designs for wallpapers, stained glass, and tapestries, and his collaborations with the architect Phillip Webb and the painter Edward Burne-Jones. Like Ruskin, he founded Morris & Co. with the aim of improving labor conditions and the quality of items made. He too believed that industry was destroying the environment and cautioned of "a danger that the strongest and wisest of mankind, in striving to attain a complete mastery over Nature, should destroy her simplest and widest-spread gifts."[29] As is well known, Morris grew frustrated that the Arts and Crafts movement of which he was a key part, produced goods only for the wealthy middle and upper middle classes and had little impact on the poor factory workers whose plight so worried him. As his frustration grew so too did his participation in Socialism, and by the 1880s, he embraced it wholeheartedly.

There is no space here to examine Morris's politics in great detail, but it is vital to understand how he connected industry, factory work, poor working conditions, and polluted air and water with the urban fabric of Britain. He staunchly believed that to remedy such societal ills, work, industry, and productivity needed to be reunited with nature and the landscape. Not only did he want to disrupt the economic status quo of capitalism, but he envisioned a society based in the pastoral tradition where wealth:

> Is what Nature gives us and what a reasonable man can make out of the gifts of Nature for his reasonable use. The sunlight, the fresh air, the unspoiled face of the earth, food, raiment and housing necessary and decent; the

[29]William Morris, "The Beauty of Life. Delivered before the Birmingham Society of the Arts and School of Design, February 19, 1880," in *The Collected Works of William Morris*, with introduction by his daughter May Morris, vol. 22 (New York: Russell & Russell, 1966), p. 52.

storing up of knowledge of all kinds and the power of disseminating it; means of free communication between man and man; works of art, the beauty which man creates when he is most a man, most aspiring and thoughtful—all things which serve the pleasure of the people, free, manly and uncorrupted.[30]

Thus, by returning to the land, to nature, and beauty, productivity and health would be restored to industrialized nations.

What is most prescient about Morris's ideas for us in the twenty-first century are his ideas about factories which he laid out over the course of three lectures in 1884. Entitled "A Factory as It Might Be," Morris expounded upon his vision of a factory according to his pastoral socialism. His factory

is a pleasant place – no very difficult matter when . . . it is no longer necessary to gather people into miserable, sweltering hordes for profit's sake—for all the country is in itself pleasant or is capable of being made pleasant with very little pains and forethought. Next, our factory stands amidst gardens as beautiful (climate aside) as those of Alcinous, since there is no need of stinting it of ground, profit rents being a thing of the past, and the labour on such gardens is like enough to be purely voluntary[31]

With echoes of Pugin's fourteenth-century poorhouse within a monastery from *Contrasts*, Morris paints a picture of beautiful, well-built factory buildings and houses, set amid gardens, orchards, and allotments, with schools, workshops, and libraries for the residents. Such a factory "does not injure the beauty of the world but adds to it rather."[32] To many, such a vision, a factory that enhances the environment, seems an oxymoron. But as we shall see in the latter part of this book, artists and architects have begun to ask similar questions about key infrastructural systems and to reintegrate the machine into the garden in ways that echo Morris's dreams.

Many were influenced by Morris's ideas. C. R. Ashbee started his Guild and School of Handicraft in 1888 in London to teach the poor of the inner-city skills and crafts. In 1902, he moved the Guild to Chipping Camden in the Cotswolds where they established workshops within the bucolic beauty of rural England. On a grander scale, Ebenezer Howard absorbed Morris's ideas about the unity of the factory in nature and realized his own vision of a city in his *Garden Cities of Tomorrow* in 1902 which we will look at in the following chapter. The

[30]William Morris, "Useful Work versus Useless Toil," in *Collected Works*, vol. 23 (New York: Russell & Russell, 1966), p. 103.
[31]William Morris, *A Factory as It Might Be* (Nottingham: Mushroom Bookshop, 1994), pp. 6–7.
[32]Ibid., p. 10.

importance of craft and honest workmanship of the Arts and Crafts extended across the Atlantic, profoundly influencing Gustav Stickley and his Craftsman furniture production, and the idea of garden cities extended to America and the wider Commonwealth. Indeed, the philosophical, literary, and artistic exchange throughout the nineteenth century between Great Britain and America was lively and vital. Carlyle corresponded with Emerson, Ruskin's works were widely read in America, Thomas Cole the landscape painter emigrated from England to America in 1818 and became the acknowledged father of American landscape painting, and Frederick Law Olmsted acknowledged a great debt to Joseph Paxton and his work on Birkenhead Park in his ideas for Central Park. We turn now to the American landscape to understand how productive infrastructural and industrial systems, nature, and progress were related and understood in art in this emerging and rapidly developing country.

5

Progress and Nature in the American Landscape

In 1964 Leo Marx first published his book *The Machine in the Garden*, in which he traced the ideology surrounding wilderness, landscape, and progress in America. Relying on texts from Shakespeare to Hawthorn and F. Scott Fitzgerald, Marx analyzed the pastoral tradition and its role in shaping American's understanding of and responses to the vast lands of the continent and the intrusion of "progress" in the form of the railroads and industry. He argued that such an overview is useful for readers in the late twentieth century (and early twenty-first for the second edition) because "The soft veil of nostalgia that hangs over our urbanized landscape is largely a vestige of the once dominant image of an undefiled, green republic, a quiet land of forests, villages, and farms dedicated to the pursuit of happiness."[1] We have already looked at the pastoral tradition as outlined by Virgil and the role that this productive pastoral landscape played in landscape painting and architecture in England in the eighteenth and nineteenth centuries. Marx also analyzes Shakespeare's *Tempest* as a means of exploring the newly discovered (by the British) landscape of Virginia. Via the play and other accounts of the settlements there, Marx identifies the colony as both an Edenic site of promise and plenty and a frightening place of wild, untamed nature. He argues that *The Tempest* "is a comedy in praise neither of nature nor civilization, but of a proper balance between them."[2] We have explored this balance in previous chapters, but it was particularly relevant on the American continent where a bounteous wilderness seemed to stretch into eternity. Marx refers to Robert

[1]Leo Marx, *The Machine in the Garden: Technology and the Pastoral Ideal in America*, 2nd ed. (Oxford: Oxford University Press, 2000), p. 6.
[2]Ibid., p. 69.

Beverly's *History and Present State of Virginia* of 1705, in which Beverley discusses his views of the landscape as primitive with the potential for pastoral improvements. Beverly argued that the Native Americans "depend altogether upon the Liberality of Nature, without endeavoring to improve its Gifts, by Art or Industry."[3] He goes on to argue that the native Americans, because they didn't apply art and industry to the landscape in order to tame it into the pastoral productive ideal are "slothful" and shamefully wasteful. Such an ideology justified the judicious use of nature's resources for the benefit of humankind. This is an overarching theme in the growth and expansion of the United States through to the end of the nineteenth century.

Thomas Jefferson was a key, if controversial, figure in American history and the development of the pastoral ideal in America. Jefferson, for all his faults, was well schooled in the pastoral tradition. His bookcases boasted many of the key writers on landscape in the eighteenth century, including William Shenstone's *Works* and Thomas Whately's *Observations on Modern Gardening*. He traveled through France and Italy and disliked the formality of French landscape designs. He visited several English country estates, studying the layout of gardens and parks such as Stowe and Leasowes, and using Whately's book as his guide.[4] Thus Jefferson was well acquainted with, and supportive of the Virgilian pastoral tradition, and he incorporated what he knew into his landscape designs at Monticello. As Elizabeth Barlow Rogers points out, Jefferson laid out his grounds as a "*ferme ornée*" an artistic blending of orchards, farming, and classical references such as we saw at Wooton Hall. His belief in a beneficent nature offering resources for his ideal yeoman farmer, helped shape the landscape of America as it expanded westward. For Jefferson, the ideal America would consist of a rural landscape, built on the continent's vast natural wealth and tended to by the industry and hard work of the American yeoman farmer. It was the middle ground that Jefferson most valued and he was wary of large-scale industry intruding into his ideal. Indeed, in his *Notes on Virginia*, he warns against the intrusion of industry on these shores. Urban industry, such as he witnessed in England on his visits, had no place in Jefferson's pastoral ideal. In his words,

> While we have land to labour then, let us never wish to see our citizens occupied at a workbench, or twirling a distaff. Carpenters, masons, smiths are wanting in husbandry; but for the general manufacture, let our work-shops remain in Europe. It is better to carry provisions and materials to

[3]Robert Beverely, *The History and Present State of Virginia* quoted in Leo Marx, *The Machine in the Garden: Technology and the Pastoral Ideal in America* (Oxford, New York: Oxford University Press. 2000), p. 86.

[4]Frederick Doveton Nichols and Ralph E. Griswold, *Thomas Jefferson: Landscape Architect* (Charlottesville: University of Virginia Press, 1978), pp. 81–2.

workmen there, than bring them to the provisions and materials, and with them their manners and principles.... The mobs of great cities add just so much to the support of pure government, as sores do to the strength of the human body.[5]

This quote expresses not only Jefferson's desire to keep industry out of America but also reveals the prevailing attitude that not only was industry a blight on the landscape, but the behaviors and attitudes of the industrial worker did not conform to Jefferson's ideal of a moral, hardworking farmer. As we have seen in England and the writings of Ruskin, many believed that cities and industry had a corrupting influence on the moral fiber of workers. In Jefferson's words, "Those who labour in the earth are the chosen people of God, if ever he had a chosen people, whose breasts he has made his peculiar deposit for substantial and genuine virtue."[6] This irony of his singling out those who work the land (i.e., the independent, white farmer) as the chosen people of God, while enslaved people worked his land, is a disturbing topic for another time.

For our purposes, what is key to the Jeffersonian ideal and the sway it held over the development of America and its landscape is his vision of a country of farmers, with few urban centers, minimal industry, and an abundance of natural resources. Indeed, his ideal of an ordered rural landscape stretching across the country led to "the rectilinear castral survey, as prescribed in the Land Ordinance of 1785, sometimes referred to as the Jeffersonian grid."[7] This survey arranged the landscape, regardless of topography, into subdivided grids to be sold as farms. Peter Ling investigates the deleterious effects of this broad, ordered overlay on the landscape itself. In this vision, Jefferson spreads the middle landscape across the nation, clearing forests and taming rivers in the service of rural husbandry. While Jefferson appreciated the power of British steam engines, he saw no need of them in America and viewed the growth of industry as harmful to his goals for the new Republic.

Nature in its wild or tamed state was a concern for other thinkers and writers in the early years of the nineteenth century. Just as we saw Wordsworth struggle in his poetry and Turner in his art wrangle with the growth of industry and the emergence of the railroad in England, so too did Emerson and the transcendentalists in America. While not opposed to the machine and industry, it was through appreciating and honoring nature and its beauty, not only in the sublime vastness but in the small details, the morning

[5]Thomas Jefferson, "Query XIX," *Notes on the State of Virginia* (Baltimore, MD: W. Pechin, 1800), p. 125.
[6]Ibid., p. 122.
[7]Peter Ling, "Thomas Jefferson and the Environment," *History Today*, vol. 54, no. 1 (Jan. 2004): p. 52.

dew or the orchards in bloom that Emerson argued one would find God. But Emerson cautions: "Nature is thoroughly mediate. It is made to serve. It receives the dominion of man as meekly as the ass on which the Saviour rode. It offers all its kingdoms to man as the raw material which he may mould into what is useful."[8] Thus, while Emerson finds a path through nature to the Divine and encourages us to delight and revel in nature's diverse complexities and beauties as a path toward religious understanding, nature itself exists for mankind, to be used for his benefit.

Twenty years after Emerson's essay, Henry Ward Beecher discussed three uses of nature for mankind. The first "as a foundation of industry," supplying man with food, sustenance, power, and shelter. The second was nature as an object of scientific study and the third was as a source of beauty for artists and poets. But Beecher warned that "The earth has its physical structure and machinery, well worth laborious study; it has its relations to man's bodily wants, from which spring the vast activities of industrial life; it has its relations to the social faculties; and the finer sense of the beautiful in the soul; but far above all these are its declared uses, as an interpreter of God, a symbol of invisible spiritual truths."[9] Nature is, both for Emerson and Beecher, a means toward understanding God, and a reverence for the world He created. But, true to the ideology of Manifest Destiny, for both these influential men, nature, as designed by God, is intended to serve man and his needs. Thus, in the name of "progress" the use of America's vast forests and mines, rivers and mountains, was divinely ordained and condoned.

Marx discusses Emerson's essays on "Art" and "The Poet," and he points out that for Emerson,

> there is nothing inherently ugly about factories and railroads; what is ugly is the dislocation and detachment for "the Whole" … To dispel the ugliness which surrounds the new technology, whether in a poem or a landscape, we must assign it to its proper place in the human scale. Artists have a special responsibility to incorporate into their work such "new and necessary facts" as the shop, mill, and railroad. For there will always be new things under the sun, and it requires genius to reveal their beauty and value.[10]

Such a call to paint or describe through poetry landscapes, inclusive of these "new and necessary facts,"[11] was heeded by the landscape painters of the

[8]Ralph Waldo Emerson, "Nature," in *The Essential Writings of Ralph Waldo Emerson*, ed. Brooks Atkinson (New York: The Modern Library, 2000), p. 21.
[9]Henry Ward Beecher, *Star Papers: Or, Experiences of Art and Nature* (New York: J. C. Derby, 1855), p. 310.
[10]Marx, *The Machine in the Garden*, p. 241.
[11]Ibid.

Hudson River School in the 1830s through the 1850s. The understood father of this school of painting was Thomas Cole.

Thomas Cole was seventeen when he arrived in America with his family. He came from Bolton Le Moors in Lancashire, England, a town known for its growing industry. Early on, he worked as an engraver and his training in the art of painting came largely from books and paintings he encountered in Philadelphia where he first settled with his parents and sisters. In contrast to the increasingly industrial landscape of Britain, Cole was struck by the American wilderness, its vast forests, mighty rivers like the Hudson, and its mountains and meadows. Like Emerson, he saw in nature a divine creation, and believed that mankind's greed and avarice were a danger to it. Art historians, from Barbara Novak and Angela Miller, to Tim Barringer have focused on Cole's famous *Course of Empire* series and *The Oxbow* to understand his approach to the landscape and his views on the railroads and industry that were transforming it. From his writings, it is clear that Cole was deeply concerned about the rapid pace of change in the American landscape, as forests were clear-cut and the railroads cut swathes across the land. His concerns are evident in the five large paintings that make up the *Course of the Empire* (1833–6). Miller points out that the series was "Cole's bid to become the voice of moral opposition to America's materially driven democracy."[12] The first in the series, *Savage State* shows a landscape of rugged mountains and cliffs, jagged trees, and threatening clouds and sea. In the foreground a hunter with a bow chases a deer, while a larger hunting party is at work in the middle distance. In the middle of the left-hand side, a small circle of tepees encircle a lawn, with a fire, the sign of an early settlement. In the third in the series, *Consummation of the Empire*, a vast city replete with architectural wonders in the classical style of civilization has conquered nature. Indeed, nature is visible only on the peripheries, pushed out from the city of stone pavements and busy streets. In the fourth image, civilization is destroyed by invaders and in the fifth, titled, *Desolation of the Empire,* nature has reclaimed the landscape, with vines creeping up the ruins.

Where nature is rugged with stormy clouds and seas in the *Savage State*, in *The Arcadian or Pastoral State* (Figure 5.1), the second in the series, Cole presents the viewer with an ideal balance of man and nature, the middle ground where nature's bounty is enjoyed without the ravages of destruction and greed. Here, skies and sea are calm, children play, and shepherds tend their flock. A small conurbation rests beside the sea and a timber ship is under construction. In the distance, a temple in the manner of Stonehenge sits upon an outcrop overlooking the sea. This is a scene of equilibrium, wherein nature

[12]Angela Miller, *The Empire of the Eye: Landscape Representation of American Cultural Politics 1825–1875* (Ithaca, NY: Cornell University Press, 1993), p. 24.

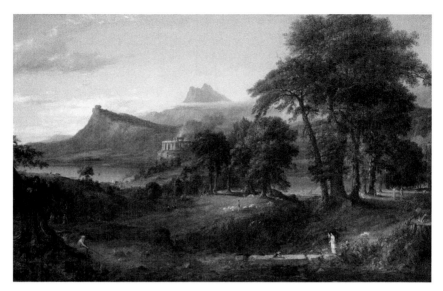

FIGURE 5.1 *Thomas Cole.* Arcadian Pastoral State, *1833–6. Oil on canvas. Height: 39.5" (100.3 cm), width: 63.5" (161.2 cm). Image# 1858–2. New York Historical Society.*

and culture rest easily together. Nature is tamed and productive, but man's greed and ambition are held in check. Angela Miller notes,

> To remove society from close contact with nature was thus to give free rein to its worst impulses. The health and durability of any culture depended in maintaining the equilibrium between imagination and nature. Without the spiritualizing agency of nature, 'the destroyer Man', as he put it in a poem, threatened to become a tyrant ruthlessly imposing his will on the world around him; nature without man, however, remained wilderness in the biblical sense. The pastoral aesthetic that increasingly characterized Cole's work of the 1840s pictured an ideal balance between the human and the natural.[13]

In Cole's "Essay on American Scenery" of 1836, he warns readers of upsetting the balance. Praising the natural world, its forests, rivers, lakes, and mountains, he laments that all people do not seem to appreciate the beauties of the earth. But he notes that "the good, the enlightened of all ages and nations, have found pleasure and consolation in the beauty of the rural earth."[14] Like Ruskin and Wordsworth before him, Cole believed that only the "enlightened"

[13]Miller, *Empire of the Eye*, p. 59.
[14]Thomas Cole, "Essay on American Scenery," in *The Native Landscape Reader*, ed. Robert E. Grese (Amherst: University of Massachusetts Press, 2011), p. 28.

could truly appreciate nature's beauty and beneficence. And it is worth noting, that Cole singles out the "rural" landscape as the source of "pleasure and consolation." Elsewhere in the essay, he praises the American wilderness the "most distinctive, and perhaps the most impressive, characteristic of American scenery."[15] But he returns to the pastoral peace toward the end of his essay when discussing the "Want of Associations" of the American landscape. Cole posited that while America had no ruins of past glories, no Roman aqueducts or ruined castles, it did have "freedom's offspring – peace, security, and happiness, dwell there ... On the margin of that gentle river the village girls may ramble unmolested ... those neat dwellings, unpretending to magnificence, are the abodes of plenty, virtue, and refinement."[16] Cole foresees the wilderness replaced by "the ravages of the ax," but it is the destruction of nature's beauty "without substituting that of Art"[17] that most troubles him. For Cole as for Emerson, the pastoral with its artistic heritage and productive, yet not destructive landscape, offers the greatest promise for the young nation.

In, *The Oxbow*, Cole articulates these concerns, juxtaposing wilderness on the left with a pastoral peace of harvests and grazing sheep. In the distance the hillsides show signs of clear-cutting and storm clouds gather above. There is an ambivalence here with the ominous clouds hovering over the untamed wilderness and the freshly timbered hillsides. Like the calm seas and sky of *The Arcadian or Pastoral* in his *Course of Empire*, the central valley with its "rural earth" is bathed in sun beneath a cloudless sky. It is the middle landscape, a place of peace and prosperity in harmony with nature, that Cole offers for the future. Sarah Burns discusses the widespread popularity of this pastoral middle ground. Drawing on a wide range of images, from landscape painting to popular prints, she identifies the myriad ways in which the pastoral state was rendered in visual and literary terms. She points out that the

> pastoral landscape was the essential component in the formula of the good life ... The terrain that was eventually domesticated represented a universe to which both ideology and emotion could attach themselves in an endless chain of associations centering on the pastoral configuration of beauty, harmony, peace and plenty.[18]

Landscape painters such as Cole and his followers, did much to establish the tradition of the pastoral landscape in nineteenth-century America. As the

[15]Ibid., p. 30.
[16]Ibid., p. 36.
[17]Ibid.
[18]Sarah Burns, *Pastoral Inventions: Rural Life in Nineteenth-Century American Art and Culture* (Philadelphia, PA: Temple University Press, 1989), p. 13.

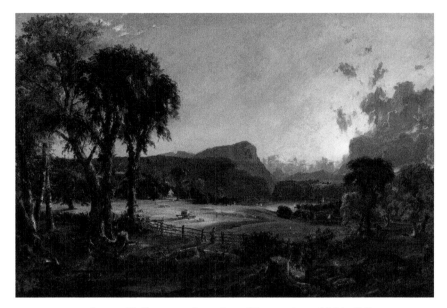

FIGURE 5.2 *Jasper F. Cropsey.* American Harvesting, *1851. Oil on canvas. 351/2 • 523/4 inches. Gift of Mrs. Nicholas H. Noyes, Ezkenazi Museum of Art, Indiana University. 69.93. Photograph by Kevin Montague.*

century progressed this verdant middle ground lost its productive elements and instead, as we shall see, became a visual trope of green swards, copses of shady trees, winding drives, and picturesque views.

One of Cole's followers in the Hudson River School of painters was Jasper Cropsey. In 1851, Cropsey exhibited *American Harvesting* (Figure 5.2) in the American Art-Union. Critics praised the painting both for its accuracy in detail and for its patriotic rendering of a typical, Edenic, American landscape. As Carol Troyen points out, the scene

> shows a modest new England farm ... with fields coming right up to the house and the farmers laboring within affectionate sight of their family. The land is rich, and nature yields its bounty willingly; composition and theme unite to suggest a harmonious, self-sufficient world. And by conferring such a macrocosmic title on this pleasant picture, Cropsey seems to be equating a bounteous harvest with a vigorous, healthy America.[19]

In Cropsey's view, the pastoral predominates, and he resolved the issue of industry and progress by avoiding them altogether. The fallen logs and

[19]Carol Troyen, "Retreat to Arcadia: American Landscape and the American Art-Union," *The American Art Journal*, vol. 23, no. 1 (1991): p. 25.

tree stumps in the foreground are the only signs of ambivalence toward the changing landscape. For the exhibition of 1851, Cropsey's *American Harvesting,* Frederick Church's *New England Scenery,* and John F. Kensett's *Mount Washington from the Valley of Conway* were reproduced by the Art-Union and touted as "archetypes of a pastoral mode of landscape painting, archetypes that served to promulgate a national myth."[20] Cropsey mythologized the American pastoral, ignoring the rapid changes industrialization was bringing and espoused instead a halcyon, national ideal expressed in the pastoral middle ground.

Other followers of Cole such as Asher B. Durand and George Inness were less pessimistic about progress and development. Durand espoused a truthful naturalism, urging students to draw and paint directly from nature. Influenced by Constable's works he saw on a visit to England, and Ruskin's writings, he promoted detailed study of nature, learning from it before studying the old masters. Many of his views are of pastoral landscapes in a Claudian or Dutch tradition, including gnarled oaks, passive cows grazing and warm gentle light bathing the landscapes. But like Turner's view of *Leeds* or *Rain, Steam and Speed,* Durand did not shy away from images of industry or the railroad. In accordance with Emerson's call to incorporate the new features of the landscape into the old, Durand did just that in his painting, *Progress* of 1853. Here, we see many of the features of Cole's *Oxbow,* including a wilderness on the left which gives way to a pastoral valley below in the center. The eye is drawn to the horizon where the smoke from trains, steamboats, and factories billows gently into the sky, blending with the cumulous clouds. A glowing light of optimism washes over the progress of technology. As Miller points out in her discussion of Durand's work, "Durand and his audience were conditioned by the utopian promise of technological change, abetted by naturalist rhetoric and popular images, to view technology, working in tandem with natural features, as the agent that would draw together the republic."[21] It should be noted, that *Progress* was painted for the industrialist Charles Gould whose fortune was built on expansionist practices. Most of Durand's oeuvre features the pastoral middle landscape, wherein nature and mankind coexist in harmonious balance.

In 1855, two years after Durand's *Progress,* George Inness was commissioned by John Jay Phelps, of the Delaware, Lackawana, and Western Railroad to paint the train and roundhouse of the railroad near Scranton, Pennsylvania. Like Durand, Inness weaves this infrastructural system into a pastoral vision. The smoke from both the roundhouse and the train itself puffs gently into the sky, merging cloud-like into the distance. Cows graze and sit in fields

[20]Troyen, "Retreat to Arcadia," p. 21.
[21]Miller, *Empire of the Eye,* p. 160.

watching their new neighbors, while a solitary figure, like a peasant in a Claudian landscape, surveys the scene. As Marx points out, *Lackawana Valley* "is a striking representation of the idea that machine technology is a proper part of the landscape."[22] By the middle of the century, artists such as Durand and Inness attempt to integrate the machine into the pastoral middle landscape, recognizing Whitman's goal that "Nature and Man shall be disjoin'd and diffused no more."[23] As it had been for the Dutch landscape painters and designers of English estate, such landscape paintings celebrated what brought prosperity to the nation, encouraging civic pride and national identify.

After the Civil War, the focus on eastern landscapes waned as the dramatic vistas of the western states grew in popularity. Fredrick Church's *New England Scenery* of 1851 heralded this change, with the inclusion of the Conestoga wagon in the foreground carrying families west toward the fertile lands of the prairies or the rich resources of the Rocky Mountains and the Sierra Nevada ranges. Nancy K. Anderson's essay "The Kiss of Enterprise" carefully investigates the ways in which artists such as Thomas Moran and Albert Bierstadt, in the 1860s and 1870s used photographs and plein air sketches to construct a sublime image of the west. She documents how these artists eschewed the damaging effects of progress on the landscape, from mining to clear-cutting, to manufacture a national image of prosperity and abundance in the western states. Such images promoted a burgeoning tourist trade after the railroads linked the east and west coasts together. As part of this campaign, Anderson notes these paintings minimized "the conflict between the spectacular natural beauty of the land (by midcentury an indelible part of America's self-definition) and the inevitable changes that accompanied the conversion of minerals, forests, and water, the conciliatory message of many studio paintings was that the natural and technological sublime were compatible, that the West could endure as both a symbol and resource."[24]

An image such as *Donner Lake from the Summit* by Albert Bierstadt of 1873 (Figure 5.3) provides an excellent example of this marriage between the sublime beauty and majesty of the Sierra Nevada mountains and the railroad. In this enormous canvas, Bierstadt sets us, the viewers, atop the mountain top with views across the turquoise blue lake and peaks in the distance jutting up above the clouds. A misty sun kisses the mountain tops. Rocky outcroppings, brush, and tall pines frame the foreground. Only with careful

[22]Marx, *The Machine in the Garden*, p. 220.

[23]Walt Whitman, "Passage to India," in *God's New Israel: Religious Interpretations of American Destiny*, ed. Conrad Cherry (Chapel Hill: University of North Carolina Press, 1998), p. 141.

[24]Nancy K. Anderson, "The Kiss of Enterprise: The Western Landscape as Symbol and Resource," in *The West as America: Re-Interpreting Images of the Frontier 1820–1920*, ed. William Truettner (Washington, DC: National Museum of American Art and the Smithsonian Institution Press, 1991), p. 243.

FIGURE 5.3 *Albert Bierstadt,* Donner Lake from the Summit, *1873. Oil on canvas. 721/8 • 120 3/16 inches. Image # 1909–16. New York Historical Society.*

study does one notice the snowsheds of the railroad stretching precipitously along a cliff on the right of the painting and disappearing into a tunnel bored into a jagged outcrop. When the viewer does spy the sheds, their presence adds to the awe of the landscape, juxtaposing the wonders of nature with the dramatic engineering achievements of man. The artist gives no hint of the environmental impact of such a feat. As with Durand's *Progress* twenty years earlier, Bierstadt presents a happy union of nature and progress, a source of civic pride, and an invitation to visit the magnificence of the West.

But, in the midst of this optimistic perspective, voices of alarm were sounding across the nation, warning of the dire effects of environmental devastation. George Perkins Marsh's *Man and Nature* was published in 1864. Marsh was an avid admirer of Alexander van Humbolt, the german naturalist who died in 1859. Humbolt's observations of the natural world, as recorded in four volumes of *Cosmos*, are still regarded as seminal works. In the course of his extensive travels through South America, Humbolt realized the interconnectedness of the natural world. His writings laid out nature as "a concept that described the natural world as a web of life, a living organism where everything was connected from the tiniest insect to the highest mountains, from humankind to a fleck of moss."[25] Marsh distilled and built

[25] Andrea Wulf, "Man and Nature: George Perkins Marsh and Alexander von Humbolt," *Geographical Review*, vol. 107, no. 4 (Oct. 2017): p. 594.

upon Humbolt's ideas, extrapolating from them the idea that if all things are connected in a web of life, then damaging one aspect will have unforeseen consequences elsewhere. Enriched by his travels in Europe and Egypt, *Man and Nature* identifies the sobering reality of humankind's actions on the environment with a haunting prescience. As Wulf points out, "In tandem with wealth and consumption came destruction, Marsh claimed. For the time being, though, his concern for the environment was drowned in the cacophony of the noises of progress—the cranking noise of mill wheels, the hissing of steam engines, the rhythmic sounds of saws in the forests and the whistle of locomotives."[26] Like Thomas Cole's *Course of Empire* Marsh's text was a sober warning to protect those resources that American entrepreneurs were so avidly exploiting.

Marsh was not alone in his call to conserve nature's resources. As the United States shrank under the connecting influence of the railroad, threats to nature's remarkable abundance were increasingly recognized. The discovery in the 1850s of the giant California redwoods sparked an early interest in preservation. Some trees were felled and displayed in the east to the wonder of huge crowds, and their huge size made them very attractive to loggers. In 1864, Abraham Lincoln designated Yosemite and Mariposa as protected parkland, though it would be several decades before all logging of the giant redwoods ceased altogether. Artists like Bierstadt flocked to paint these massive trees and tourism grew up quickly as the scale was hard to convey via photographs and painting. What struck many was the age of the trees. Dating back to the time of Christ and before, added fuel to the idea that America was a new Eden, an untouched nature. Such reverence stood at odds to those who calculated just how much timber each tree would provide the resulting financial benefits of felling one.

What is significant about these awe-inspiring sites such as Mariposa Grove, Yosemite, and, a decade later, Yellowstone, is that praise for these landscapes did not echo the praise of Emerson and Whitman, Ruskin, or Wordsworth. These were not productive pastoral scenes, but areas of extreme natural beauty, which men such as John Muir wanted to preserve for their unspoilt wilderness, not for their gentle middle ground. Thus, in the second half of the nineteenth century, we can trace an emerging call to celebrate nature in its own right—not a nature tamed and coiffed in the service of humankind, but one enjoyed and sadly often exploited for its splendor alone. And this new appreciation of the wilderness is part of a larger divorcing of nature and productive infrastructures. Nature, as represented in Yosemite Valley or Niagara Falls, was now a consumable commodity, visited by the growing middle

[26]Wulf, "Man and Nature," p. 600.

classes who could escape the city, feast upon nature in its "raw" state, and then return home to their suburban enclaves. Increasingly as the century wore on, industrial "progress" was devoid of nature. Like Cole's *Consummation of the Empire*, nature was sidelined to the periphery, a destination for the leisured classes. As agriculture became more industrialized, it too became something other, taking over large swathes of the American mid-west. Small farms within a pastoral setting became part of the American mythology but no longer played a significant role in feeding the nation. Whether in Kensett's luminous sunsets over Lake George, Bierstadt's mountainous terrain, or Church's views of the tropics in South America, nature was reveled in, visited, photographed, and painted, but its productive, idealized harmony with humankind was lost.

Nowhere is this more visible in art than in the landscapes of Winslow Homer. While Homer's early work captured pastoral scenes of children and the school yard, or scenes of the south after the Civil War, his later work of the 1880s and 1890s was applauded by many as his finest work. Painting from his home in Prout's Neck, Maine, Homer captured the drama and energy of the sea, crashing against the rocks with daunting energy. In her article about these later works, Sarah Burns connects these rugged landscapes with an assertive new cult of masculinity that emerged toward the end of the century. As men increasingly left the rural life behind for office work in the city, doctors and social commentators increasingly saw nature as a place where men could recover their masculine vitality and energy. Burns identifies both resorts and men's clubs as sites where men could access "adventure therapy."[27] Homer, Burns argued, painted for this audience, creating bracing, rugged landscapes intended to blow "the city smoke out of the lungs."[28] Where nature was a balm to the spirit for Wordsworth and a path to the divine for Emerson, for the city dweller enjoying Homer's landscapes it was an invigorating source to restore a man's energy, vitality, and masculinity. Homer's later landscapes such as *Northeaster* of 1895 offer escape from the city. But they were not the pastoral, productive landscapes of Durand or Inness.

While this survey of American landscapes cannot be comprehensive, it serves to trace crucial trends in societal attitudes toward nature and the landscape throughout the nineteenth century. In doing so, it signals a shift in American's understanding of the landscape. While Durand, Inness, and even Cole to some extent sought to marry new forms of industry and infrastructure with the pastoral tradition, and Bierstadt wove the sublime engineering of the railroad into the exalted splendor of the western landscape, the vast consuming

[27]Sarah Burns, "Revitalizing the 'Painted-Out' North: Winslow Homer, Manly Health, and New England Regionalism in Turn-of-the-Century America," *American Art*, vol. 9, no. 2 (Summer 1995): p. 30.

[28]*Boston Evening Transcript* quoted in Burns, "Revitalizing the 'Painted-Out' North," p. 26.

energy of progress and the Industrial Revolution denied the hoped-for balance between nature and man. The voracious appetite for resources scarred the landscape. Warnings from Marsh and others highlighted the consequences of unchecked industry and development, and the loss of forests and pollution of rivers highlighted the need for conservation led by figures such as John Muir, Frederick Law Olmsted, and Theodore Roosevelt. The wilderness became something to be enjoyed and consumed, whether for masculine rejuvenation or adventure tourism. Resources, so boundless in Jefferson's eyes, were now understood to be limited and tensions arose between those seeking to protect such materials and those still keen to exploit them. Such a tension is still with us today. And so too is the divide that emerged in the second half of the nineteenth century between nature and humankind. For it was here as we have seen that artists illustrated the divorce between nature and culture. The pastoral with its productive pastures, grazing sheep, and rural farmers was now a nostalgic vision of the past. Most of the population lived in cities or towns by the end of the century.

This segregation of nature and productivity can be traced in the design of landscapes throughout the nineteenth century as well. To illustrate this trend, we will look at the evolution of landscape gardening in the work of Andrew Jackson Downing together with three examples of park design in the nineteenth century. The first of these is Fairmount Park in Philadelphia, which developed around the Fairmount Water Works, begun in 1810 under the designs of Frederick Graff, a student of Benjamin Latrobe. The second is Central Park, designed by Fredrick Law Olmsted and Calvert Vaux in 1858, and we will conclude with a look at Olmsted's plan for Yosemite. Downing's influential designs and the plans of these three projects mirror in soil, rock, water, and architecture the trend toward separating nature from a productive pastoral tradition that we have seen in landscape painting.

Andrew Jackson Downing is widely considered the father of landscape architecture in America. Influenced by the likes of the English landscape theorists such as Pope, Whately, and Gilpin, Downing sought to introduce their ideas into America through the design of landscape and domestic architecture. Downing's *A Treatise on the Theory and Practice of Landscape Gardening Adapted to North America* was extremely well received when it was published in 1841. In it Downing hoped not only to unify the design of the modest American residence with its landscaped grounds but also to improve and educate the American public in matters of taste. The *Treatise*, together with his many articles in magazines such as *The American Agriculturalist*, illustrated examples of rustic cottages and larger country houses and villas. Sometimes relying on designs by the architect Alexander Jackson Davis, Downing wove both modest and more elaborate houses into his landscape designs, featuring gentle landscapes with green swards of lawn, winding

drives, and picturesque scenes with varied plantings and controlled views of the house and garden. He believed that a well-designed cottage within a carefully laid-out landscape could help improve the moral character of the average citizen. Careful siting and planting could "evince a more cultivated taste in a farmer."[29]

As David Schuyler points out, part of the success of Downing's works, such as *A Treatise*, was due to the way he wove the benefits of good design together with efforts to raise the moral character of his audience. Indeed, "the critics found most praiseworthy Downing's evocation of the reformist powers of the middle landscape—a domesticated landscape nestled, symbolically, between the frantic pace, squalid conditions, and sordid temptations of city life, on the one hand, and the barbarism of the frontier on the other."[30] Downing died early in a boating accident in 1852. But prior to his death, he had partnered with the English architect Calvert Vaux on designs for a series of country estates including Matthew Vassar's Springside. Vaux is, of course, most famous for his work on Central Park in conjunction with Frederick Law Olmsted. Downing's work, both with Davis and with Vaux, is significant for its lasting impact on the design of residential landscapes in America. His work integrated the pastoral middle ground with a wide variety of housing options, both for the middle and working classes, as well as wealthier clients. The designs of these grounds have deep roots in the eighteenth-century landscape tradition we have already examined. Significantly, Downing hoped such landscapes would be more democratic than their English precedents, thereby appealing to a much wider and less elite audience. Though he presented schemes for farmhouses and their productive landscapes, many of his designs did not include the productive pastoral of the older tradition. Instead, they borrowed winding paths and drives, copses of trees set off against a broad expanse of lawn, and a rustic gothic architecture. Downing's work established a suburban precedent wherein a pastoral veil shrouds the house and grounds, but the middle ground no longer features productive systems of agriculture or animal husbandry so characteristic of the Virgilian landscape. The popularity of his writings and designs and his influence on figures such as Vaux and Olmsted, testify to the hegemonic power of the pastoral tradition, even as it became solely an aesthetic paradigm.

Just as suburban landscapes gradually lost their productive features, the evolution of public parks in the nineteenth century also began to focus more on the aesthetic pleasure of landscape and recreation than on a prosperous and

[29]David Schuyler, *Apostle of Taste: Andrew Jackson Downing 1815–1852* (Amherst, MA: Library of American Landscape History, 2015), p. 66.
[30]Ibid., p. 55.

productive (and romaticized) harmony of man and nature. The three examples that follow chart this development and exemplify larger trends in park design.

The city of Philadelphia was the nation's temporary capital until 1800 and played an important role in the founding of the United States as home to the Continental Congress. William Penn, the founder of Pennsylvania had drawn up plans for a city along the Schuylkill River in 1683 along a strict grid interspersed with green squares in the manner of London, Penn's birthplace. As the city grew, this grid served as the basis for development, while the banks of the Schuylkill, particularly to the west of the city proper developed as the more rural estates of the wealthy, much like Alexander Pope's home of Twickenham along the Thames. Elizabeth Milroy quotes Carl and Jessica Bridgenbaugh who argued that "At the Schuylkill, elite Philadelphians created 'the most nearly perfect replica of English country life that it was possible for the New World to produce'."[31] This goal of re-creating the pastoral ideal of the English countryside was to hold sway in Philadelphian's imagination for over a century.

The city was struck by outbreaks of yellow fever throughout the eighteenth century, which led to demands for fresh water to help prevent the disease. Benjamin Latrobe was also an immigrant from England who arrived in the United States in 1796 and settled in Philadelphia in 1800. Latrobe is often considered America's first architect, bringing with him the neoclassical style of William Chambers and Ledoux from England and France, respectively. In his new city of Philadelphia, Latrobe was tasked with designing the Bank of Pennsylvania in 1798–1801. He was also responsible for the design of several estates along the river for the wealthy landowners. In the same years he designed a Central Pump house for the city as part of a campaign to tackle the spread of yellow fever. This pump house was set in a parklike setting in the heart of the city. Latrobe employed a hybrid Greek Revival style for the structure in the manner of Claude Nicolas Ledoux's Parisian toll houses, which Latrobe would have seen on his European travels. A simple square base with Doric columns marked the entrance that supported a two-story domed cylinder housing the water pump. Smoke from the engines within escaped via a central chimney. In her thorough study of the planning of the city of Philadelphia, Elizabeth Milroy points out that this fusion of new steam engine technology, as found in the pump house within a parklike setting, was inspirational for the residents and Watering Committee of the city, whose decisions about planning and the water systems had a powerful impact on the growth of the city. To heighten its aesthetic charm, in 1809 William Rush designed a fountain set before the entrance. This sculptural centerpiece

[31]Elizabeth Milroy, *The Grid and the River: Philadelphia's Green Places, 1682–1876* (University Park: Pennsylvania State University Press, 2016), p. 95.

featured a life-size woman as the embodiement of the River, carrying a bird with water flowing out of its beak. This piece was made famous by Thomas Eakins's painting *William Rush Carving His Allegorical Figure of the Schuylkill River* of 1877.

Such a centrally located infrastructure project, designed in the fashionable neoclassical style within a park, set a precedent for Philadelphia. Latrobe designed it with the assistance of a young man named Frederick Graff. Graff had studied with Latrobe and learned much from him about the classical architecture of Palladio and ancient Greece and Rome both from his work with Latrobe and from Latrobe's extensive library. The Centre Square Pump House, which had difficulty meeting the water demands of the city and whose steam pumps frequently broke down, was closed in 1815. As early as 1811, the Watering Committee, anticipating the closure, had bought five acres of land along the river on a former estate called the Hills, in Fairmount. In 1811, the Committee hired Graff to design a new steam-driven pump house at this new site. This new system pumped water from the river uphill to a large reservoir. Graff housed the engines in a "faux mansion"[32] built of local stone, with classical details such as stringcourses and segmental arches over the windows. This dressing of such a functional building tied it to its neighbors, the fashionable estates which lined the river. The pump house began working in 1815, but soon proved inefficient. It required an enormous quantity of wood to fire the pumps and the engines were prone to breakage and possible explosions. The Watering Committee then hired Graff to design a dam with water wheels to draw water up to the reservoir. To house these massive wheels and the accompanying required spaces, Graff relied on the neoclassicism of neighboring estates. In Milroy's words,

> Graff married the ancient and modern in the pavilions, evoking the engineering achievements of antiquity and the popular classical follies of contemporary landscape gardening. The complex was an engine of change that affirmed the resonant memories of its site. As a facility designed to deliver fresh water to the city, the waterworks became a powerful emblem of civic health and progress.[33]

Both recent photographs and paintings from the time, by figures such as Thomas Doughty (Figure 5.4), show Graff's bold vision for this significant infrastructure project. Marrying utility with architectural tradition, Graff cloaked the water mills within a classical vocabulary of temple-like structures with Doric

[32]Arthur Marks, "Palladianism on the Schuylkill: The Work of Frederick Graff at Fairmount," *Proceedings of the American Philosophical Society*, vol. 154, no. 2 (June 2010): p. 212.
[33]Milroy, *The Grid and the River*, p. 187.

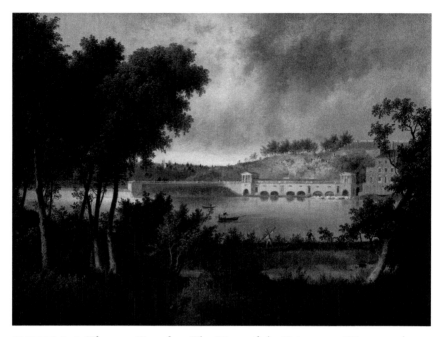

FIGURE 5.4 *Thomas Doughty.* The View of the Fairmount Waterworks, from the Opposite Side of the Schuylkill River, *1824–6. 21 1/8 • 29 1/8 inches. The Museum of Fine Arts, Houston. Museum Purchase funded by the Agnes Cullen Arnold Endowment Fund, 97.731.*

columns and pediments, resting upon a stone dam articulated by segmental windows and heavy arches. A delicate balustrade keeps the public from the dangerous edge. The waterworks proved to be not only very successful at delivering clean fresh water to the city but also a source of tremendous civic pride. Their classical garb set along the river invited visitors, and Fairmount Park developed around the site. As Arthur Marks points out, "Improved during the course of the century with promenades and meandering paths, statuary, fountains, and sheltering gazebos, the mill house and its surrounding park regularly attracted appreciative locals and tourists."[34] Here, then, was an infrastructure project that was celebrated for its advanced water production, but also for its beneficial landscape. Graff effectively adopted the language and productivity of the traditional English estate such as we have seen at Croome Hall and other homes for the landed gentry, into an urban park with democratic access to clean water. The park around the water mill and dam grew in the succeeding decades. Late in the century as plans evolved for a new art museum, the Board of Directors chose the site of the reservoir on

[34]Marks, "Palladianism on the Schuylkill," p. 203.

the hill above the waterworks. As designed by Howell Lewis Shay and Julien Abele and built in 1927, it is also in the neoclassical style—another temple on the hill. As seen from across the river, the complex of art and industry in classical guise creates a striking image with dramatic echoes back to ancient Athens. It is a remarkable example of a productive marriage between nature and the needs and expectations of infrastructure and culture.

Half a century later, just outside of Boston, Massachusetts, in the suburb of Brookline, the local architect Arthur H. Vinal designed the High Service Pumping Station in 1886-7. Ten years later it was enlarged by Edmund M. Wheelwright. Both architects used the Richardsonian Romanesque style of architecture to clothe this important source of municipal water. Built of granite and sandstone, with heavy arches and turrets, its architecture, much like urban neighbor, Trinity Church by H. H. Richardson, provides a weighty and powerful presence indicative of the importance given to the monument to clean water for the city of Boston. Set alongside a park and local reservoir, with subway lines running behind it, like the Fairmount Water Works, the pumping station represents a union of crucial infrastructure within a parklike setting, a source of recreation, civic pride, and clean water.

We can see parallels in the union of nature and productive infrastructure at Fairmount Waterworks and the landscape paintings of Durand and Inness discussed above. In these examples, the artists and designers wove together a pastoral image with productive progress. Such unity was the source of civic pride on a national, regional, or urban level. Similarly, as in the case of Fairmount and Bierstadt's paintings, this marriage attracted the public, enticing them to enjoy leisurely walks along the Schuylkill or travel to the sublime beauty of the West. While visually such examples appear disparate, they represent a similar unity of beauty, utility, and landscape. It is this unity that architects, artists, landscape architects, and engineers are revisiting in the twenty-first century and which is explored in detail later in this book.

Fredrick Law Olmsted is generally considered the father of landscape architecture in the United States. He left a lasting legacy in city parks across the nation, in the layout of suburban streets and college campuses and even in plans for our national parks. Olmsted had a variety of careers before he arrived at "landscape gardening" as he called it. Interested in farming, he owned two different farms in the late 1840s where he not only worked the soil but planned the landscape with orchards, roads, and farmland. In 1852, he published *Walks and Talks of an American Farmer in England*. In the text he wrote about his travels through the English countryside and his impressions of farming techniques, topography, and life in urban and rural Britain. Most significant for our purposes was a trip he recorded to Birkenhead Park. As mentioned in the previous chapter, Birkenhead was designed by Joseph Paxton in 1847. Paxton's design with its meandering paths, undulating hillsides,

and sheltering trees had a tremendous impact on the young Olmsted. He admired the layout of the new town of Birkenhead and the open access for residents to the green swards of the park. He described his tour of the park:

> Five minutes of admiration, and a few more spent in studying the manner in which art had been employed to obtain from nature so much beauty, and I was ready to admit that in democratic America there was nothing to be thought of as comparable with this People's Garden … we passed by winding paths, over acres and acres, with a constant varying surface, where on all sides were growing every variety of shrubs and flowers with more than natural grace, all set in borders of greenest, closest turf, and all kept with most consummate neatness.[35]

As this quote makes clear, he was particularly impressed with the elegance of this gentle nature, neatly kept and mowed (by "broad scyths, and shears, and swept by hairbrooms"[36]) all at the service of a range of social classes. He remarked on the sheep quietly grazing in the meadows and the children playing with their mothers. Olmsted praised Paxton for the careful manipulation of the land, to create effective drainage, a naturalistic water feature, and varied spaces within the park for different forms of recreation. Paxton had re-created the aristocratic landscape for the people of Birkenhead. Olmsted was inspired by both the democratic nature of the park and its lush pastoral views, and these two aspects he and Calvert Vaux incorporated into that most famous of parks, Central Park in New York City.

Two chapters of Olmsted's *Walks and Talks,* including his review of Birkenhead were published in the highly popular *Horticulturist* journal founded by Andrew Jackson Downing. Olmsted met Downing and it was through him that he met Calvert Vaux. As mentioned above, Vaux was an English architect who Downing persuaded to move to America and work with him on the architecture and landscape design of American estates. In 1857, four years after Downing's tragic death, Olmsted and Vaux teamed up and submitted plans to the Central Park Commission's competition for park design. Titled "Green Sward," Olmsted and Vaux's plans won and Olmsted had a chance to incorporate those ideas that so impressed him at Birkenhead into an American landscape.

Central Park (Figure 5.5) is much larger than Birkenhead and surrounded not by residential terrace houses but by the growing bustle of New York

[35]Fredrick Law Olmsted, *Walks and Talks of an American Farmer in England* (New York: G. P. Putnam's Sons, 1852), p. 79.
[36]Ibid., p. 81.

FIGURE 5.5 *Frederick Law Olmsted and Calvert Vaux. "Olmsted and Vaux Design of Central Park, First Study of Central Park. From a Woodcut Made in 1858." The Laura Wood Roper Collection. Olmsted Job #502 Central Park, New York. Courtesy of the National Park Service, Frederick Law Olmsted National Historic Site.*

City. The Commission had many requirements for the board which included recreational and parade grounds, transportation routes across the park to connect both sides of the city, an exhibition and concert venue, and varied landscapes including a three-acre flower garden. Of interest for our purposes was the already existing Yorkville Reservoir which took up 150 of the 770 acres of the park. The Yorkville reservoir was built in 1842 to supply the city with clean drinking water. It was housed in large-walled cisterns, with Egyptian-style walls and walks across the top for viewing the water. Olmsted and Vaux incorporated this older reservoir into the park, though its severe angularity sat uncomfortably beside the sinuous walks and rural effects of their design. That the team was unhappy about the exisiting reservoirs is clear from a report by Olmsted of 1858:

> The walk around the reservoirs is unobjectionable, but it seems undesirable to accept them as important objects for the walk, because they must always be disappointing. They are tanks on cisterns, on a large scale it is true, but perfectly comprehensible and uninteresting after one or two visits of examination. It is considered that they are unfortunately situated

because it is one great purpose of the Park to supply to the hundreds and thousands of tired workers ... a specimen of God's handiwork.[37]

They added a larger reservoir, identified on early maps as the Croton Reservoir and now named for Jackie Kennedy Onassis with characteristically irregular outlines and a naturalistic shoreline. For the new reservoir, just below the Yorkville reservoirs, Vaux and Olmsted proposed a "ride"[38] around it, that offered views of the large watery expanse, from the high banks surrounding it. This new addition served both the functional purpose of housing drinking water for the city of New York while maintaining the picturesque irregularity of a natural lake so valued by Olmsted and Vaux. This was a passive infrastructural system that the team did their best, within required constraints, to weave into the artistic whole of the park. From early maps and Martel's lithograph bird's-eye view of the Park, the rectangular rigidity of the older reservoirs stood out starkly within the meandering paths and carriageways and naturalistic landscape of the park. Olmsted and Vaux most likely were pleased from their graves when the 'cisterns' they so disparaged were demolished and replaced by lawn.

Another pastoral feature that served a productive purpose in the park were the sheep. Sheep were employed to mow the lawns of the park. In a letter to the president of the Department of Public Parks, H. G. Stebbins, regarding changes to the plans made in 1872, Olmsted writes about the maintenance of the park. To keep the grass mown close, "the cheapest and best way of keeping it close on the pastoral surface of the Park is to graze it with sheep."[39] To accommodate the sheep, the architect Jacob Wrey Mould and Calvert Vaux designed the sheepfold, an impressive building of red brick with stone trim, turrets, and gilded ironwork. It included a central building of two stories with one-story wings extending out toward the green and ending in a pavilion at each end. The building offered the sheep shelter at night and in bad weather as well as accommodation for the shepherd. The pavilions were "designed for the use of visitors, and it has been intended that portraits of sheep and specimens of wool should be hung upon their walls. It is expected, as stated in the Annual Report, to be 'a great attraction to all classes.' "[40]

Sheep were not a new phenomenon in public parks. Olmsted remarked on them in his observations of Birkenhead Park and they have been celebrated

[37]Fredrick Law Olmsted, "Designers Report as to the Proposed Modifications in the Plan, 31st May 1858," in *Frederick Law Olmsted, Landscape Architect 1822–1903*, ed. Frederick Law Olmsted Jr. and Theodora Kimball (New York: G. P. Putnam's Sons, 1928), p. 239.

[38]"Description of a plan for the improvement of the Central Park, 'Greensward' 1858," reprinted in Olmsted Jr. and Kimball, *Frederick Law Olmsted*, p. 229.

[39]Olmsted, "Letter II: Examination of the Design of the Park and Recent Changes Therein," in *Frederick Law Olmsted: Landscape Architect 1822–1903*, ed. Olmsted Jr. and Kimball (New York: G. P. Putnam's Sons, 1928), p. 261.

[40]Ibid., p. 267.

as part of the pastoral landscape since Virgil. Their wool brought great wealth to England and they served a productive purpose on the estates of the landed gentry, maintaining the lush green swards so characteristic of the landscape, while providing vital commodities in the form of their wool and meat. In an age prior to the gas-powered lawn mower, sheep were an inexpensive, practical, and picturesque feature of an expansive pastoral landscape. Thus, while Olmsted eschewed industrial intrusions on his pastoral landscape, such as Durand and Inness portrayed in their images, the designs for Central Park celebrated both water features and animal husbandry as useful, pastoral features that contributed to the aesthetic and the well-being of New Yorkers.[41] The reservoir and the sheepfold and meadow in Central Park were features that Olmsted and Vaux incorporated into the landscape of Central Park. They were elements that educated the public while they enjoyed the benefits of nature. In his essay "Public Parks and the Enlargement of Towns" from 1870, Olmsted wrote of this landscape:

> there is no more beautiful picture, and not can be more pleasing incidentally to the gregarious purpose, then that of beautiful meadows, over which clusters of level-armed sheltering trees cast broad shadows, and upon which are scattered dainty cows and flocks of black-faced sheep, while men, women, and children are seen sitting here and there forming groups in the shade, or moving in and out among the woody points and bays.[42]

Olmsted, inspired by the pastoral tradition and the estates, public parks, and British authors on the subject such as Price and Repton, adopted these gentle and productive landscapes into the design of his democratic and inclusive city parks.

These are picturesque elements that Olmsted accommodated in his designs. In his later writings, he focused on the health benefits that accompanied a connection to nature. Central Park offered a respite of clear air and relaxation that was good for both the physical and mental well-being of city dwellers. He defied critics who expressed skepticism that the park would ever be the democratic inclusive place that Olmsted espoused. For example, an author in the *Herald* argued that the rougher working class would prevent the wealthier from visiting the park: "Is it not obvious that he [the working man] will turn them out [the upper classes], and that the great Central Park will be nothing but a great beer-garden for the lowest denizens of the city,

[41]The sheep remained in Central Park until the 1930s when Robert Moses had them moved to Prospect Park. They were later relocated to the Catskills.
[42]Frederick Law Olmsted, "Public Parks and the Enlargement of Towns" 1870, reprinted in *Frederick Law Olmsted: Essential Texts*, ed. Robert Twombly (New York: W. W. Norton, 2010), p. 231.

of which we shall yet pray litanies to be delivered?"[43] This passage identifies a trend we have seen earlier in the writings of Ruskin and Wordsworth and illustrates a prevailing belief that nature, be it a city park, suburban enclave or wilderness, cannot be truly appreciated except by those enlightened few, the educated and elite of society. This strain of elitism as it runs through nineteenth- and twentieth-century Western ideas about nature and the appreciation thereof has enabled planners and zoning laws to place industrial infrastructure projects, such as coal-fired power plants or chemical plants far away from elite suburbs or wilderness, instead of constructing them in low-income, disadvantaged neighborhoods. This insidious yet widespread claim, that the poor could not somehow appreciate nature, or that their presence might pollute it, prevailed throughout the nineteenth and twentieth centuries. It was, however, vehemently disputed by Olmsted, whose 1870 account includes examples of the various classes equally enjoying the pastoral benefits of the park in equal measure. He pointed out that "No one who has closely observed the conduct of people who visit the Park, can doubt that it exercises a distinctly harmonizing and refining influence upon the most unfortunate and most lawless classes of the city—an influence favorable to courtesy, self-control, and temperance."[44]

Nature for Olmsted and for the Romantics and Transcendentalists who preceded him and influenced him, had a restorative effect on people. The bucolic landscapes of Central Park were a balm to the spirits of *all* those who visited it. And it is this spiritual benefit that was, for Olmsted, perhaps the greatest outcome of the Park. Olmsted's ideas about the physical and emotional benefits of nature are paralleled in writers such as Hamilton Wright Mabie who, in his *Essays on Nature and Culture*, believed that men who were receptive to the sublime power and beauty of nature would be lifted "above drudgery" and made "poet, artist and creator."[45]

In his Introduction to Olmsted's selected writings, Robert Twombly points out that Olmsted, who spent two years in Mariposa, California, as superintendent of the Mariposa Estate, a gold mining company, "preferred graceful, gentle, restful landscapes that subtly changed with passage through them – 'friendly' landscapes, it might be said, that eased the spirit and soothed the soul."[46] While he was partial to the bucolic scenes of New England, he couldn't help but be moved by the drama of the Yosemite Valley. It was during his time in Mariposa that Olmsted became involved in efforts to preserve Yosemite. In 1864, the Yosemite Park Grant was formed to develop plans to

[43]Ibid., p. 239.
[44]Ibid., p. 246.
[45]Hamilton Wright Mabie, *Essays on Nature and Culture* (New York: Dodd, Mead, 1896), p. 46.
[46]Twombly, *Frederick Law Olmsted: Essential Texts*, p. 22.

protect Yosemite and the Mariposa Grove of giant redwoods. Yosemite Valley had been lived in and managed by the Ahwahnechee Indians for centuries. But to the white men who "discovered" the Valley it appeared as an Edenic, untouched garden. As Simon Schama pointed out, artists like Bierstadt and Moran, or writers like John Muir, represented "it as the holy park of the West; the site of new birth; ... a democratic terrestrial paradise."[47] No doubt Olmsted's experience in Central Park was a key reason he was hired to create a plan for the protection of Yosemite as a place of scenic preservation. The US government granted the land to the State of California for this purpose. For Yosemite, Olmsted relied on his previous experience in New York, creating a circuit drive through the park with key resting spots to access certain views. To this he added pedestrian pathways that accessed other views. Ethan Carr's research into the growth and development of National Parks outlines the means by which these areas of wilderness were organized and presented to the Nation. He makes the convincing point that such wilderness was managed and presented with the same picturesque ideology that we've seen in Central Park and which evolved in England in the eighteenth century.[48] What is missing in the national park is the productive landscape. Whereas even in Central Park, the pastoral landscape was home to wool- and meat-producing sheep and clean water for the city residents, the western landscapes such as Yosemite and Yellowstone were preserved for their scenic beauty alone. The landscape was exploited by the tourist industry (and is still) and tourists consumed the arranged scenic views, postcards, and souvenirs. Thus, the wilderness, a term with roots in the term wildness or waste land, had by the end of the nineteenth century become a commodity appreciated for its beneficial effects on the spirit, for its ability to restore masculine energy and vitality and a place to "get away from it all" (with the other tourists).

Olmsted applied his ideas of park design to the landscape of Yosemite and to the development of suburbs such as Riverside, Illinois. Common to all are sinuous roads and pathways, greenswards and vistas. Also common to all is the erasure of all industry. Infrastructure such as roads and bridges provide picturesque passage through the spaces. It may be said that the last vestige of the productive pastoral were the sheep that mowed the lawns and meadows, but with the advent of the gas-powered lawn mower, their useful life in such spaces was over. This is not to necessarily lament the loss of sheep in the landscape—indeed, the introduction of domestic sheep in Yosemite had disastrous consequences for the bighorn sheep of the Sierra Nevadas.

[47]Simon Schama, *Landscape and Memory* (New York: Vintage Books, 1996), p. 7.
[48]Ethan Carr, *Wilderness by Design: Landscape Architecture and the National Park Service* (Lincoln: University of Nebraska Press, 1998), pp. 27–9.

Sheep aside, what is crucial here is that the Olmstedian landscapes that spread across the country are disengaged from a productive, pastoral nature. The result of this divorce has been that the systems which brought prosperity to society became essentially separate from nature. By the end of the nineteenth century in America, nature was (and still is) an escape, a wilderness that soothes the soul or invigorates the office worker on holiday. The suburban landscape is the gentle landscape of Downing and Olmsted's pastoralism, without the sheep, cattle, deer, or stands of timber that brought wealth to the eighteenth-century landowners in England, yet reliant on the basic aesthetic they established. This creates a tripartite system: suburbia, wilderness, and industry, or progress and the separation of these has powerfully impacted the American landscape. Works such as Marsh's *Man and Nature* provided confirmation for those skeptical of the rapid rate of "progress"; that industry and unchecked consumption of the earth's resources would have disastrous environmental consequences. His writings helped spur environmentalists such as John Muir to petition and fight for the preservation of sites such as Yosemite or Yellowstone. While such legislation helped to check the rampant clear-cutting of forests and has isolated and preserved areas of spectacular beauty, the balance of Thomas Cole's *Arcadian or Pastoral State*, wherein humankind and nature ideally exist in a symbiotic relationship was lost. As nature became a balm for the soul, an aesthetic escape, it was stripped of its sustaining systems. And the suburbs with their pastoral aesthetic are segregated from those systems which sustain the suburban lifestyle, and suburbanites are unaware of the sources of their electricity, their clean water, or their food production. As we shall see, in the twentieth century, some planners, architects, and writers envisioned returning to what has always been considered a more balanced system. But in general, the pastoral landscape, as explored above, became a hegemonic, aesthetic paradigm laid over American and English suburbs and parks. With few exceptions in the twentieth century, such spaces were no longer productive. Agriculture, industry, and infrastructure, separated from the pastoral tradition, resulted in zoned and segregated spheres with costly environmental consequences.

6

Infrastructure and Landscape in Early-Twentieth-Century England and America

In 1902, Ebenezer Howard published his seminal book *Garden Cities of Tomorrow*. As the name suggests, Howard was promoting a marriage of city and country in an effort to ameliorate many of the problems plaguing cities and the countryside at the start of the twentieth century. In Chapter 4 we saw William Morris promoting *A Factory as It Might Be*, wherein he envisioned a manufacturing plant set within a bucolic natural landscape as part of his socialist agenda. Howard was influenced by Morris and by the novel by Edward Bellamy, *Looking Backward*, a utopian novel that garnered a huge following for its depiction of an ideal socialist system of cooperation and exchange with pleasant working conditions, fair pay, and benefits upon retirement at forty-five. It was an optimistic re-visioning of society in response to the ills of poverty, poor working conditions, and degraded urban life.[1] Howard absorbed these and other issues as he formulated his ideas. In the Introduction to *Garden Cities of Tomorrow*, Howard lamented the migration into cities for work and the subsequent detachment from rural life. He argued,

> The question is universally considered as though it were now and forever must remain, quite impossible for working people to live in the country and yet be engaged in pursuits other than agricultural; as though crowded, unhealthy cities were the last word of economic science; and as if our present form of industry, in which sharp lines divide agriculture

[1] Edward Bellamy, *Looking Backward: 2000–1887*, general ed. Stanley Appelbaum and vol. ed. Thomas Crofts (Mineola, NY: Dover Thrift Editions, 1996).

from industrial pursuits, were necessarily an enduring one … There are in reality not only, as is so constantly assured, two alternatives- town life and country life—but a third alternative, in which all the advantages of the most energetic and active town life, with all the beauty and delight of the country, may be secured in perfect combination.[2]

Howard objected to the traditional dichotomy and his proposal, as outlined in his text, sought to marry the urban and rural, "and out of this union will spring a new hope, a new life, a new civilization."[3] His text carefully outlined the organization of this new city-type with an implied flexibility in terms of topography and actual city planning that afforded practical freedom.

Howard's plans included a site of 6,000 acres. The population would be limited to 32,000 residents. Precedents of planned communities such as Port Sunlight included housing specifically for workers at the Lever Factory. In contrast, Howard envisioned a range of industry, residences, and cultural institutions, such as the town hall, library, museum, and opera houses, all the aspects of urban life encircled by an agricultural green belt. He began with the concept of the three magnets, wherein he identified the problems of the town, with its lack of nature, crowded isolation, poor working conditions, polluted air and water, and wealth discrepancies and compared them with the positive aspects of cities such as culture and amusements, a large work force, and social opportunities. The country also had issues of social isolation, long arduous labor, lack of a workforce, and few cultural amenities, yet it was blessed with water, sunshine, and natural abundance. Howard's third magnet marries the first two and his diagram illustrated how he envisioned his garden city solving the problems of both the urban and rural examples. Without actually planning a city, which couldn't be done until a site was chosen, Howard located public amenities such as the library, museums, and town hall in the center of his scheme, set around a garden space (Figure 6.1). Wide boulevards branch out from the center providing access to bands of varied housing stock. A Grand Avenue with schools, playgrounds, and churches set within a green belt encircles the housing areas. Beyond this, smaller roads lead to the industrial areas, where factories have easy access to the railroad for supplies and the shipment of goods. Further out lay the agricultural fields. Key to Howard's ideas was the limiting of the population to contain sprawl.

Howard envisioned a populace employed in manufacturing with easy access to well-paying jobs, yet surrounded by farmland and interspersed with allotments, parks, and gardens. What is key here is that Howard is not

[2]Ebenezer Howard, *Garden Cities of Tomorrow*, edited with preface by F. J. Osborn and introductory essay by Lewis Mumford (London: Faber & Faber, 1960), pp. 45–6.
[3]Ibid., p. 48.

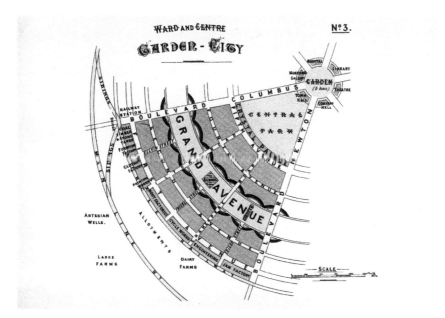

FIGURE 6.1 *Ebenezer Howard. "Diagram #3, Garden Cities of Tomorrow." Public domain. https://commons.wikimedia.org/w/index. php?title=File:Diagram_No.3_(Howard,_Ebenezer,_To-morrow.).jpg&ol did=223279302.*

proposing a suburb/city dichotomy, nor a city/country one. Rather, he argued for a marriage of the two. According to Lewis Mumford in his introduction to the text, "*The Garden City, as Howard defined it, it is not a suburb but the antithesis of a suburb: not a more rural retreat, but a more integrated foundation for an effective urban life.*"[4] As we have seen thus far, the pastoral had also married productivity and the landscape in relative harmony. What Howard outlined was a new sort of pastoral, Leo Marx's middle ground, wherein productivity, nature, recreation, and culture coexisted together. Howard was seeking a path toward a "new industrial system in which the productive forces of society and of nature may be used with far greater effectiveness than at present."[5] The machine could exist in the garden, providing housing, jobs, food, and recreation.

During Howard's lifetime, two garden cities took shape in England, Letchworth and Welwyn Garden City. Letchworth was begun in 1903 and was designed by Raymond Unwin and Barry Parker. The pair adjusted Howard's ideas to the topography of the site, while following the basic tenets of the

[4]Mumford, Intro., *Garden Cities of Tomorrow*, p. 35.
[5]Howard, *Garden Cities of Tomorrow*, p. 130.

garden city ideal. Manufacturers founded factories there such as the Spirella Corset Company, and by 1945, F. J. Osborn could write that Letchworth was

> a faithful fulfillment of Howard's essential ideas. It has today a wide range of prosperous industries, it is a town of homes and gardens with ample open spaces and a spirited community life, virtually all its people find their employment locally, it is girdled by an inviolate agricultural belt, and the principles of single ownership.[6]

Welwyn Garden City, founded in 1919, was begun by Howard who hired the architect, Louis de Soissons to design the houses, civic buildings and factories such as the Shredded Wheat Company. Architecturally, Soissons employed a neoclassicism popular with traditionalists of the day. At Letchworth, Parker and Unwin clad their buildings in an arts-and-crafts style of red brick or white stucco, deep sheltering roofs, bands of vernacular windows, and touches of the classical or gothic according to building type. Howard's ideas and Unwin and Parker's designs at Letchworth influenced suburban design in places like Forest Hills Gardens in Queens, New York. But in this case, as in many future suburbs, the pastoral aesthetic of winding streets, lush lawns, and shade trees in a residential area are all that remain of Howard's ideal of a unity of industry, landscape, and culture. The modernity of Howard's garden cities lay not in their architectural expression or suburban influence but in their layout and the determined integration of domestic, industrial, and civic buildings wedded with parkland and agriculture.

The City Beautiful Movement was another effort at the turn of the twentieth century to ameliorate some of the greatest ills of the modern industrial city. This movement grew out of the ideas of Frederick Law Olmsted's planning of the Chicago World's Fair and efforts of architects such as John Root and Daniel Burnham to design first the Exposition and later cities in general along new "modern" principles. These included elements from the Beaux Arts tradition, such as wide boulevards; large, neoclassical buildings; and tidy city parks. As efforts to remediate the overcrowding of narrow city streets and poor hygienic standards of city slums, proponents of the City Beautiful worked to improve sanitation and waste issues, provide clean drinking water, accommodate the fast-changing transportation systems, and offer recreational opportunities to an urban population. Understandably, infrastructure systems were a part of these efforts, from grand train stations such as McKim, Mead, and White's Pennsylvania Station of 1912 to Daniel Burnham's Union Station in Washington, DC. But smaller efforts were part of the Movement as well, such as the small Jesse Street substation that Willis Polk designed for the Pacific

[6]Osborn, "Preface" in *Garden Cities of Tomorrow*, p. 13.

Gas and Electricity Company in 1905. While not an expensive building, Polk employed a warm red brick, detailed in white stone with a dentiled string course, and roman-inspired arched entranceway. On another modest scale, cities like Harrisburg, Pennsylvania, closely adhered to the principles of the City Beautiful Movement in the layout of their parks, such as Capitol Park designed by Arnold Brunner *c.* 1910. As part of wider planning schemes, buildings like the Harrisburg water filtration plant were tastefully designed and landscaped. Such care taken with these small infrastructure projects, often set in parklike settings or open city plazas, illustrates a basic tenant of the City Beautiful Movement: that beautifully designed spaces and architecture (as understood by civic leaders) would lead to healthier cities and greater civic pride.

The City Beautiful Movement is significant for our purposes because of the interest architects and civic leaders took in dressing infrastructure projects such as power generation or water filtration systems in an architectural language that helped integrate such projects into the cityscape. Power generation, and a clean water supply were modern aspects of society worthy of pride and prestige. The idea of a well-dressed building, providing the modern comforts of electricity and water, meant that such structures were included in the urban view and celebrated. Larger infrastructure projects were often given greater prominence in the 1920s and 1930s. Not always associated with the City Beautiful, they nonetheless wed aesthetics with engineering in arresting ways.

For example, in 1913 the City of Toronto began a scheme for a large water filtration plant on the shores of Lake Ontario. The development of the R. C. Harris Water Filtration Plant (Figure 6.2) began in 1913, but the realization of the project was delayed until 1928. R. C. Harris was the commissioner of

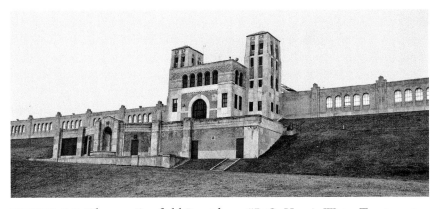

FIGURE 6.2 *Thomas Canfield Pomphrey, "R.C. Harris Water Treatment Plant." Toronto Canada, 1932–41. Public domain. https://commons. wikimedia.org/wiki/File:RC_Harris_Water_Treatment_Plant_2009.jpg.*

works for the City of Toronto. He was a proponent of the sort of progressive ideas that spurred the City Beautiful Movement which included clean, hygienic cities; playgrounds and recreational spaces within the urban confines; the prohibition of alcohol; and attempts to purge politics of graft and corruption. As commissioner of works, Harris fought for a water purification plant that would be both beautiful and productive, a beacon of civic pride on the lakeshore. After several false starts, plans were drawn up by the city architect, Thomas C. Pomphrey in 1926. According to Steven Mandell's history of the project, these early plans were a mundane reworking of a neoclassical style applied to a water treatment plant. Harris rejected these as too bland, and by 1928, Pomphrey introduced plans for a grander civic statement, with three tiers of structures stepped up from the lakefront. The main filtration building and public rooms are on the top tier, stretching out horizontally across the hillside in a series of bays articulating the filtration rooms. The main entrance to this building is dramatized by a grand, roman-inspired arch. Pomphrey articulated the entrance and decorative details with a white limestone that contrasts with a buff brick adding an almost byzantine flavor to the whole. Just below the main entrance along one of the paths that snakes between the buildings, a fountain offers freshly purified water to visitors, designed with echoes of holy water stoups in churches. While this was part of a Christian ritual, here at Harris, "the ritual process employs rational human technology, and the initiatory was is a Progressive-era offering of water to drink, purified by science and bureaucratic organization."[7] Thus, the site, architecture, landscape, and even details such as the drinking fountain were chosen to celebrate this infrastructure project that promised clean water to the citizens of Toronto.

Another high-profile infrastructure project from the 1920s illustrates similar concerns with civic pride, efficiency, and good design. Since the early days of the Industrial Revolution, London had been plagued with smog and poor air quality. In the first half of the twentieth century, London's electricity came from a mix of private and public municipal operators who were regulated by the Central Electricity Board or CEB. In the mid-1920s, it was expensive to build pylons and transmit energy across great distances. The more affordable options were locally placed power plants, and in 1927, the CEB together with the private company, London Power Supply, agreed on an already industrial site in Battersea to build a new, more efficient power plant. Just along the Thames, this site offered unlimited water for cooling, thus eliminating the need for large, unattractive cooling towers. But the owners faced strident objections to the new project. Opponents were concerned about smoke pollution and an

[7] Steven Mannell, "From Indifferent Shell to Total Environment: The Design Evolution of Toronto's Victoria Park Water Works, 1913–1936," *Journal of the Society for the Study of Architecture in Canada*, vol. 37, no. 2 (Jan. 2012): p. 70.

unsightly mass along the river, just opposite the posh borough of Chelsea and not far from Westminster and the national seat of government. The owners countered saying this new plant would be more efficient with grit collectors and high smokestacks, thus producing less smoke than older plants. They promised gas scrubbers to reduce the noxious sulfur emissions.

Also agitating against the planned project was the arts establishment, such as the Royal Fine Arts Commission and the Trustees of the Tate and National Gallery. Cultural leaders expressed concern about the health and well-being of London's parks, architecture and artworks, and how the emissions from such a plant might affect them. And the London Society complained that such a plant would be a blight on the cityscape of London. To counter these concerns, London Power Supply hired the architect, Sir Giles Scott, grandson of the well-known Sir George Gilbert Scott. Stephen Heathorn's 2013 article about Battersea and Bankside power stations goes into great detail about the evolution of these power plants. He quotes Frederic Towndrow in the *Architect's Journal* of 1927 who laments the ugliness of power stations but warns that the "prettification" by an architect who adds classical or gothic details in an attempt to camouflage such buildings is even worse.[8] Scott was tasked with designing a building, which, by its very nature, was considered an eyesore. With its prominent location just beside the river, and constrained by technical requirements, Scott focused his attention on the cladding and detailing of the upper stories, those most visible from the river and across it (Figure 6.3). He clad the building in red brick and accentuated the verticality of the structure via brick pilasters along the length of the building. At each end, where the smokestacks are, the corners are articulated by narrower bands of pilasters that lead to stepped platforms out of which rise the white concrete smokestacks. These, Scott fluted in the manner of a classical Greek column. When the second half was completed, the whole resembled an upside-down table. Even in 1935, with only one half completed, the building had a monumental quality and it still stands proudly on its site, a symbol of the age of electricity and progress.

There are several significant aspects of the history of the power plant worthy of note. With an architect at the design helm, the building became more than just a power station but quickly became a beloved landmark on the London skyline. Through careful massing and subdued but thoughtful detailing, Scott gave the structure a striking, architectural monumentality. And it was the arts establishment of London whose complaints and warnings about the project led to London Power hiring Scott. Thus, the role of artists and critics in shaping such a prominent infrastructure project is significant.

[8]Stephen Heathorn, "Aesthetic Politics and Heritage Nostalgia: Electrical Generating Superstations in the London Cityscape since 1927," *London Journal*, vol. 38, no. 2 (July 2013): p. 130.

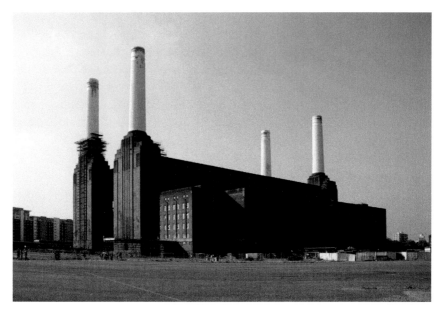

FIGURE 6.3 *Sir Giles Gilbert Scott. "Battersea Power Station." London, 1929–55 (two phases). Public domain. https://commons.wikimedia.org/w/index.php?title=Special:CiteThisPage&page=File%3ABattersea_Power_Station_in_London.jpg.*

Curious as well, in light of power generation in the twentieth century, was the need for locally based power production. As the cost of transmission lines went down, power stations were increasingly placed outside urban centers, away from the public eye. Recent, more environmentally friendly electrical production is returning to the cityscape or landscape. Such projects will be discussed later in detail. But it is important to understand that Battersea was shaped by, and its emissions controlled as a result of, its proximity to an urban core. The public that objected to the planned power station forced a degree of accountability that would not have existed had the plant been out of sight. Its high-profile site determined advances in managing emissions and the aesthetic appeal that led Battersea Power Station to become a listed and protected landmark.

 After many years and several proposed iterations, the Battersea Power Plant is now being developed as a mixed-use venue with shops, restaurants, and high-end flats and a members' gym. The Bankside Power Station is also no longer a functioning power station (it was closed in 1981) and has been home to the Tate Modern since 1994. Its history is very much like that of Battersea. In this instance, a power plant already existed at the site in 1946 when the London County Council announced plans for its enlargement. Once

again, the arts establishment voiced concern about the development, citing its proximity to St. Paul's Cathedral just across the river. And once again, the angry resistance led to advanced scrubbing technologies incorporated in the plans and the hiring of Sir Giles Scott to design the new building. Here, the central smokestack appears almost like an Italian campanile.[9] Once again, Scott articulated the brick facades with pilasters and cornices that obfuscated the industrial appearance of the plant. Ironically, concessions made to reduce the sulfur emissions, both at Bankside and Battersea, proved ineffectual and at times actually more harmful to London's architecture. While the technology may have failed, the public's input and response to such an urban project impacted the design and attempted pollution control. While these two projects were in no way softened by a pastoral aesthetic, their visual presence was due to public participation and the involvement of a talented architect. Those two factors conditioned how these power plants evolved and thus provide thoughtful precedents as we consider infrastructure in the twenty-first century.

The architectural conservativism of Howard's garden cities and the City Beautiful Movement may have put off critics and architects intent on creating a modern architecture expressive of the age of the machine. Even Scott's designs for Battersea and Bankside used a traditional brickwork and made reference, albeit in a pared-down architectural vocabulary, to traditional architectural styles. But the first half of the twentieth century was a period of rapid modernization with the introduction of flight, the automobile, the assembly line, and the power of the machine. Many architects and artists wanted to capture this new machine age in their art and architecture and did so by throwing off the shackles of past styles in an attempt to create something unique to their age. An early example of this was Tony Garnier's "Cite Industrielle," which he published in 1917. In these plans Garnier envisioned a city on a plateau, powered by a large hydroelectric dam located northeast of the city proper. Garnier's ideas grew out of nineteenth-century utopian ideas with a social structure based on the goodness of mankind; thus he included no prisons or courts, or even churches in his plans. Houses are laid out along grid-like streets, and just across the railroad tracks Garnier includes a large industrial area to the north and east. While novel at the time, with its flat-roofed houses and prominent industry, his plans do not appear as radical today. Industry and productive infrastructure are separated from the residential and civic areas of the city by green belts, thus segregating these areas from residents of the city. Thus, while Garnier's scheme celebrated the new industrial age, he assigned the functions of the city into segregated

[9]Heathorn, "Aesthetic Politics and Heritage Nostalgia," p. 133.

zones, isolating industry and infrastructure from the housing and cultural core. It is just this sort of segregation that exists in our cities today.

Another vigorous proponent of the Machine Age was le Corbusier. One of the twentieth century's most iconic architects, le Corbusier's architecture and urban planning eschewed historical precedents and sought to incorporate the thrilling benefits of the automobile and airplane into the cityscape. Between 1922 and 1935, le Corbusier presented three versions of his modern city. Beginning with his "Contemporary City for Three Million Inhabitants," which he presented in 1922 through the ensuing decades, le Corbusier expounded on his theories of urban life in the Machine Age. Reacting to the overcrowded and congested cities of the early twentieth century, such as Paris, le Corbusier argued for a clean urban slate upon which he would build the modern city. Key characteristics of the "Cité Contemporaine" included high-density living in tall, glass skyscrapers set amid parkland and accessed by a range of transportation options. His wide highways converged in the center of the city above train and subway tracks with an area for landing planes above the highway. Replacing monuments, churches, or temples as the foci of urban intersections, the infrastructure of modern movement was the urban destination. As William Curtis points out, the crossing points of the city were not monuments but "a seven-level transport terminal including railways, roads, subways and an airport on top."[10] In his vision of a tightly ordered, hierarchical society of efficiency and technology, nature played a role as a backdrop for modernity, providing clean air and recreational spaces within the landscape. To avoid accidents with pedestrians, roads were raised off the ground, leaving green space (albeit shaded) for pedestrians, trees, and sports. In an ironic echo of the English pastoral estates such as Chatsworth or Stourhead, the productive landscape was viewed by the elites. Curtis again notes, "The elite, 'the brains of the country'—philosophers and artists as well as businessmen and technocrats— worked high in the skyscrapers, surveying the theater of daily life around them. In the distance, beyond the fields, they could see factories (placed down-wind), and workers' garden cities."[11] Yet the vast distance between the elite in their glass towers and the productive infrastructure set well outside the city ensured a zoned disconnect between the two spheres—one that has remained through the twenty-first century.

Le Corbusier had a particular fascination with housing throughout his long career and this typology received much of his attention in his plans for the City Contemporaine, the Plan Voisin for the rebuilding of Paris of 1925 and his Ville Radieuse of 1930–5. In all three, tall residential towers dominate the skyline and social classes are housed according to their work and status. Smaller

[10]William J. R. Curtis, *Le Corbusier: Ideas and Forms* (New York: Phaidon Press, 2015), p. 110.
[11]Ibid., p. 113.

homes for the working classes included allotment gardens. But le Corbusier placed productive infrastructure such as power plants or water treatment plants downwind of these cities, separated via a green belt of agriculture, thus protecting citizens from the pollution and smog that fouled contemporary cities. In the Romantic tradition discussed earlier, nature offered solace and healthy respite from the modern workday, and productive industry was zoned apart from daily life. For his independent villas, such as the iconic Villa Savoye of 1928, le Corbusier made his "Five Points of a New Architecture" a material reality. He replaced the ground taken up by the house with the roof terrace with views of the surrounding pastoral countryside. In his words,

> I shall place this house on columns in a beautiful corner of the countryside; we shall have twenty houses rising above the long grass of a meadow where cattle will continue to graze. Instead of the superfluous and detestable clothing of garden city roads and byways, the effect of which is always to destroy the site, we shall establish a fine arterial system running in concrete through the grass itself, and in the open country. Grass will border the roads, nothing will be disturbed—neither the trees, the flowers, nor the flocks and herds. The dwellers of these houses, drawn hence through love of the life of the countryside, will be able to see it maintained intact from their hanging gardens or from their ample windows. Their domestic lives will be set within a Virgilian dream.[12]

This is a fascinating quote that sheds light on how le Corbusier wed the past with the present. While rejecting traditional gardens and paths, he planned to provide access to this seminal house of the twentieth century via a concrete funnel of roads lined with grasses. He combined the conveniences of a hygienic modern lifestyle with a celebration of new building materials and the automobile, and set them within a Virgilian landscape. As we noted at the start of this book, Virgil's Georgic poems celebrate the productive bounty of the pastoral landscape. For le Corbusier, this landscape, is recognized for its pictorial contrast to the modernity of the Villa Savoye, which offered views from "their hanging gardens or from their ample windows."[13]

Le Corbusier's approach to nature and the machine shifted in the 1930s and 1940s when he began to look for more expressive forms and a new spirituality in his architecture. His interest in infrastructure married with architecture also grew at this time as can be seen in his designs for Algiers. But as in

[12]Le Corbusier, *Precisions*, quoted in Christopher Tunnard and John Dixon Hunt, *Gardens in the Modern Landscape: A Facsimile of the Revised 1948 Edition* (Philadelphia: University of Pennsylvania Press, 2014), p. 101. https://ebookcentral.proquest.com/lib/UMA/detail.action?docID= 3442396. (ProQuest).
[13]Ibid.

his Ville Contemporaine, what intrigued him most was the infrastructure of transportation. Indeed, in his published Ville Radieuse, he included an illustration of the new Lincoln Express Highway in Newark, New Jersey, as an example of large-scale urban concrete systems. Nature remained an escape, a place for exercise or a beautiful view. His views were shared by Mies van der Rohe, another iconic twentieth-century modernist. Mies's Farnsworth House of 1950 epitomized his "less is more" program, wherein this small house sits lightly on the site, a glass box open to the fields, woods, and river surrounding it. About Nature Mies wrote,

> Nature should also live its own life, we should not destroy it with the colors of our houses and interiors. But we should try to bring nature, houses and human beings together in a higher unity. When you see nature through the glass walls of the Farnsworth House, it gets a deeper meaning than outside. More is asked for from nature, because it becomes part of a larger whole.[14]

Frampton likens Mies's presentation to framed "wallpaper"—a nature that the architect in his genius, then improves upon. Ironically, one of Edith Farnsworth's complaints, which she raised in her lawsuit against Mies, was the lack of fresh air available with the inoperable windows and glass walls. Nature for Mies was to be celebrated for its visual interest, and the other senses were not affected; it was to be enjoyed through the lens of the architect for its visual qualities, but not for its productivity.

Broadacre City was Frank Lloyd Wright's vision of urban planning for the American landscape. Like le Corbusier, Wright was excited by the potential of the automobile and modern transportation such as trains and airplanes. But rather than le Corbusier's tall glass skyscrapers in the heart of the city, Wright envisioned a sprawling landscape stretching out across the plains, with each resident's house set on an acre of land. And like le Corbusier, Wright emphasized the transportation systems that connected residences, work, and recreation. Productive infrastructures such as factories and industry were placed along the transportation spine. In Chapter 5, we discussed the Jeffersonian ideal of a gentleman farmer and Jefferson's vision of the United States as a productive pastoral nation. While he admired the productivity and technological advances of the Industrial Revolution in England, he saw no role

[14]Mies van der Rohe in interview with Christian Norberg Schultz in *L'Architecture Aujourd'hui* quoted in Kenneth Frampton, "In Search of the Modern Landscape," in *Denatured Visions: Landscape and Culture in the 20th Century*, ed. Stuart Wrede and William Howard Adams (New York: Museum of Modern Art with Harry N. Abrams, 1991), p. 46.

for such enterprise in the fledgling United States. Wright shared Jefferson's belief in the bounty and beauty of an agrarian nation. Cornelia Brierly, a Taliesen fellow in 1934 described Wright as "A Jeffersonian democrat. Like Jefferson, he felt that people should spread out on the land, maintaining an agrarian situation of great beauty."[15] Wright dismissed cities as dirty and inhumane places, crowded with people stacked atop each other in high rises amid congested streets.

To remedy these urban problems, Wright envisioned Broadacre City. Unlike Ville Radieuse, Wright imagined a decentralized city, spread out across four square miles with a population limited to 2,300 people. In the model he presented in 1935 at Rockefeller Center during the depths of the Depression, Wright laid out his city in rectangular blocks in an incomplete grid system. Most of the housing was centralized with each house laid out on one acre of land. Certain areas were zoned for particular activities such as civic areas or residential.

> Standard elements of the settlement included farms "correlated" with production, and sales; small-scale, nonpolluting factories; decentralized schools; monorails; a controlled traffic system with separation of classes of vehicular traffic; warehouses incorporated into highway structures; and cost-saving houses.[16]

Near the light industrial areas were smaller houses, and some small factories had workers' dwellings above. Just beside the industrial area, parallel to the main rail tracks and industrial buildings were orchards and vineyards for the city. Brierly, in her conversation with Meunier, emphasized that Broadacre took shape during the Depression. At that time, while many were going hungry, fellows at Taliesen were growing all their own food, from chickens and meat to vegetables and fruit. Thus, Wright wove into his expansive urban fabric farms and space for each family to farm as they wished. Brierly again notes, "In the overall landscape he envisioned 'patterns of cultivation mingling with good buildings,' blocks of woodland held in trust for future generations, and homes designed with such architectural integrity that small homes and large estates could exist side by side complimenting each other."[17] With echoes of the Virgilian Georgic poetry, Broadacre wove productivity, both industrial and agricultural, into the cityscape.

[15]John Meunier, "A Model for the De-Centralized City: An Interview with Cornelia Brierly," in *Frank Lloyd Wright: The Phoenix Papers. Volume 1: Broadacre City*, ed. K. Paul Zygas (Tucson: Arizona University Press. 1994), p. 42.
[16]Anthony Alofsin, "Broadacre City—Ideal and Nemesis," *American Art*, vol. 25, no. 2 (Summer 2011): p. 21.
[17]Ibid., p. 41.

In his book *The Living City*, Wright wrote about his desire to reintroduce nature to the city dweller. Complaining about the lives of greed, graft, and man's disconnect from the natural world, Wright wrote, "Perpetual to-and-fro excites this citified citizen, robs him of deeper sympathy, of the meditation and reflection once his as he lived and walked under clean sky among the fresh greenery to which he was born companion. On solid earth he was neither fool-proof nor weather-proof, but he was a whole man."[18] Wright's ideas for Broadacre City are sometimes demonized as having encouraged the sprawling suburbs that blight the landscape. Like le Corbusier, he was enthralled by the automobile and airplane and saw great promise in these new forms of transportation that could more easily link people and communities and shrink previously vast distances. Today, such expansive development is understood as wasteful and we have seen the results of great highways systems clogged with mind-numbing traffic and resulting smog. But delving deeper into Wright's ideas reveals a prescient approach to urban agriculture and industry that remarries civic, residential, and productive systems into the urban landscape. As we shall see architects, artists, and planners are exploring once again this marriage of function, beauty, and nature in exciting and sustainable ways.

In 1958, the frontispiece of *The Living City*, includes a map of Broadacre with a numbered key identifying specific parts of the urban fabric (Figure 6.4). The overall form and ideology had not changed since Wright introduced his model in 1935. But the map is helpful in specifying various parts of the city. The importance of nature is obvious to the viewer, as the city resembled a patchwork quilt in green tones, with areas of water, recreation, and wooded areas, and the family's one-acre plot providing rectilinear regularity. In the upper left of Section C, number 16 is identified as "Little Factories, dwellings above." Number 15 locates "Workers' homes" while 47 indicates larger homes. Below the key, Wright wrote, "A New Freedom for Living in America," wherein he promises his Broadacre city will have no 'Landlord or Tenant," "No Poles, no wires in sight," "No glaring cement roads or walks," "No slum. No scum."[19] Wright's Broadacre cities are often described as democratic, classless ideals. He was ardently anti-socialist and pro-individual. But as his landscape makes clear, he does recognize and instill a social hierarchy into his urban factory. His smaller homes and factory workers' dwellings are close to the industrial areas, while the middle-class homes in the center of town and the larger homes on the rural fringe are isolated from the industrial hub. The placement of the working classes close to the industrial sites illustrates a tension we saw in the writings of Ruskin, Wordsworth and Repton. All four men understood

[18]Frank Lloyd Wright, *The Living City* (New York: Horizon Press, 1958), pp. 17–18.
[19]Ibid., frontispiece.

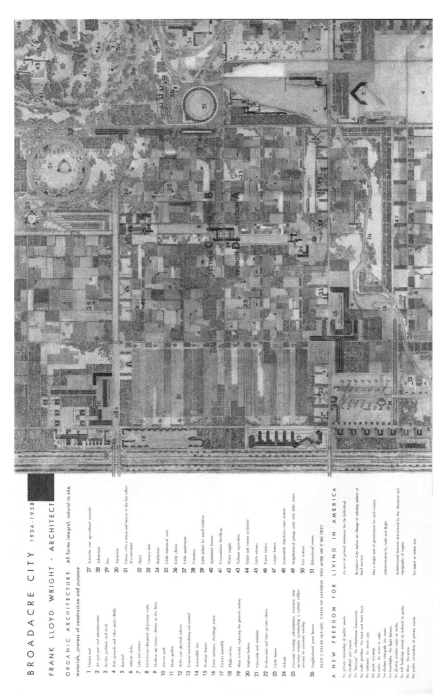

FIGURE 6.4 *Frank Lloyd Wright. "Frontispiece of* The Living City*," 1958. © 2018 Frank Lloyd Wright Foundation. All Rights Reserved, Licensed by Artist Rights Society.*

that nature was beneficial for mankind, but they also believed that the working man or woman needed less nature and was incapable of enjoying it as the writers believed it should be enjoyed. Wright wanted his residents to have access to nature, to their acre of land. But not all the residents have this access and those with less live closer to the industrial areas.

Also missing from Wright's plans for Broadacre City are powerplants and waste treatment sites. While reservoirs supply the residents with water, and he promises no poles and wires, it is not clear just where or how the power was generated, or how the water was treated when it left the city. Such infrastructural systems do not appear to have interested Wright enough to have included them. But the overall union of agriculture, recreation, work, and living, together with nonpolluting industry is a prescient sign of some architects' twenty-first-century goals.

The Great Depression of the 1930s inspired Wright's ideas for Broadacre. It was also the catalyst for some of the most dramatic infrastructure projects in the United States. One such was the Tennessee Valley Authority (TVA), a comprehensive scheme that affected the states of Tennessee, Kentucky, Virginia, Mississippi, Alabama, Georgia, and North Carolina. The TVA Act was signed in 1933. Its goal was the regeneration of one of America's poorest and least advanced regions. Years of flooding of the Tennessee River and poor farming practices had degraded the soil and made agriculture very difficult. Few families had electricity or access to modern infrastructural systems of any kind. The TVA was part of Roosevelt's New Deal, with the goal of increasing employment opportunities and the quality of life for those in the region. Its goal was also to generate power, provide flood control, and develop industry and agriculture while restoring the health of the landscape. This was a hugely ambitious plan, not only with regard to its infrastructure goals but also in terms of its social aims. It represents a remarkable cooperation between conservationists, land management ideologies, and electrical and industrial production.

The Norris Dam was the first of twenty-nine dams built along the Tennessee River. Together with the power house, we will look at its development in terms of its unique architectural expression, engineering might, and environmental benefits. As Christine Macy points out in her analysis of the project,

> It involved eleven main river dams and numerous tributary dams, public power generation and distribution, resettlement of long-established residents, model towns, construction camps, experimental farms, parklands on reservoirs, a freeway, and much more.[20]

[20]Christine Macy, "The Architects' Office of the Tennessee Valley Authority," in *The Tennessee Valley Authority: Design and Persuasion*, ed. Tim Culvahouse (New York: Princeton Architectural Press, 2007), p. 26.

With such a varied and vast project, it was, of course, important to bring the residents affected on board. Architects for the TVA were tasked with providing designs that reflected the power and ambition of the project, the marvels of the engineering that went into it, and a sense of the promise of modernity and a future of convenience, energy, and beauty. The key architect of the Norris Dam and powerhouse (Figure 6.5) was Roland Wank, a Hungarian-born architect from New York City who was well schooled in the trends of German Modernism. Rejecting a proposed powerhouse with neoclassical pilasters and arches applied to the dam itself, Wank opted for a pared-down, honest expression of the power of modern engineering and materials. He was in charge of the appearance of the dam and additional buildings related to it. For the dam, Wank presented a sublime wall of concrete that dwarfs the visitor by its scale and textured concrete surface. Visitors can walk over the dam and peer over the precipice to heighten the awe-inspiring effect.

The role of the visiting public was considered vital to the project. From the start it was understood that this project was in the service of the populace—not only those living in the region, but the millions of visitors who would marvel at the splendors of nature, engineering, and modernity. Wank was in charge of the designs of various visitor's amenities such as souvenir shops, soda fountains, promenades, and even a dancing pavilion.[21] The workings of the dam were revealed in the powerhouse, where tourists could learn about how their electricity was generated.

> The viewer's experience of the TVA dams was carefully orchestrated. In all the TVA projects, visitors circulated through a world of modern architecture, with open-air terraces, white-plastered exteriors, and richly polychromed interiors of tile, stone and aluminum. They encountered backlit TVA exhibits that extolled the accomplishments of the Authority, and they reclined on upholstered banquettes overlooking dams and powerhouses, locks, and recreational facilities.[22]

Tourists came to see the dams, but they also came to the newly made parks, set within reforested woodlands alongside newly made lakefronts. They camped, boated, hiked, and ate within a "naturalistic setting in the tradition of the 18th century English romantic landscape."[23] New towns such as Norris were designed in the tradition of Howard's garden city, with winding streets and easy access to the workplace. The comprehensive nature of the TVA is

[21] Ibid., p. 44.
[22] Ibid., p. 45.
[23] Marian Moffett, "Noble Structures Set in Handsome Parks: Public Architecture of the TVA," *Modulus*, no. 17 (Jan. 1984): p. 77.

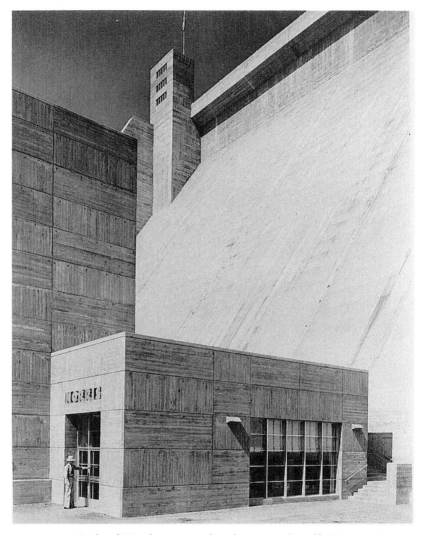

FIGURE 6.5 *Roland Wank, principal architect, and staff. "Norris Dam, Tennessee Valley Authority," National Parks Service (Library of Congress, Prints and Photos Division, Farm Security Administration Collection, LC-USW33-015707-C).*

the result of a remarkable moment in history when the government took seriously its role of public servant, when architects like Wank were inspired by European ideas of social housing and the promise of an architecture of the twentieth century that could solve some of society's worst ills, and conservationists who saw the regeneration of this vast and varied landscape and the preserved parkland as valuable to the public good. In many ways, we can see echoes of Fairmount Park in Philadelphia. In both instances, an

accessible water supply was employed to offer great benefits to the local residents. And in both projects, the architecture was designed to inspire and add beauty to the landscape. Visitors to the Norris Dam and Fairmount could learn about the machinations of the respective plants while roaming through carefully designed parklands. Though the scale differs greatly, and a century divides the two, both were large-scale infrastructure projects designed to invite the public to learn about the water supply and enjoy the site while enriching the landscape setting. Architecturally, Fairmount set a precedent of neoclassical architecture that characterized Philadelphia and determined the look of the Philadelphia Museum of Art on the hill above it.

At Norris, Wank's treatment of the concrete facades of both the dam and powerhouse included leaving the imprint of the formwork visible. This created a checkerboard pattern of verticals and horizontals that added a textured vitality to the facades. In 1946, le Corbusier visited the Norris dam with Eugene Claudius-Petit, a deputy in the French National Assembly who traveled with Corbu and other architects to study American architecture, particularly infrastructure as part of their efforts to re-build France after the Second World War. Le Corbusier was said to be impressed with the bare and honest treatment of concrete. Michel Echochard, a French architect touring with le Corbusier and Claudius-Petit, "called this rough exposed concrete 'béton brute de decoffrage.'"[24] This treatment of the concrete surface would appear in le Corbusier's works in the 1950s such as Unité d'Habitation.

Le Corbusier was powerfully affected by what he saw in Tennessee. He wrote of the experience:

Masterly symphonic urbanism. Negligence and greed had impoverished the land, deforested mountains, floods, erosion, desert increasing each year, misery spreading everywhere. Coup de barre [change of course]: symphonic idea. One makes twenty or thirty gigantic dams, one regulates water madness. With these dams there is electricity in abundance, this power produces electrolysis, chemicals, fertilizers ... With these fertilizers, one regenerates the land, sowing grass that makes deep roots, fixes the land, removes erosion, and allows cows to graze in open fields in winter, enriches farmers who have mechanical equipment and electricity. The industry extends into the valley, the boats go back to New Orleans to the depths of the earth through gigantic locks. One of these dams is a marvel of complete agreement and harmony between man and nature ... It is an edifying spectacle.[25]

[24]Mardges Bacon, "Le Corbusier and Postwar America: The TVA and *béton brute*," *Journal of the Society of Architectural Historians*, vol. 74, no. 1 (Mar. 3, 2015): p. 17.
[25]Le Corbusier, quoted in Bacon, "Le Corbusier and Postwar America," pp. 22–3.

This lengthy quote reflects le Corbusier's ardent admiration for what he saw in Tennessee. But it also, rather poetically, captures the essence of what was attempted at the TVA. The comprehensive planning and the goal of addressing power production, land regeneration, employment and housing, education, and recreation was extremely ambitious and its realization awe-inspiring. It is an example of a union of productive infrastructure within a pastoral setting that resembles Ruisdael's paintings of Haarlem or William Kent's landscape at Rousham. In the examples reviewed in this text, such landscapes celebrated nature and a productive pastoral much like we see at the Norris Dam. Similarly, this productive pastoralism usually elicits feelings of civic pride, whether of the promise of clean drinking water for the city of Philadelphia or electricity for the Tennessee Valley. In 1941, the Museum of Modern Art held an exhibition of the architecture of the TVA. In reviewing the exhibition, Lewis Mumford cited the introductory message to the exhibit by Stuart Chase, who wrote, "A new Architecture, bold as the engineering from which it springs, is rising in the valley … Look at it and be proud that you are American."[26] Mumford agrees and likened the dams to the Egyptian pyramids. Yet where the pyramids were built by slaves to honor the dead, Mumford argues, "Ours was produced by free labor to create energy and life for the people of the United States."[27]

Overall, such unity of landscape, infrastructure, and civic pride was not the norm in twentieth-century industrialized nations. Alvar Aalto's Sunila Plant in Takaisin, Finland, of 1937–9 is an unusual example of an architect taking on industrial projects. At Sunila, Aalto wove a large pulp factory plant and workers' housing into the rocky landscape. The plant itself rose up from great granite outcrops a study in contrast between the rugged organic quality of the stone, the delicate steel pylons, and the blocky masses of the plant itself. Workers' housing nestled into the landscape providing an intimate connection with the natural landscape for those who worked there. As Michael Chapman and John Roberts point out, Aalto was keenly interested in helping shape Finland's industrialization process, "specifically, the way that industry and nature work in harmony to create an ideal model of future urbanization. For Aalto, Finland was a model of industrial development that could form a precedent for other nations to follow, marrying traditional and primitive values with the contemporary needs of a modernizing population."[28] Aalto worked on other industrial projects, but his interest in the design of factories was rare in the early to mid-twentieth century. Most of his peers, such as Walter Gropius and Mies or le Corbusier, while they were ardently pursuing an architecture of

[26]Lewis Mumford, "The Skyline: The Architecture of Power," *The New Yorker Magazine* (June 7, 1941): p. 60.
[27]Ibid.
[28]Michael Chapman and John Roberts, "Industrial Organisms: Sigfried Gideon and the Humanisation of Industry in Alvar Aalto's Sunila Factory Plant," *Fabrications*, vol. 24, no. 1 (2014): p. 77.

the Machine Age, that reflected the trending Socialist politics and technology of the day, were more concerned with questions of housing, tall buildings, or civic structures than with industrial or infrastructural design. Within the romantic tradition, nature, for these architects, provided a visual balm and aesthetic contrast to the steel, glass, and concrete of their architectural vocabulary.

The duality between nature and the machine percolates through the history of art in the first half of the century as well. The Italian Futurists, led by Filippo Marinetti and his *Futurist Manifesto* zealously promoted the machine and the glory of the automobile, speed, and energy. Antonio Sant'Elia's images for the "New City" of the future, such as his "Power Plant" of 1914, illustrate this group's passion for the power of electrical production and the bold masses and sublime scale of this emerging infrastructure and architecture of the future. Speed, smoke, and new forms of transportation promised to wipe away the old world. His imagery and that of his peers envisioned a new urban fabric devoid of nature and the past. Other artists such as Ferdinand Leger or Joseph Stella captured the intricacies and complexities of twentieth-century city life in canvases tight with industrial abstractions. Realistic landscape painting, so popular in the nineteenth century in both Europe and America, fell out of favor. The natural world provided rich material for a spiritual exploration of nature and abstraction, in the case of Kandinsky and his peers, or formal cubic contrasts between nature and the built environment in the works of Picasso and Braque in the 1910s. Nature was a backdrop for intellectual explorations into abstraction or urban change.

The relative alienation of nature in the art and architecture of the twentieth century was explored in an exhibition at the Museum of Modern Art in New York in 1988. Entitled, *Denatured Visions: Landscape and Culture in the Twentieth Century*, scholars from Art History, Architectural History, and Landscape Studies contributed essays exploring the disconnect between nature and the arts. In the introduction to the catalogue, editors Stuart Wrede and William Howe Adams recognized that "aesthetics of the 20th century, particularly in the visual arts, were fundamentally hostile to nature; that the modern movement had, on the whole, led to a divorce between architecture and nature ... and that generally, a vital, modern landscape tradition never emerged."[29] Even Georgia O'Keeffe whose intimate focus on nature characterized her painting style, honed in on and abstracted her subject, isolating floral structures or landscapes from their wider context in order to explore form, depth, and color.

[29]Stuart Wrede and William Howard Adams, "Introduction," in *Denatured Visions* (New York: The Museum of Modern Art, Harry N. Abrams, 1988), p. 4.

FIGURE 6.6 *Charles Sheeler.* American Landscape, *1930. Oil on canvas. 24 • 31 inches. Gift of Abby Aldrich Rockefeller. © The Museum of Modern Art/Licensed by SCALA/ Art Resource, New York.*

Charles Sheeler's *American Landscape* of 1930 (Figure 6.6) best illustrates the industrial paradigm of twentieth- century power and infrastructure. In *American Landscape*, Sheeler presents an eerily sterile image of the Ford Motor River Rouge plant. Cranes, factories, silos, and smokestacks receive equal treatment with his precise brushstroke. The solitary figure of a worker in the center of the painting is dwarfed by the vast scale of this industrial site. The sublime power of industry leaves no space for nature, not even a blade of grass dares to struggle to grow in its shadow. Sheeler painted more traditional landscapes such as the barns of Bucks County, Pennsylvania, where he froze these iconic agricultural forms in a still and quiet landscape. But he is best known for his records of industry. By naming his painting *American Landscape*, he ties his subject to a longer tradition of landscape painting in the manner of Cole or Durand. Yet Sheeler replaces their pastoral vision of a harmony between man's progress and nature with an industrial system which isolates man and obliterates nature. With the growth of industry, vast networks of highways, overpasses and underpasses, and massive coal and nuclear power plants rose up to meet the energy needs of cities and their suburbs. Nature has been isolated in public parks, suburban lawns, the rural

landscape, or wilderness. The pastoral middle ground wherein productivity, landscape, community, and recreation worked together has been abandoned and productive infrastructures are isolated on the fringes of cities, often closest to low-income communities.

The following chapters look at artists, architects, and landscape architects whose works focus on reintegrating productive infrastructure back into our cities and suburbs. With green energy solutions and quality design, productive systems can once again be celebrated features on the landscape. Such a reintroduction addresses issues of social justice, environmental degradation, industrial accountability, and community interaction with sources of power and clean water, and food, and once again offers the promise of a pastoral middle landscape. In 1948, Christopher Tunnard, a landscape architect and author of *Gardens in the Modern Landscape*, argued that designers needed to search for a new landscape expression and avoid the overplayed romantic tropes of the past. In discussing the planning of national parks and the preservation of wilderness, he complained that conservationists who were against all intrusions on "the view" were being reactionary. He insisted,

> Is it not conceivable that a well-designed and well-placed building, a bridge or a road, can be an addition rather than a menace to the countryside? The truth is that where the public is admitted and encouraged, art and architecture come too, and none of the preservation schemes will be of use without them. Keeping areas of the countryside free from the horrors of unplanning is not enough. For these parks to be valuable they must cater to the needs of the community.[30]

As we shall see in the following pages, artists, architects, and landscape architects hired to work on infrastructure projects bring to their work a concern for community, recreation, aesthetics, and ecology. It is through their efforts that the middle ground with vestiges of the pastoral tradition can again become productive. In their introduction to the themed issue of the *Journal of Landscape Architecture* in December 2018, Imke van Hellemondt and Bruno Notteboom introduced the readers to debate around Elizabeth Meyer's article, "Sustaining Beauty: The Performance of Appearance: A Manifesto in Three Parts" of 2008. Meyer's subsequent paper, "Beyond 'Sustaining Beauty': Musings on a Manifesto" of 2015, and several other scholars' reactions to her writings explore issues of beauty, productivity, and landscape architecture within questions about a sustainable future. Van Hellemindt and Notteboom argue that

[30]Tunnard, *Gardens in the Modern Landscape: A New Facsilmile of the Revised 1948 Edition.* Foreword by John Dixon Hunt (Philadelphia: University of Pennsylvania Press, 2014), p. 185.

the reason why eighteenth-century aesthetical concepts of the beautiful, the picturesque, and the sublime became a point of reference, is their ability to conceptualize both the separation and the reconciliation of nature and culture. But since the nineteenth century they have been delegated, along with ecology and aesthetics, to separate domains: the sciences and the arts.[31]

The chapters above have illustrated the evolution of these now separate domains. The artists, architects, and landscape architects whose works are discussed below, are seeking to rejoin them.

[31] Imke van Hellemondt and Bruno Notteboom, "Sustaining Beauty and Beyond," *Journal of Landscape Architecture*, vol. 13, no. 2 (2018): p. 5.

7

Questioning the Infrastructure Paradigm in the Late Twentieth Century

In 1962, Rachel Carson published her groundbreaking work *Silent Spring*, a book often credited with jump-starting the environmental movement. Much of her text unveils the toxicity of industrial production in the twentieth century. But in the context of productive infrastructures and the pastoral tradition explored above, it is worth looking briefly at Carson's first chapter, "A Fable for Tomorrow." A pen-and-ink drawing encircles the start of her text. The image illustrates a pastoral idyll of farms and fields, copses of trees, and the branch of a blooming dogwood snaking across the lower half of the page. Her title, "A Fable for Tomorrow," establishes that this bucolic scene is a tale with a moral. She begins,

> There once was a town in the heart of America where all life seemed to live in harmony with its surroundings. The town lay in the midst of a checkerboard of prosperous farms, with fields of grain and hillsides of orchards where, in spring, white clouds of blooms drifted above the green fields. In autumn, oak and maple and birch set up a blaze of color that flamed and flickered across a backdrop of pines. Then foxes barked in the hills and deer silently crossed the fields, half hidden in the mists of the fall mornings.[1]

[1] Rachel Carson, *Silent Spring*, 40th ed. (Boston, MA: A Mariner Book: Houghton Mifflin, 2002), p. 1.

In the first few paragraphs Carson evokes the pastoral middle ground. Not the wilderness and wilds, but a healthy and balanced synergy between humans and nature, productive and beneficial. In so doing, she ties this image to a tradition with roots back to Virgil and *The Georgics* in which he too celebrates the beneficence of nature working in tandem with culture:

> In new spring, when from snowy peaks the run-off
> Flows, and the mouldering clod crumbles under the Zephyr,
> Straightaway I'd hitch my bull to groan before the deep-
> Driven plough, its blade scoured to gleaming by the furrow.
> That field alone fulfills the farmer's prayer
> Which twice sun and twice frost has felt:
> Its teeming harvest burst the granaries.[2]

While deeper readings of Virgil's poem identify political arguments and literary allusions, the overarching theme is about the working of the land, from plowing and harvesting to tending bees and orchards. Together with bucolic scenes, Virgil includes warnings and accounts of dangers and blights affecting crops and herds. Right away Carson echoes Virgil as her arcadian vision is blighted by death and decay: "Then a strange blight crept over the area and everything began to change. Some evil spell had settled on the community: ... Everywhere the shadow of death."[3] Like Virgil, Carson writes of blight and danger, but for Carson, these threats come from the invention and widespread use of chemicals and unchecked industry. Carson's book goes on to identify these toxins, their effects, and safer alternatives. Her reliance on the image of a pastoral infrastructure—one of bounty, productivity, and harmony with nature—is powerful in part because of its roots in such a long tradition and one that, as we have seen, is intimately tied to our understanding of landscape.

Art and Architecture in the 1960s and 1970s

While the environmental movement grew sparked by texts like Carson's and often inspired by the visionary ideas of Buckminster Fuller, the art and architecture of the period were focused elsewhere. Architects such as Paul Rudolph and Kevin Roche were exploring the powerful union of space and form, creating textured and expressive monuments to modern materials and their expressive nature. Denise Scott Brown and her husband Robert Venturi

[2]Virgil, *The Georgics: A Poem of the Land*, trans. and ed. Kimberly Johnson (London: Penguin Classics, 2010), p. 7.
[3]Carson, *Silent Spring*, p. 2.

were questioning the narrow breadth of modernism and began mining the past, commercial culture, and mundane materials for their inspiration. Rudolph did dabble in infrastructure in the designs he drew up for the Lower Manhattan Expressway project in which he united a transportation hub with parking, a rail line, pedestrian spaces, and housing all of which expanded upward in a jagged corridor of concrete. The multiuse network of spaces prefigures large-scale projects like the San Francisco Transbay Transit Center, designed by Pelli Clark Pelli architects, but Rudolph's rendering for the project suggests none of the green space and parkland included in the San Francisco project.

The oil crises of the 1970s spurred some architects to explore low-energy solutions to help address the energy issues of the day. Buckminster Fuller had been advocating for a sustainable unity between engineering, energy and architecture since the 1930s, but for many his legacy lay in his geodesic dome and ingenious engineering solutions. Figures like Paolo Solleri and his wife Colli founded Arcosanti in the Arizona desert as a site to explore solutions to the sprawl and wasted spaces of twentieth-century cities. His ideas attracted other architects interested in early efforts at "green" building but failed to attract mainstream figures such as Venturi or Frank Gehry who were more interested in exploring the theoretical ideas of Post-Modernism or Deconstruction than in low-energy architectural solutions. William McDonough began working toward a unity between environmentally friendly architecture and manufacturing as early as 1984 when he designed the new headquarters for the Environmental Defense Fund. For the project he eschewed all toxic materials and opened up the conversation about architecture's role in designing healthy buildings for a healthy planet. Such ideas led to his collaboration with the chemist Michael Braungart and the launch of their book, *Cradle to Cradle* in 2002. But it was not until the first decade of the twenty-first century that mainstream architects began to address environmental sustainability in earnest.

In the art world, figures like Andy Warhol and Roy Lichtenstein introduced Pop Art, exploring the world of commodity and commercialism. In the late 1960s, Earth Art (sometimes referred to as Land Art) was the result of artists exploring the nature of the artist and his/her works. Removing works from the context of the museum or studio, freed artists to explore "the *limitlessness*, and not the *limitedness*, of the earth" and this "was the basis of its radicality."[4] The most famous, Robert Smithson, Walter de Maria, and Michael Heizer, used the earth as their palette with sometimes massive manipulations of the landscape. Such works addressed questions of time, conceptual ideas about the nature of art and the object itself, and the role of photographs and videos as purveyors of the project. But they had little or nothing to do with ecology

[4]Amanda Boetzkes, *The Ethics of Earth Art* (Minneapolis: University of Minnesota Press, 2010), p. 18.

and environmental problems. Other Earthwork artists, such as David Nash, Richard Long, or Andy Goldsworthy used natural materials, often in ephemeral ways to explore our human presence on the earth. They too rely on the camera to record and disseminate their ideas and works.

I make no attempt here to give a comprehensive overview of Earth Art in the 1960s and 1970s. Rather, I refer to these trends to offer a brief background out of which the work of the artist Michael Singer emerged. Singer came of age in the late 1960s in the New York art scene. He received early recognition as an artist and was one of ten included in an exhibition at the Guggenheim Museum in 1971, entitled "Ten Young Artists: Theodoron Awards." This show set Singer on an enviable path into the New York City art scene. Yet the art world of New York City, gallery shows, and agents didn't sit well with him. Instead, he used the funding from the Guggenheim and moved to a simple cabin in the Vermont woods. There, as well as learning to light fires, keep warm, and chop wood, he walked the woods, watching the natural world, the way trees fell, and branches broke, the way a midnight snow would wipe away the past, presenting a sparkling new slate in the morning onto which nature's processes would paint something new. We will explore Singer's career trajectory here because while he continues to produce sculptures that reflect his interest in nature's processes, time and change, his work has expanded into wider fields including productive and regenerative infrastructures. With roots in the conceptual and minimalist trends of the late 1960s and efforts of Earthwork artists, Singer has, by means of questioning why and how things work in nature, and what human's role is and can be in the environment, forged a remarkable place for artists in the design of power plants, urban landscapes and harbor restoration power plants, urban planning, and harbor restoration.

In the 1970s and 1980s, Singer created works of sculpture that developed an intimate connection between nature and the viewer. Architecture critic Benjamin Forgey commented that "Making art for Singer becomes a sort of absorption into a place, and this is reflected in the structures he builds, not only in the materials he makes them with but also in the ways they are placed in the site, and their visual presence."[5] As Singer explains, "the description of being an artist was about searching and the asking [of] questions and the process of exploring."[6] His sculptures in the 1970s and early 1980s were often in remote sites, using materials native to the place. The curator Michael Auping remarked in 1982 that Singer's "works operate as a mirror-like

[5]Benjamin Forgey, "Art Out of Nature Which Is about Nothing but Nature," *Smithsonian Magazine* (Jan. 1978): p. 66.
[6]Michael Singer, interview with Roger Sorkin and the author, Wilmington, VT, July 28, 2011, unpublished transcript, p. 5.

apparatus, reflecting and magnifying our perception of landscape in a literal sense."[7] To this day, Singer's works are intimately related to the site, whether it is a remote garden or an industrial project. And the sensitive relationship he creates between his work and the place grows out of questions he asks about the site's history, biology, or community to name but a few considerations. In the past thirty years, Singer's art has expanded to include the design of large infrastructure projects and urban planning. At the core of these large-scale works remains Singer's deep connection with place and his understanding of nature's interconnected processes regarding water, energy, habitat, and waste. His evolution presents an impressive journey of crossing professional boundaries and collaborative processes, challenging our assumptions about what role an artist can have in society.

In 1984, Singer had a one-man show at the Guggenheim Museum, a singular honor recognizing the superb quality of his work as a sculptor. Then in the late 1980s, several events conspired to change the course of his career. In 1988, Singer was one of several artists invited by Grand Rapids, Michigan, to design a work for the city. When Singer visited Grand Rapids looking for a site, he noticed a dilapidated riverbank with a tenacious stand of cottonwood trees. He inquired about the area and was told that the Army Corps of Engineers was planning on reworking the whole area, cutting down the cottonwoods and building a flood wall. Singer asked why the trees had to go, and in keeping them, could this flood wall be smaller, occupying only the highly eroded section of the site? No one had a good answer, so Singer invited an engineer he knew, Varusian Hagopian of Sasaki Associates, to come out and tour the site with him and assess it. After Singer heard that there was no reason to lose the trees, he designed a sculptural flood wall of granite, softened by native plantings, providing a fully accessible ramp and walkway along the river. This floodwall structure also collects and filters storm water coming from paved areas above the wall. Leaving the cottonwood trees along almost one-half the originally planned site resulted in saving considerable funds that were used to provide access to the city's first accessible walkway along this riverbank. This project reclaimed an area, inviting citizens for fishing and recreation while saving a naturally occurring erosion control area of cottonwood trees. It presented an aesthetic design approach which successfully replaced the standard concrete retaining floodwall.

Singer sees this project as seminal in the development of his career. "I may have been able to ask a question but I needed other people to help me answer that question ... I needed to collaborate."[8] His teaching in the architecture

[7]Michael Auping, *Common Ground: Five Artists in the Florida Landscape, Hamish Fulton, Helen and Newton Harrison, Michael Singer, Alan Sonfist* (Sarasota, FL: John and Mabel Ringling Museum of Art, 1982), p. 64.
[8]Singer, interview with author and Roger Sorkin, unpublished transcript, p. 19.

school at the Massachusetts Institute of Technology (MIT) further inspired him to work as part of a team, and it was with the help of some of his former students that he undertook one of the most significant works of infrastructure of the late twentieth century in the United States. In 1989, the city of Phoenix set aside money for public art projects around the urban landscape. One site was the local landfill and transfer station that was overseen by a visionary public works director, Ron Jensen. One of Jensen's goals for the project was to engage people with the activities of the transfer station, to help them understand the issues surrounding both recycling and trash disposal. Singer and the artist Linea Glatt were chosen to work on the public art for the new solid waste transfer station for the city. Jensen gave Singer and Glatt the engineers' plans for the site and invited them to submit their ideas. Singer immediately asked his former MIT students to read through the engineering jargon. They reported back on the problems they found with the plans that had been drawn up hundreds of miles away from the actual site.

With the technical expertise from his former students, Singer and Glatt questioned key aspects of the plan such as the location of offices and public spaces just downwind of the trash and why interior columns were used for a space that needed an open and flexible floorplan. Through this process of questioning, the two artists found solutions. The building has been a huge success and became a place that citizens of Phoenix liked to visit. The areas of trash disposal are downwind of the public spaces, so the daily breezes blow the odors away across the desert. Singer and Glatt introduced a huge truss that spans the building and serves not only to keep interior spaces open and flexible but also stands tall against the desert as a visual landmark. Natural light and an atrium provide a comfortable space for school groups and the community to learn about the waste they produce and how it is processed. And finally, it does what Singer's work has always done so well; it focuses the visitor on the site itself. Set between the urban core, the Salt River and views of the South Mountains, the building juxtaposes the waste of the city with the dramatic beauty of the surrounding natural landscape and urges people to ask questions about their role in the production of trash and the protection of the environment. With the large open interior space and its views into the inner workings of trash and recycling processes, visitors could watch and learn about the waste they produce. In his 1993 review of the project, Herbert Muschamp, the architecture critic of the New York Times, referred to it as "an operating theater for environmental therapy."[9]

The Phoenix Solid Waste Transfer and Recycling Center was much beloved in its community. It is also a project that cost $4 million less than the original

[9]Herbert Muschamp, "Architecture View: When Art Becomes a Public Spectacle," *New York Times*, Sunday, August 29, 1993.

plans. Singer sees his collaborative, questioning approach as cost-effective. He points out, "Paying attention to the amenities and opportunities to enhance [a] facility for the community does not necessarily mean more money. And if it does mean more money you also need to understand the benefits that are coming with those enhancements and those interconnections to the community ... you have to realize its value on many levels."[10] Singer's approach caught the interest of other companies involved in sometimes controversial infrastructure projects. In 1999, he was invited to work on a cogeneration plant in Londonderry, New Hampshire. The plant owner, AES Londonderry, LLC, asked Singer for designs that would help integrate the plant into the surrounding community. Singer's plans included green roofs and living walls, glass, color, and earthworks to visually connect it to the New Hampshire landscape. He also identified the opportunity to use excess waste steam from the plant having this piped nearby for use in Stoneyfield Farms' yogurt production facility.

In 2002, Singer and his Studio presented plans for the TGE Cogeneration plant in New York City. Central to the planning of this project was the underlying question posed by Singer and his team: "Can there be a close relationship between a Power Plant and its surrounding community, a communion between functional needs and environment, natural systems and exciting design?"[11] And to skeptics worried about the extra costs associated with these additional considerations, Singer asked the executives and lawyers involved in the project, "Why can't we look at where the opportunities are in this project to make it a project that's embraced by its community rather than a project that has to be opposed and fought ... to the death?"[12] Such questioning raises issues of social justice and NIMBYism (not in my backyard) and challenges us to think beyond the mere functioning of a power plant to consider the environment and community in which it is sited. Calen Colby, a structural engineer who has worked on several projects with Singer over the years, sees huge benefits in this approach. In his words, when you work on a Michael Singer project, "you realize, 'Oh my gosh. This is ... for the good of everybody! ... It takes off on its own. You know it doesn't need a lot of money or energy, it just goes."[13]

For TGE, Singer and his design team drew up plans for a unique multiuse power station, which included using the vast roofs to collect rainwater to irrigate greenhouses that grow native plants destined for New York City's green spaces. The greenhouses in turn are heated from excess heat generated

[10]Singer, interview transcript notes, p. 35.
[11]Michael Singer, Ramon Criz, and Jason Bregman. *Infrastructure and Community: How Can We Live with What Sustains Us?* White Paper (Environmental Defense and Michael Singer Studio. 2007), p. 17.
[12]Singer, interview transcript, p. 38.
[13]Calen Colby, interview with the author, October 4, 2011.

by the plant. Solar panels produce electricity, and connected buildings house a charter school with a focus on environmental studies, recreational facilities, and even a museum featuring the history of the Bushwick Inlet where the plant is located. As we have seen, at the turn of the twentieth century, the architecture of many such infrastructure projects were a celebrated part of a city. Singer's goal is to reintroduce such projects back into the community and to prove that "Rightly imagined and effectively executed infrastructure projects can become public places of cultural understanding and symbols of the evolving relationships among natural landscapes, industrial expansion and engaged society."[14]

The Michael Singer Studio applied similar thinking when invited in 2004 by the Environmental Defense Fund to draw up plans for a Marine Transfer Station as part of wider efforts in New York City to manage the transfer of waste. These once ugly, blighted scars on the waterfront were transformed by Singer's designs. They included systems for collecting and storing rainwater which is then used to wash down the garbage trucks. Green walls and roofs filter and clean the water and provide habitats for migrating birds while photovoltaics power the facility. A dramatic, spiraling, automated ramp accommodates the garbage trucks, allowing them to turn off their engines while waiting to transfer their trash. This would end the practice of idling in long queues which contributes to air pollution and smog, a major complaint from the nearby residents. With input from the neighboring communities and a careful study of the site's ecology, Singer and his team created a design that would regenerate both the natural and the human environment.

For the past several years, the Michael Singer Studio team has been involved with a large-scale urban revitalization project with the city of West Palm Beach on the creation of a Waterfront Common Park. Once again, Singer took care to understand the history of the area, the environmental degradation it suffered, and the needs of the community. With the moving of a road and one building, the waterfront has become accessible to the public, inviting visitors to stroll the paths, sit under shaded pavilions, or access boat taxis. The Lake Pavilion, with its solar array and LEED silver certification houses a community center. One large dock has in-water planters filled with native spartina grasses, mangrove trees, and oyster beds, all easily recognized by visitors. As part of Singer's goal of regeneration, the team worked closely with the Department of Environmental Resource Management to fill a deep borrow pit in the Intracoastal Waterway with clean fill and plant the resulting intertidal mangrove islands with native grasses and oyster reefs. Such a project serves not only to beautify a site and revive a once dead area of water,

[14]Michael Singer, Ramon Cruz, and Jason Bregman, *Infrastructure and Community: How Can We Live with What Sustains Us?* (Environmental Defense Fund and Michael Singer Studio, 2007), p. 5.

but also to encourage bird habitats, natural filtration systems, and a restored fish population.

The Michael Singer Studio has several unrealized projects for multiuse infrastructure such as the Co-Generation plant for Greenpoint, New York, or a solid waste transfer facility in Manhattan. But its aim of wedding infrastructure, community, and landscape was realized recently in a Waste to Energy facility in West Palm Beach County (Figure 7.1), owned and operated by the Solid Waste Authority (SWA) of Palm Beach County. Waste to Energy is a power source frequently scorned by environmentalists who associate it with older versions of incineration, which produced dangerous levels of particulate matter, dioxins, and heavy metals. Recent advances in filters and scrubbers have resulted in much cleaner emissions, and Waste to Energy plants are extremely popular in Europe where recycling rates are high and converting remaining waste into energy saves on landfill space while providing a relatively clean energy source. The technology exists for such plants, yet few have been built in the United States.

The construction of the new SWA Waste to Energy plant in West Palm Beach is remarkable on many levels, the first and foremost that it was built at all given that many environmentalists, such as the Sierra Club, oppose the technology. They argue that it decreases recycling and composting efforts and instead support the goal of zero waste. While concerns about toxic ash need to be seriously addressed, the contention that Waste to Energy reduces recycling rates is not borne out in places like Denmark or West Palm Beach. On the contrary, recent research has shown that while recycling rates are similar in Denmark and the United States, only about 4 percent of Denmark's waste ends up in landfills, while in the United States, over 50 percent of our waste is sent to landfills. Landfills are significant producers of methane, a major greenhouse gas. While zero waste and a circular system of materials such as those McDonough and Braungart promote are crucial goals to aim for, Waste to Energy is considered to be a reasonable and workable interim solution to the duel problems of waste disposal and energy production. China's recent ban on the import of materials for recycling makes Waste to Energy an even more relevant solution as we work toward a zero-waste goal.

The SWA Waste to Energy plant is remarkable as it realizes several of the goals expressed by Michael Singer since his early work on the Phoenix Transfer Station. Access to the plant is via a long road off Highway 710. Sited less than two miles away from the luxury Ironhorse Community, preserve, and golf course, the plant sits beside the Grassy Waters Preserve, a 23-square-mile conservation area that offers bird watching, trails, and kayaking. Bioswales and a catchment pond planted with native species surround the visitors' center, while a solar array shades cars in the parking lot and powers the communal spaces. A green roof on the visitors' center

FIGURE 7.1 *Palm Beach Renewable Energy Facility no. 2 & Education Center, West Palm Beach, Florida. Artist/Designer: Michael Singer. Singer Studio Project Manager and Environmental Designer: Jason Bregman. Michael Singer Studio Project Team: Jonathan Fogelson and Colby Co Engineering. SWA Core Team: Mark Hammond, Dan Pellowitz, Patrick Carroll, Ray Schauer, Marc Bruner, Bob Worobel, and Malcolm Pirnie. Arcadis Engineering Project Team: Leah Richter, Tom Henderson, Joseph Krupa, Jason Rivera, Nichole Lynch-Cruz. Interactive Educational Exhibits: Potion and Art Guild Team. Construction: B+W Team including KBR and CDM. Patricia Fallon, Photographer.*

filters rainwater as it progresses toward the bioswales. Upon entering this structure, a long, interactive table, designed by Potion and Art Guild, challenges visitors to show off their knowledge about recycling, encouraging a friendly competition as to who can recycle how much in a short period of time. Exiting from the second floor, tours are guided along a covered bridge toward the plant itself, past a lush green wall of vines that serves to soften the industrial walls of the building. A large air-cooled condenser cools and reuses water on site. Together with a rainwater system that stores two milllion gallons of water and waste water from an adjacent facility, the facility uses no potable water, and does not draw from Florida's sometimes scarce supply. A viewing platform within the plant offers views into the massive refuse pit where large claws lift five tons of trash at a time into the burner. But if the visitor turns away from the refuse pit, they are greeted with views of the Grassy Water Preserve and can watch herons, flocks of birds, and deer in the landscape.

The proximity of this plant to both a wildlife preserve, and an upscale neighborhood speaks to the success of the clean burning technologies and the careful management of waste and recycling as it is processed here. The Michael Singer Studio guided the environmental, educational, and aesthetic aspects of the project from planning though construction, working directly with SWA and Arcadis Engineering. The Studio was involved in the landscape design and supported the educational aspects of the project as worked out by Potion and Art Guild that created informative and educational signage and interactive spaces to engage the public and educate them about waste and recycling. They also were instrumental in designing the emissions stack as an oval, thus reducing its visual impact on the landscape. The result of collaborative discussions and questioning the status quo of infrastructure design, the facility breaks new ground in the United States for both its state-of-the-art technology and low emissions and its inviting, interactive, and educational spaces. It is a source of pride for the community alongside a favored recreational site, and thus its presence in the landscape is not seen as a negative and has not deterred residences from building homes and playing golf in the nearby Ironhorse community.

As a young man in the 1970s, Singer decided that "making art was a process of questioning."[15] He has thought long and hard about the role of the artist in our culture and believes that an artist can have a proactive place in society, pushing us to question our assumptions. In his early works in remote environments, he wrestled with the interaction between humankind and nature and realized that "You're either controlling, ... manipulating it, you're managing it, or you're observing it. But how are we interconnected to

[15]Singer, interview transcript, p. 4.

it?"[16] As he grew to understand how cultures are always intervening in the natural world, he began to recognize that his role as an artist should be to make those inevitable interventions regenerative rather than destructive. That questioning led him to ask more questions about the role of art in the world, and how an artist's probing might save a stand of cottonwoods or restore an oyster habitat. Singer's art is still a process of questioning, now often on a very large scale, and it acknowledges the need for collaboration with policy makers, biologists, social anthropologists, engineers, and whatever experts the project demands. He continues to create powerful sculptures in his studio, complex constructions that explore issues of balance, form, and texture, and whose intricate layerings hint at archeological explorations. But early on he understood, as scholars like Simon Schama have argued, that humans have been managing/controlling/affecting the land from the very beginning. Wilderness, untouched and unspoilt by humans, is a historical construct. By accepting this, Singer began to question how to regenerate a landscape—not by erasing human's presence, but by offering restorative and beneficial solutions to it.

For Singer and his team, infrastructure has a responsibility to give back to the community.

> The next generation of energy sources, water systems and waste facilities must be conceived of with the assumption that infrastructure represents an asset in each and everyone's community …cooperation among communities, government officials and development agencies, … can promote environmental justice, generate ecological renewal, inspire civic responsibility and enhance quality of life without sacrificing economic viability.[17]

Singer has not been the only artist to engage in regenerative landscapes or probing questions about an artist's role in our environmental crisis. But the scope of his and his Studio's work into the realm of infrastructure has been groundbreaking. Their determination to weave the machine back into the garden, to address vital questions about infrastructure's role in society— questions that upset the status quo and yield beneficial results has been contagious. In Singer's works and goals, one is reminded of Thomas Cole's or Asher Durand's paintings such as *River in the Catskills*, where the pastoral middle ground of a productive balance between humans and nature is played out. Into these landscapes, artists wove the new railroads, heeding Emerson's

[16]Ibid., p. 9.
[17]Singer, Cruz, and Bregman, *Infrastructure and Community,* p. 5.

call for artists to make beautiful these burgeoning technologies. Singer, via his private journey as an artist, seeks to weave infrastructure, community, and nature into a productive pastoralism for the twenty-first century. The Michael Singer Studio has been seminal in framing new questions about what infrastructure can be today and in the future.

8

Twenty-First-Century Power Generation: An Invitation to the Public

In his discussion of infrastructure and its conceptual roots, Mitchell Schwarzer outlines the isolated nature of much post-war infrastructure of the twentieth century, pointing out that this disconnect "reduced the role of aesthetic and holistic considerations and the involvement of architects and everyday users."[1] Without the connection to these systems that provide us with our energy, clean water, food, and transportation, the public loses touch with the sources of those vital commodities. They are seldom aware of where and how their energy is produced or their water comes from, until, as was the case in Flint, Michigan, people become ill. Those that manage these almost invisible systems have little accountability to the public who are content to sideline such infrastructure as an ugly necessity. But as Schwarzer points out, "it is the invisibility of the systems that sustain our splendid artificial environments that leads to the neglect of ambient nature, urbanity, and infrastructure itself."[2] To resolve this problem of invisibility and neglect Schwarzer posits,

> if infrastructure design and construction is to expand its purview to its social and natural effects, it must be recalibrated from unnoticed background to conscious foreground, from linear networks to encompassing landscapes. For too long it has been our proclivity to be served by systems and yet be

[1] Mitchell Schwarzer, "The Conceptual Roots of Infrastructure," in *Intelligent Infrastructure: Zip Cars, Invisible Networks, and Urban Transformation*, ed. T. F. Tierney (Charlottesville: University of Virginia Press, 2016), p. 56.
[2] Ibid., p. 57.

largely disconnected from their residual consequences. But is an outward-looking gaze upon the full infrastructural landscape likely?[3]

While Schwarzer is concerned with digital infrastructures of communication and transportation, the growing trend of productive infrastructures answer his question in the affirmative. As we shall see, the examples below are conscious attempts to bring power generation, water treatment facilities, and agricultural systems into a visible and celebrated middle ground, thereby increasing our awareness of such systems, and holding them accountable for producing our green energy, clean water, and healthy food.

In her comprehensive study of *Next Generation Infrastructure*, Hillary Brown outlines the need and increasing development of "community-friendly infrastructure."[4] Written to inspire planners, municipalities, and government entities, she defines the need for an infrastructure that "exceeds public health codes and regulatory requirements" but also includes community input, artistic and architectural ingenuity and design, educational messaging, and collaboration that ensures the health and well-being of those effected by the projects.[5] When infrastructural planning is shared and elements of the project meted out to architects, artists, and landscape architects, the result is, as we shall see, an infrastructure of inclusion, of beauty, history, recreation, and civic pride. As such, these projects, while upsetting the traditional twentieth-century paradigm for such infrastructure, have roots deep in a longer tradition wherein infrastructure, that which sustained and brought prosperity to a region, was a celebrated, integrated element of society.

A relatively early project is the Naka Incineration Plant in Hiroshima City, Japan. The city chose Yoshio Taniguchi as the architect of the project. This is a remarkable project for an architect who is best known for his sensitive and beautifully subtle addition to New York's Museum of Modern Art. While incineration is a controversial method of waste disposal, in 2004, when the plant was built, the City had a garbage issue that needed an efficient solution. The site chosen abuts the sea. Rather than obscure the view, Tanaguchi designed the plant as a physical and visual link between the city and the park along the coast. Visitors walk up and through the plant, watching and learning about the amount of waste they create and its ultimate destination. Tanaguchi used a material palette of glass and steel to enhance visibility, providing views both into the incinerator's processes and through the building to the sea

[3]Ibid., pp. 57–8.
[4]Hillary Brown, *Next Generation Infrastructure: Principles for Post-Industrial Public Works* (Washington, DC: Island Press, 2014), p. 97.
[5]Ibid., p. 100.

beyond.[6] There is an honest transparency enhanced by the materials that does not hide, but rather celebrates, the nature of the building and its civic role. As in Singer and Glatt's Transfer Station in Phoenix, this honest expression is educational and architecturally inspirational.

The firm of C. F. Møller has a long and successful history in Denmark. Founded in 1924 by C. F. Møller, it has grown and flourished, becoming a leading firm in Denmark with offices across Scandinavia and in London. Since the early 2000s, C. F. Møller has taken on a wide range of infrastructure projects as part of an overarching goal to create an architecture of "social innovation"[7] wherein buildings and infrastructure perform on multiple levels and give back to the community. The firm is responsible for a wide range of building types, from housing and schools to power stations, museums, and master plans. Several of their projects are relevant to this discussion as they illustrate remarkable efforts to integrate productive infrastructures into the landscape with expressive and responsive aesthetics.

Around 2010, the Danish parliament passed a resolution to upgrade the visual appeal of Denmark's power grid. As a relatively small country with a long tradition of socially responsible building and infrastructure, this goal is in keeping with the overall approach to both the urban and rural landscape. C. F. Møller designed a new gas-insulated switchgear station for the national energy transmission company Energinet.dk. Traditional switchgear systems are responsible for the protection and control of the electricity grid. Like a giant fuse box, these units are often large, and set in the open landscape, a complex web of wires, steel trusses, and circuit breakers. For Energinet. dk, C. F. Møller was asked to design a gas-insulated switchgear station. The gas-insulated variety allows for these units to be slightly smaller and thus can be housed within protective cladding. For this GIS station, the firm designed a series of encompassing blocks clad in weathered zinc, which straddle the equipment inside and are angled in such a way as to create a jagged silhouette. The sides of the framing walls were then cut away, offering glimpse of the equipment within. Walls and roof seem to stand tiptoe over the station like folded origami paper, allowing golden triangles of light to break up the façade. Such an architectural treatment inserts an artistic veil over a mundane yet vital energy fixture—a striking intervention in the landscape that does not hide the functions within but couches the severity with a visual drama.

In a similar vein, C. F. Møller designed a natural gas compressor station again for the national Energinet.dk (Figure 8.1). This is a plant that is traditionally hidden and isolated due to the hazardous nature of compressed gas. To keep

[6]Fred Berstein, "Beauty in Garbage: Naka Incineration Plant by Yoshio Tanaguchi," *ArchNewsNow. com,* Nov. 9, 2004. http://www.archnewsnow.com/features/Feature152.htm.
[7]Julian Weyer (Partner, C. F. Møller), phone interview with author, Jan. 25, 2018.

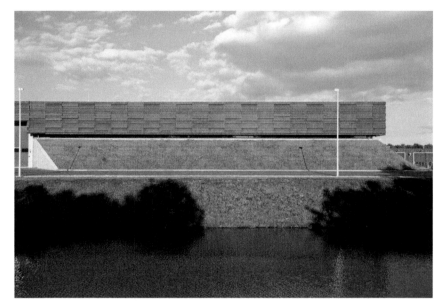

FIGURE 8.1 *C. F. Møller Architects, Compressor Station Egtved, 2010–14, Egtved Denmark. Photographer, Julian Weyer.*

the public safe while creating a structure that fits within a more urban setting, the firm set the plant behind a watery moat system, and then within a grassy berm. Rust-colored COR-TEN steel walls arranged in a faceted pattern seem to hover above the greensward separated by a sliver of clerestory windows that provide natural light to the interior. The blocky contrast between the flickering surface of the moat, the vibrant green of the berm, and the fractured surface of the steel provides a striking vision of layered horizontals. Issues of safety and protection are welded to a dramatic and aesthetically considered composition.

C. F. Møller is also responsible for the designs of a new cogeneration heating and power plant in London. Cogeneration is a process of utilizing the energy from steam production to create electricity and then using the waste heat for heating needs. The Greenwich Peninsula Low Carbon Energy Center (Figure 8.2) is part of a new development on the Peninsula which will eventually include 15,700 new homes as well as mixed-use spaces. Due to be completed in 2030, bike lanes and shady parks already link apartments, schools, and the new energy plant, the largest newly built heating network for homes in Europe. The Energy Center sits on a tight lot between the growing residential area and a primary school and the heavily trafficked Blackwall Tunnel highway. For the plant, C. F. Møller encased the machine rooms, administration, and visitors' center within a sleek black steel box. Large windows on either end of

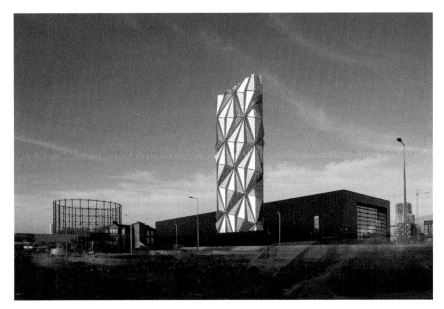

FIGURE 8.2 *C. F. Møller Architects, Greenwich Peninsula, Low Carbon Energy Center, 2008–17. Conrad Shawcross, Optic Cloak. Photographer: Mark Hadden.*

the building light the interior spaces, such as the visitors' center—a two-story space with white walls that offer a sleek contrast to the solid black of the exterior. Standing tall above this structure are a series of nine chimney stacks. These stacks stand guard over the busy highway on the southwestern side of the building.

The original plan included a heavy steel casing over the chimneys. But this proved unsatisfactory, and the project was set forth as a design competition for the chimney casing. The artist and sculptor, Conrad Shawcross, won the competition with designs for a lightweight and visually dramatic tower, called the *Optic Cloak*. Using perforated steel for transparency, Shawcross employed a series of triangles that angle up the sides of the tower, some of which pull out from the surface, while others recede inward. The effect is a crinkled and folded surface that plays with reflective light and transparency. As cars drive by and the sun moves across the sky, the forms shift, creating a varied sculptural surface. In a TEDx Talk from 2016, Shawcross called the project an "artistic response to a problem"[8] in which he had to take into account the functional requirements of the tower, including the chimneys

[8]GreenPen.London, "Low Carbon District Energy Centre," May 27, 2015. http://www.greenpen.london/blog/district-energy-centre.

and ladders within, flexibility for future changes, and a lightweight surface to reduce the energy used in production and materials. He researched ideas surrounding camouflage, looking back to techniques from the First World War of ships and planes painted in zebra patterns. Such patterns, when viewed from afar, broke up the surface of the object thereby obscuring its location and form. Shawcross also studied the history of towers and how they played a crucial role in identifying distance and location. With these influences, he created a landmark that shifts and changes while providing a distinguished marker on the horizon. In the tradition of Michael Singer, the work is the result of collaborations between the artist, architects, engineers, and materials manufacturers. Together, they transformed an infrastructural heat-and-energy plant into a shimmering node on the horizon.

Julian Weyer, a partner in the firm, is deeply involved in the planning and development of many of the firm's infrastructure projects. He articulated the firm's interest in these projects in an interview with the author:

> The key is that we see any project as having a potential of benefitting our society (or people & planet, broadly speaking)—this means there is no limit in terms of typology to where we as architects can make a difference, given the chance. Combine this with our love for cross-disciplinary thinking, especially integrating landscape and architecture as closely as possible, these kinds of projects actually are a welcome challenge. We don't have solutions in mind when we set out, rather each design is the result of understanding the site, the functions, the possible added-value to the surroundings, and very much also the people that will use these installations—we always design them for humans, even if they are primarily filled with machinery.[9]

Denmark is an understood leader in the development of clean energy systems and infrastructural aesthetics. Perhaps due to its small size, the intersection of architectural solutions and infrastructural problems has been the purview of Danish firms for decades. Ingrained is the notion of giving back to the community, creating visual and contextual solutions that weave power and water treatment plants, GIS, or compressed gas substations into the rural, suburban, or urban landscape.

Another Danish firm that is very involved in infrastructure projects is Gottlieb Paludan Architects. They too have a long history of work in the field and specialize in infrastructure from bridges and light rail to power and water treatment plants. While their oeuvre is extensive, we will look at two particular projects here that illustrate the firm's approach to the design of power

[9]Julien Weyer, correspondence via email with author, June 21, 2018.

plants. Jesper Gottlieb is the creative director of the firm. He is passionate about infrastructure and the crucial role it plays in moving toward a greener energy grid. Architects, he believes, can create efficiencies and a public face for infrastructure that are often lacking in a work of pure engineering. Increasingly, energy companies are bringing architects to the table because they want to feature their plants, highlight the new energy source or high-tech engineering that results in a reduction in greenhouse gas emissions. The architects interviewed for this book spoke again and again about the ways in which they approach a project and by understanding the issues involved from a broad perspective, they go on to create works that meet programmatic requirements with greater efficiencies while reaching out to the public and offering educational and sometimes recreational spaces.

For example, construction is underway at a new biomass plant in Copenhagen called BIO4 (Figure 8.3). Located in the Amager district, a traditionally industrial site, Gottlieb Paludan Architects have designed the master plan of the area together with a new cogeneration plant powered by wood chips. The wood is purchased from a variety of timber companies keen to sell the otherwise waste material. The use of wood is part of a wider plan enacted by the city of Copenhagen to be carbon-neutral by 2025—the first European capital to do so. Wood chips are an efficient source of energy and are clean burning relative to oil, coal, or natural gas. To recognize the role of

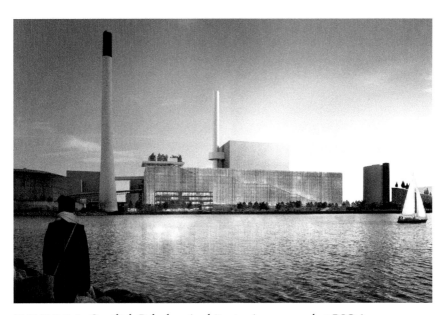

FIGURE 8.3 *Gottlieb Paludan Architects, Amagevaerket BIO4, Copenhagen, 2020. © Gottlieb Paludan Architects.*

trees in this plant, Jesper Gottlieb designed the exterior as an artificial forest. The silvery brown walls are hung with approximately nine thousand eucalyptus trunks. The trees are suspended above and around external walkways for visitors to walk through a newly created forest, looking out between the textured columns to the watery landscape of the Oresund Straits beyond. The exterior cladding pays homage to the source of heat and electricity produced within. To accommodate changing energy sources, when the wood fuel has been replaced by future energy sources, the suspended trunks will feed the furnaces for the final burn.

This unique system of wood cladding works on a number of levels. As mentioned above, passage through this artificial forest is an expressive and metaphoric means of referencing for the residents of Copenhagen, the source of energy used in the plant. The referential wood also serves to warm and soften the façade of this industrial structure. The site on Amager island has long been industrial. It sits on a small peninsula, surrounded by water on three sides. As Copenhagen grows, housing is moving into the area. To the south, water-ski jumps dot the watery landscape. To the north, the area of Refshaleøen was once an industrial site but is now a burgeoning hotspot with cafes, bars, and an active music venue. Just inland from the site is a large housing complex. And to the east, the horizon is lined with large wind turbines, symbols of Copenhagen's green ambitions. Thus, the site of BIO14 is crowded with an encroaching urban fabric. Gottlieb's forested façade does more than reference its power source. It adds the warmth of bleached eucalyptus, creating shadows that play across the surfaces, and light up at night with a warm, natural glow. The idea of highlighting infrastructure that we saw in earlier projects such as the R. C. Harris Water Treatment Plant in Toronto of 1926, is revisited here. Visible from numerous angles and urban spaces, it offers an enriched landscape. In a tour of the site with Gottlieb, he referred to the pastoral tradition. And here we see again the productive middle ground of the pastoral, with architectural features that celebrate new technologies and cleaner energy sources, inviting the public to visit and learn in the midst of an increasingly popular scene of recreation, housing, and entertainment.

Gottlieb Paludan Architects' goal for infrastructure is to create lasting and flexible buildings that can adapt to change. In all their work, they take care to give back to the community.[10] Jesper Gottlieb strives to create infrastructural buildings that are "discreet and elegant,"[11] and appropriate to their purpose. Quality of form and materials are vital to him and his design ethic. On a very

[10]Gottlieb Paludan Architects, *Energy and Utilities*, trans. Birgit Ducasse (Copenhagen: Gottlieb Paludan Architects A/S, 2017).

[11]Jesper Gottlieb, quoted in "The Beauty of the Underplayed" (check translation) by Kamilla B. Kjaegaard, *Byggeri & Arkitektur*, https://byggeri-arkitektur.dk/Skoenheden-i-det-underspillede. Accessed June 2018.

small scale, a Peak Load Station at the airport in Copenhagen illustrates the firm's high standards. Here, Gottlieb raised the ground like a peeled skin and inserted the mechanical spaces of the small plant which are visible through a wall of glass. The sides and roof slope back to the land creating a green roof planted with sedums whose colors change with the seasons. Three oil and water tanks and three slim chimneys jut up from the sheltering roof, announcing the industrial nature of the structure. Even here, in this small station set apart from the bustle of the terminals, Gottlieb took pains to create a visually impressive site. At night when flying over, the orange paint of the tanks shimmers in the light, creating a fire-like glow emerging from the surrounding grassy meadow.

Gottlieb Paludan Architects have recently partnered with the Danish firm Schmidt Hammer Lassen Architects to design the world's largest waste-to-energy plant in Shenzen, China (Figure 8.4). After winning the commission via an international competition, the firms have devised a scheme for a massive circular structure set within a hilly and wooded area just outside the city. Set to burn five thousand tons of waste per day, this is only one-third of the waste produced by the twenty million residents of the city. The circular form breaks out of the traditional boxy nature of such plants. The large roof is slated for a substantial solar array to provide more clean energy to the city of Shenzen.

The circular form is clad with aluminum fins, angled at 45 degrees. Between these slats, glass and ventilation screens bring natural light to the interior and

FIGURE 8.4 *Gottlieb Paludan Architects and Schmidt Hammer Lassen Architects, Shenzen East Waste-to-Energy Plant, Shenzen, China, 2020.* © *Gottlieb Paludan Architects, Schmidt Hammer Lassen Architects and Beauty and the Bit.*

offer glimpses of the inner workings to those walking outside. Inside, visitors can walk the circumference of the plant to watch and learn about the sorting and using of waste for recycling and energy production. In addition to the interactive and transparent structure and its workings, the architects designed the chimneys as monumental columns framing the visitors' entrance. Like ancient gates before a fortress or palace, the chimneys create a processional approach to the building. The landscape design mirrors the circular nature of the plant itself, with arcing walkways and water features that radiate out from the plant like ripples in a pond. Trees and plantings provide visual links with the surrounding woodlands. From viewing stations within the building, visitors can see into the forests or look toward the city of Shenzen. These views suggest a reciprocity—just as a visitor looks out from the plant toward the city or woods, so too can city residents or nature lovers see the plant both from the urban and wooded surroundings. Thus, once again, the plant sits in the middle ground, a productive pastoral feature visually connected to both the cultural hub and the wilderness. Within this space the plant represents positive developments in energy production and a reduction of greenhouse gases. It offers educational opportunities within the recreational area of the forest. Like Fairmount Park in Philadelphia, such a project is a source of pride and optimism for the populace, a place to explore the natural world and to learn about how to protect it. It is a site of transformation: of waste into energy, of the ugly into the beautiful, of discarded goods into electric light.

There are several features of the new plant that are striking in light of our discussion of the pastoral tradition. Sited in the middle ground and surrounded by the natural world, it reimagines what an industrial site can be. In a similar vein, Grimshaw Architects designed the Energy from Waste facility in Great Blakenham, Suffolk, England (Figure 8.5). Increasingly, waste to energy has become an attractive energy source in England as the cost of disposal in scarce landfills has gone up. Grimshaw Architects was brought into the project to design a waste-to-energy plant in the rural Suffolk countryside. It was originally understood that the role of the architects here was to "prettify" the building to make it more palatable for the local residents. Set within the traditionally pastoral English countryside, the site is surrounded by fields and pastures and the village of Great Blakenham. Residents were concerned about traffic, noise, and smells as well as the intrusion of such a plant on their bucolic views. Lead architect Kirsten Lees, together with Andrew Usher of Grimshaw, worked to create greater efficiencies in haulage and traffic patterns. They shifted the orientation of the plant east-west, thus increasing the safety of the workers and created views for visitors across the Gipping Valley while creating a welcoming, transitional forecourt with a pond and projecting visitors' block. It was important to the architects that they honestly express the nature of the building while making it an aesthetic feature in the

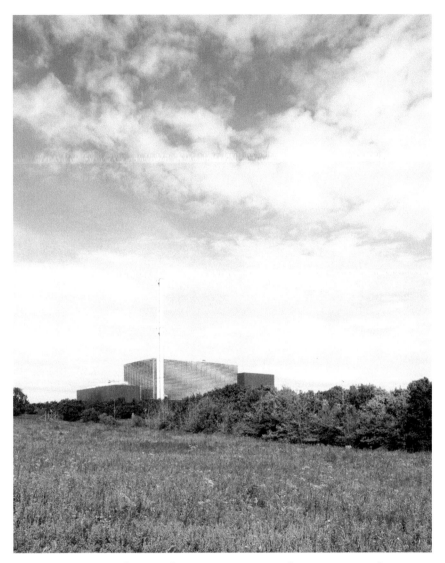

FIGURE 8.5 *Grimshaw Architects, Suez Energy-from-Waste Facility, Suffolk, UK. © Photographer, Jim Stephenson.*

landscape. Andrew Usher asserted that they strove to create a "confident expression of power"[12] by both featuring and softening the industrial innards. This they did by adding a series of louvers across the facades, which provide visual access to the inner boiler while catching the light and creating a rich play of shadows across the façade. The colors of the louvered cladding seem

[12]Andrew Usher and Kristin Lees, interview with the author, June 4, 2018.

to change as the sunlight passes over and the soft blues and greys contrast with the greens and yellows of the neighboring meadows and pastures. Like at the Shenzen plant, Grimshaw sought to both declare with bold honesty the nature of the structure in the landscape, while bringing warmth and visual interest to such a project.

One of the most striking waste-to-energy plants to go up in Denmark, indeed in the world, sits beside Gottlieb Paludan's BIO4 plant. The Amager Bakke waste-to-energy plant (Figure 8.6), designed by Bjark Ingels of the Bjarke Ingels Group with the assistance of SLA Landscape Architects, consists of a silvery checkerboard of steel and glass rectangles with curved corners. The steel panels pull out from the windows providing a textured pattern across the façade. The rectangular footprint has a sloped roof that turns back upon itself as it descends toward the ground to the north. One tall chimney stack pulls out from the eastern side, a sleek steel column creating a landmark on the Copenhagen skyline. Like the BIO4 plant or Shenzen, visitors are invited in to view the inner workings of the plant and learn about its efficiencies. Sophisticated technologies in the burning process remove dioxins and provide a 99 percent reduction in hydrochloric acid. CO_2 emissions are reduced by hundred thousand tons, while NO_x and sulfuric acid are reduced by 96 percent and 95 percent, respectively. These are the sort of facts that visitors are given when they tour the facility.[13]

As mentioned previously, while the Amager area boasts several recreational and leisure options and is growing in popularity, what is unusual here is the integration of recreational facilities and the plant itself. While the innards process waste and create electricity, the extensive and sloping roof, designed by SLA landscape architects, hosts a myriad of activities, from hiking trails and a playground to a climbing wall and all-season ski slope with both beginner and advanced slopes. Trees and plants provide shade and wind protection with hiking trails winding through them. A ski lift brings skiers to the top of the structure where they ski down over grass and a specially designed artificial turf. The landscape architecture firm describes the plantings on the roof as "seed bombs"[14] which aim to increase plant life and biodiversity in the area as the flowers and trees disperse their seeds in the wind. The challenges of creating an artificial mountain atop a waste-to-energy plant have been enormous, but the promise of such a site has encouraged residential development in the area. Indeed, a new housing block just east of the plant was designed with open spaces which frame views of the facility. The paradigm for a power plant has been turned upside down. Rather than a threatening eyesore, hidden

[13]Amager Resource Center Amager Bakke, https://www.a-r-c.dk/amager-bakke#r%C3%B8grensning. Accessed Aug. 2018.
[14]"AmagerBakke," SLA website, http://www.sla.dk/en/projects/amagerbakke. Accessed Aug. 2018.

(a)

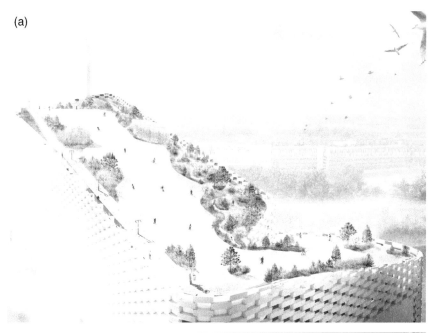

(b)

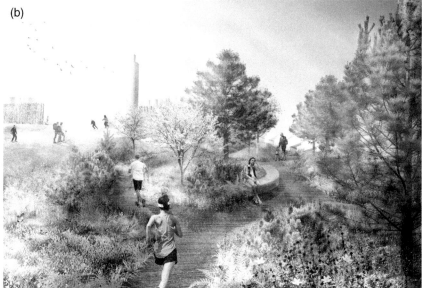

FIGURE 8.6 *a and b: Bjarke Ingels Group and SLA Landscape Architects, Amager Bakke Waste-to-Energy Plant, Copenhagen, 2018.*
© *Illustration by SLA Landscape Architects.*

from view or placed in an underserved neighborhood, the plant is integral to the regeneration of the area. Not only will the landscaping around the facility offer recreational activity, trails, and kayaking, the plant itself becomes part of the landscape. This reimagining of the machine in the garden realizes Marx's and Emerson's call for artists to integrate the two. The pastoral middle ground snakes up the building providing an interactive space for the public to learn from and enjoy the benefits of such a space.

While architects and designers have explored exciting means of uniting clean energy sources within the landscape, few have tackled the issue of solar power head on. Solar farms are sprouting up across the world, spreading over deserts and farmlands, creating electricity and revenue for landowners and concern from some environmentalists and landscape architects. Indeed, the genesis of this study has roots in the objections of neighbors over a proposed solar farm on an old landfill. Rows of solar panels surrounded by chain-linked fences do little to create a welcoming pastoral middle ground. Some artists have suggested solar panels arranged as flowerlike trees in the landscape. In China, a huge solar farm resembles a panda from the sky but does not have much visual effect on the ground level. The challenge is the repetitive nature of a photovoltaic array and the need for vast open spaces with good southerly orientation. In some instances, farmers let goats and sheep graze beneath the panels and experts in permaculture are experimenting with ways to grow foods within the arrays. But an artistic and welcoming arrangement of this burgeoning energy source has remained elusive.

One landscape architect to take up the challenge is Walter Hood. Based in Berkeley, California, Hood has an extensive practice in park design and urban landscapes. His work includes installations, artworks, and sites of memory and commemoration, such as the Rosa Parks Neighborhood Masterplan. In 2010, the University of Buffalo staged an international competition with the goal of integrating their newly acquired five thousand photovoltaic panels into a work of public art. Walter Hood won the competition with a design that honestly and openly weaves rows of panels into the landscape. From above, the alignment of the "Solar Strand" (Figure 8.7) resembles a strand of DNA, "the genetic code to all human life."[15] From the ground, lush meadows of native plantings surround stone and gravel pathways in and around the arrays. In some places, the stone paths open into wider spaces and serve as outdoor classrooms where flora, fauna, and energy production are studied. A campus app connects you to real-time energy production. The "Solar Strand" marks the entrance of the University, thereby proclaiming its commitment to green energy supplies and to meeting the American College and University Presidents' Climate

[15]Catherine Slessor, "Energy in the Landscape: Turning a Solar Array on a US Campus into Land Art," *Architectural Review*, vol. 228 (Oct. 2010): p. 38.

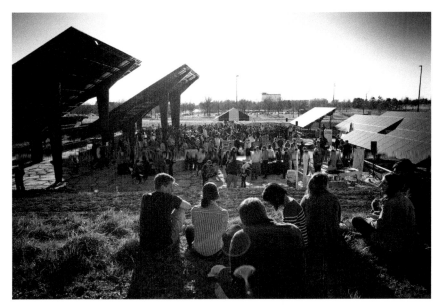

FIGURE 8.7 *Walter Hood Studio, "Solar Strand," University of Buffalo, Buffalo, New York, 2012. Courtesy of University of Buffalo. Photographer, Robert Shibley.*

Commitment of 2007. Without chain-link fences the Strand invites visitors to sit, walk, and learn amid this increasingly vital energy source. Hood's honest expression together with the simple paths and plantings creates a bucolic space wedding education, power, and landscape.

While the projects above are built or under construction, many architects, engineers, and entrepreneurs are imagining exciting and inspiring new forms of energy production. For example, Ray C. Anderson was the CEO of the carpet company, Interface. Over the years he worked with William McDonough and Michael Braungart to create Cradle to Cradle Certified carpets. As a businessman intent on weaving design excellence and sustainable practices, Anderson was a pioneer in greening his industry, supplying recyclable carpets to the Adam Joseph Lewis Center for Environmental Studies at Oberlin College. Opened in the year 2000, and designed by William McDonough, the building introduced a radically new approach to building science by creating its own energy, cleaning its grey water on site via the Living Machine by John Todd, and creating a productively pastoral landscape with fruit trees and solar arrays flourishing side by side. Anderson supplied the carpeting and upholstery for the Center and incorporated a system of carpet recycling considered novel at the time.

Anderson died in 2011. To honor him and his pioneering spirit, his family founded the Ray C. Anderson Foundation, to be a catalyst for daring and

exciting environmental solutions to our various environmental crises. One such project, funded and propelled forward by the Foundation is the Solar Ray, named after Anderson. This is an eighteen-mile stretch of highway in Georgia designed as an experimental site exploring the potential for energy-producing highways. This short stretch is lined with special solar tiles laid down over an existing roadway. The tiles, Wattway by Colas, were manufactured in France and installed by Hannah Solar. This is an experimental technology designed to produce electricity both as cars pass over it and when empty of cars, via the sun. The leaders of the Ray C. Anderson Foundation understand the potential of turning our vast network of roads into productive infrastructure. Along the route of the Ray are charging stations for electric cars, experimental farming of Kernza wheat, a specially engineered crop with deep roots and the ability to filter storm run-off, verges filled with wildflowers to attract pollinators and the reuse of old tires as part of the pavement to decrease noise and extend the life of the roadway.[16] The solar-powered highway has faced questions about expense and durability in the long term. But the Ray is intended as a laboratory for innovative thinking and is an example of an experimental infrastructure that is both multiuse and productive.

The Swansea Bay Tidal Lagoon was a proposal for a tidal range power station. While tidal power is still in its infancy, it has been a successful power source in the Sihwa Lake Station in South Korea, which is the largest such station in the world. This hosts a small, ecotourist wetland area for water sports, but the plant itself is a no-nonsense infrastructural system. In contrast, plans for the Swansea Bay Tidal Lagoon included a long causeway for tourists, bicyclists, and school groups who would learn about tidal power in the visitors' center which was designed as a destination by JUICE Architects. LDA Design was responsible for the masterplan and consultation work. The inner bay was to host a myriad of water sports, while the aboveground pathways over the infrastructure of the turbines served as a part of a new seaside park for residents. The projected energy production was estimated at 500 GHW per year, enough to power 90 percent of the nearby homes. Just recently, the British government shelved the plan due to exorbitant costs. Yet, the concept of a multiuse infrastructure, productive and welcoming is part and parcel of this new approach to infrastructural design, and the role of the architects and landscape architects is crucial in integrating the two.

The Land Art Generator Initiative is the brainchild of Robert Ferry and Elizabeth Monoian. An architect and artist, respectively, in 2008, the pair were inspired to found the Land Art Generator Initiative as an incubator for fresh approaches for clean energy and water production. Every two years in different

[16]"The Ray Today," The Ray, http://theray.org/technology/the-ray-today/. Accessed Aug. 2018.

TWENTY-FIRST-CENTURY POWER GENERATION

cities, the LAGI puts out a call to artists, engineers, landscape designers, and architects to submit innovative designs for particular issues. For example, in 2016, Southern California was the site for designs as varied as the winning entry, "Regatta H2O" by Christopher Sjoberg and Ryo Saito wherein giant sails of mesh were planned to capture the fog and harvest clean water while powered by a "Windbelt." "The Pipe" was designed by Khalili Engineers to rest just off the Santa Monica pier. There it would desalinate sea water while providing an interactive and educational destination for visitors in sea kayaks. The competitions held by LAGI serve as catalysts for new ways of thinking about productive infrastructures, and entries illustrate often thrilling unions of art, community, and infrastructure. They consistently imagine productive pastoral landscapes, in which "Art always reflects society—whether past, present or future—and serves a function by showing us ourselves as we are (and as who we might become)."[17]

[17]Elizabeth Monoian and Robert Ferry, *Powering Places: Santa Monica. Land Art Generator Initiative* (Munich: Prestel Verlag, 2016), p. 6.

9

Clean Water and Recreation: New Approaches to Water Treatment Plants

While LAGI proposals address a range of projects from power production to clean water, the following are completed or nearly completed projects that process and clean their community's water supply. These are sophisticated engineering works wherein architects, artists, and landscape architects have worked with engineers, hydrologists, and municipalities to create inviting, didactic spaces around vital hydraulic infrastructure. The visual celebration of such infrastructure is not new. Roman aqueducts and sewer systems continue to impress and awe as they represent the renowned feats of Roman engineering. As discussed in Chapter 1, water control and management in places like Maillezais Abbey played a crucial role in the development and societal power of both religious and secular entities. Canals and irrigation systems have made possible new land for agriculture and irrigation. Mills and windmills that pumped water in the Netherlands in the seventeenth century were widely represented in Dutch landscape paintings.

When Louis XIV settled on a small hunting lodge at Versailles as the site of his new palace, the water supply was inadequate for the construction of the many water features throughout the gardens designed by Andre le Notre. To supply the fountains, canals, and irrigation of this vast garden network, the Machine du Marly was constructed between 1681 and 1687. This was a monumental engineering endeavor, pumping water from the Seine uphill to a series of aqueducts that eventually brought water to the palace. An engineering feat, it never actually brought enough water to adequately supply the extensive water features at Versailles. Visitors to the enormous machine were greeted by fourteen paddle wheels which fed a system of 250

pumps. Along the water's route were several reservoirs holding tanks and more pumps. Repairs were often needed, and the pump required a staff of sixty workers to keep the water flowing. Accounts of the Machine detail the enormous noise it made, which was heard in neighboring chateaux. Thus, for our purposes, the Machine du Marly was an engineering wonder, admired for its ambition and scale but not as a leisure or recreational escape such as the Fairmount Park Waterworks 150 years later.

Throughout the twentieth century, waste water treatment facilities were traditionally placed out of sight of most urban and suburban residents. Isolated especially from wealthy neighborhoods, these are odoriferous, unpleasant sites where humans' waste can be conveniently forgotten except by city engineers and planners. Those with means and political voice are usually successful in ensuring that their waste is not treated in their neighborhood. Such was the case in New York City in the 1960s. In 1965, New Yorkers needed a new sewage plant along the West Side that would stop the pumping of raw sewage into the Hudson River. Upscale neighborhoods fought its placement nearby and thus Harlem, a traditionally African American and lower-income community, was chosen as the site of the new plant. Residents of Harlem also protested against this intrusion in their neighborhood and the resulting compromise was Riverbank Park, a 200,000-square-foot assemblage of buildings, playing fields, theaters, and community spaces that cover the roof of the North River Wastewater Treatment plant. The plant itself sits over the Hudson. The whole project was up and running in 1986, twenty years after the initial state and federal requirement for such a plant was proposed. Richard Dattner designed the buildings with extensive collaboration with local residents. Abel Bainnson Butz Landscape Architects were in charge of the landscape design. Care was taken with materials and the layout of buildings above the plant to avoid too much weight on the roof.[1] From across the river, a series of arches define the sewage plant, with three large single-arched bays to the south. The bulk of the river façade consists of two stories of arched bays, with smaller arches below and a slightly larger row on the second level. These arches echo the form of ancient roman aqueducts, a postmodern nod to the hydraulic engineering might of Ancient Rome. They also echo the Palladian dam at Fairmount Park discussed earlier. What is different here and lamented by Herbert Muschamp in 1993, is the fact that "there is scarcely any connection between the park and waste treatment plant on which it sits. Though this arrangement reflected community desires, an opportunity was nonetheless lost to rethink the way a public place can enlighten us about the way our city works."[2]

[1]Susan Grayson, "Riverbank State Park: tout un parc sur un toit=Riverbank State Park: Up on the Roof," L'Architecture Aujourd'hui, no. 364 (May 2006): pp. 72–7.
[2]Muschamp, "When Art Becomes a Public Spectacle."

Muschamp's call for connections between the processes of infrastructural systems and the public has been heeded in the projects that follow. Though Riverbank Park has succeeded in creating a popular public amenity, it did so by camouflaging or veiling the works below. As we saw with Singer and Glatt's Phoenix Transfer Station, increasingly the emphasis has been on integrating the infrastructural system together with an engaged public. This book began with a look at the Whitney Water Purification Facility in Connecticut, where an expressive pastoral landscape rests above and around a water filtration plant. As we mentioned, this project was the result of collaborative discussions between local residents, engineers, the Water Authority, and the designers, and the result educates the public about the water processes while offering trails and seating for visitors and habitat for birds and local wildlife. The case of the Newtown Creek Waste Water Treatment Plant is another example of how this vital connection which Muschamp called for has been realized.

The Greenpoint neighborhood of Brooklyn is both densely residential and heavily industrial. It has a history that dates back to before the arrival of the colonists with Native American villages in and among the streams that feed the Creek. Newtown Creek opens into the East River and early on the Dutch and English colonists used it as a vital industrial site. Since the nineteenth and twentieth centuries, the creekfront has become highly industrialized, polluted and contaminated by the oil and chemical manufacturers along its banks. Additionally, it has been the home of the Newtown Creek Waste Water Treatment Plant since 1972, processing the waste from three of New York's boroughs. For decades, the open treatment tanks fouled the air and water. Residents complained of "the persistent smell of oil in their basements, as well as odors from the chronically underperforming sewage-treatment plant."[3] In the late 1980s, the Department of Environmental Protection (DEP) was admonished to fix the problems of the plant. They hired three engineering firms, Greely Hansen, Hazen & Sawyer, and Malcom Pirnie. When the engineers' scheme was rejected by the New York City Public Design Commission, the DEP brought the firm of Ennead Architects (formerly Polshek Partnership Architects) on board. As was the case with the Suez Energy-from-Waste facility in Suffolk, England, the architects' interventions created both efficiencies and effective solutions to some of the more egregious problems surrounding the plant. But their work also resulted in an integrated site that welcomes visitors to learn about where and how their waste is treated.

As described by Richard Olcott, the principal architect on the project, the firm was expected to design "architectural enclosure systems for a series of highly complex industrial processes, involving heavy machinery, long spans,

[3]Hillary Brown, *Next Generation Infrastructure: Principles for Post-Industrial Public Works* (Washington, DC: Island Press, 2014), p. 101.

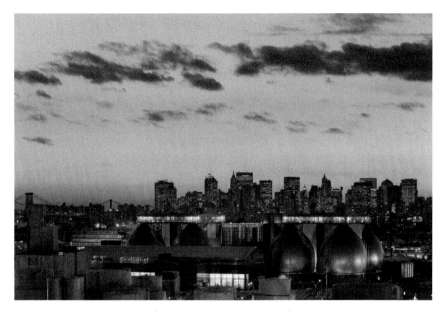

FIGURE 9.1 *Ennead Architects, "Newtown Creek Wastewater Treatment Plant." Brooklyn, New York, 2014. © Jeff Goldberg / Esto.*

toxic materials, corrosive environments, and stringent safety standards."[4] The greatest challenge was to create new spaces and structures while all the while keeping the plant working in order to process the waste of millions. The firm also needed to account for changing technologies and create systems that were flexible to accommodate future systems. According to Olcott, they approached the design of the plant by creating a "kit of parts,"[5] which could be added to or upgraded as needed. Key for Ennead was the honest expression of the functioning plant, an open and readable landscape of structures with easily glimpsed and understandable roles within the plant (Figure 9.1). These are linked by aerial walkways of glass and steel. Color and materials identify the other elements of the plant, for example, the tanks are clad in stainless steel with a blue glazed brick base, while the stairs and elevators are clad in green tiles. The plant's main building has abundant glazing and the visitors' center is identified by its orange tile façade which is pulled out from the body of the building. This is not a prettified plant, but Ennead's treatment of parts is rational, clear, and sleek. Gone are the foul odors and exposed tanks. The flexibility of their scheme has paid off as the plant now incorporates a renewable gas digester that includes composted food waste from local

[4]Richard Olcott, "An Architecure of Change: Newtown Creek Wastewater Treatment Plant," *Oz*, vol. 34 (2012): p. 53. https://doi.org/10.4148/2378–5853.1505.
[5]Ibid., p. 54.

schools, creates methane and sells the methane to National Grid for home heating. This was not a feature planned for at the start, but the system was designed to shift and accommodate change as needed.

Like Phoenix in the late 1980s, New York City has a Percent for Art Law which skims a relatively small amount off such projects to pay for art. Newtown Creek has two such projects. Vito Acconci designed "Waterfall: Out & In" at the entrance to the visitors' center. With a dramatic sinuousness, walls and water swirl in and out of the building, referencing change, process, and clean water. Such an introduction entices the visitor, evoking a sound of water as you enter to learn about the wonders of turning something so unpleasant as waste into a benign product.

The outdoor sculptor, George Trakas designed the 'Nature Walk' around the complex. A contemporary of Michael Singer, Trakas's work honors both industry and nature, the artificial and manmade. Here at Newtown, he created a series of spaces in which history, industry, and nature all play a key role. References to shipbuilding are found in the "Vessel," a concrete boat form which leads the visitor into the walk. Industrial views and the wastewater plant are framed in stages, as is the Empire State Building, locating the visitor both in the site and in the greater urban fabric of New York City. The "Seven Stone Circles" include native place names, referencing the Native American history of the site. Indigenous plantings line the walk and signage identifies their uses by Native Americans and settlers. Important to Trakas was access to the water. Replacing the older seawalls are nine granite steps that reach down to the water providing access for boats and fishing. Along the walk Trakas united precolonial history with the industrial past, views of aging industry with promising new infrastructural paradigms.[6] The site sandwiched as it is between a dense residential area and heavy industry becomes a liminal space, productive, educational, and recreational. In discussing "green infrastructure" Thomas Hauck and Daniel Czechowski write of a new for a new green functionalism which aims for the "unity of art and life or beauty and everyday life."[7] Newtown Creek, with its sleek silver eggs, lit blue at night according to the designs of L'Observatoire, its scrappy nature amid an industrial past and its orange visitors' cube with its watery flow, does just that. While hardly pastoral in the traditional sense, Trakas and Ennead borrow skeletal ideas from the older tradition. The "Nature" walk winds through the site, frames views, invites visitors, and references history while celebrating

[6]Department of Environmental Protection, *The Newtown Creek Nature Walk*, Flyer. http://www. nyc.gov/html/dep/pdf/newtown_creek_nature_walk_flyer.pdf. Accessed Aug. 2018.

[7]Thomas Hauck and Daniel Czechowski, "Green Functionalism: A Brief Sketch of Its History and Ideas in the United States and Germany," in *Revising Green Infrastructure: Concepts between Nature and Design,* ed. Hauck Czechowski and Georg Hausladen (Boca Raton, FL: CRC Press, 2015), p. 3.

productivity, and Ennead's integration of art and infrastructure benefits both the neighborhood and visitors. The ideology within the design of Newtown Creek shares much with the design of Fairmount Park, though they are, of course, visually distinct.

In 2007, Alexandros Washburn, the Chief Urban Designer for New York City wrote a brief piece for the online version of *Metropolis* magazine. Titled "Civic Virtue by Design," Washburn referenced then Mayor Bloomberg's Earth Day plans to help New York City become more resilient and sustainable in the face of global climate change. He argued that "Civic Virtue is the cultivation of habits important for the success of the community. The ideas Mayor Bloomberg laid out are nothing short of a new compact with nature for the urban dweller, an acknowledgment that the success of our city will in large part be determined by our success in managing our environment."[8] He goes on to call for a new paradigm, one that weaves nature, infrastructure, and urban life into a more sustainable future. As part of this goal, the City announced plans in 2004 to build a new water treatment facility to treat water from the Croton watershed. Plans for this facility had been a long time in the making, with the first discussions of need beginning in 1989.[9] The water from Croton did not meet Federal standards in part because of unchecked development along the watershed. The site ultimately chosen for the new facility abuts the Mosholu Golf Course on van Cortland Park in the Bronx. Pushback came from neighbors who foresaw huge disruption of their environment while the plant was under construction and the loss of a section of park with graceful woods of sweet gum trees and oaks. As was the case at Newtown Creek, the original scheme presented by the engineering team Hazen and Sawyer/Metcalf & Eddy Joint Venture was rejected by city officials. They had presented an in-house design for the driving range. To address issues of security, they planned to place a chain-link fence around the perimeter.[10] While these options would have saved money, they did little to placate the neighbors in the area of Norwood in the Bronx, a low-income neighborhood with a mostly Latinx population. The City held a design competition as part of New York City's Design and Construction Excellence Initiative. Grimshaw Architects, the firm responsible for the Suez Energy-from-Waste facility in Suffolk, England, won the competition together with the Ken Smith Workshop, a landscape architecture firm based in New York. Architects David Burke and Eric Johnson worked with Ken Smith FASLA on designs that would re-create the lost driving range, include a public clubhouse and tree canopies, provide secure structures for DEP offices

[8] Alexandros Washburn, "Civic Virtue by Design," *Metropolis Magazine*, Sept. 5, 2007. https://www.metropolismag.com/cities/civic-virtue-by-design/.

[9] "Croton Water Filtration Plant," Water Technology website, https://www.water-technology.net/projects/crotonfiltration/. Accessed Aug. 2018.

[10] David Burke and Eric Johnson, interview with the author, Apr. 25, 2018.

and plant monitoring, restore woodlands lost during construction all while creating a visually beautiful, secure site to protect this major source of clean drinking water.

The enormous plant itself is buried below ground (Figure 9.2). Atop this massive undertaking is a nine-acre green roof designed as a driving range. In an interview, Ken Smith discussed how the project at Croton fell just on the heels of a roof he'd designed for MoMA. There, in a whimsical, ironic way he had played with the idea of camouflage, creating sinuous forms of colors which both disguise the roofs while highlighting them. For Croton, the idea of camouflage was much more literal. Before him was the question how to design a lightweight roof structure with vital cooling vents for the plant below that would function as a demanding driving range for the golfing public. Smith used polystyrene blocks to create hillocks that both challenge the golfer as artificial greens and traps while hiding the necessary vents. These stretch across the bowl-shaped roof. Around the plant stretch two miles of stone veneer fencing and basket gabions that encircle the plant following the gradient of the landscape. These in turn are encircled by a watery moat, designed as a series of catchment cells that capture, store, and filter both rainwater from the site and groundwater from the plant below. The long access-drive up to the site is bordered by sunken verges

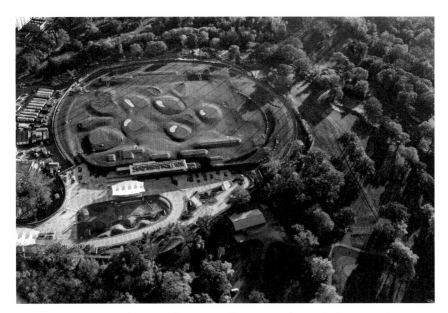

FIGURE 9.2 *Grimshaw Architects and Ken Smith Workshop Landscape Architects. "Croton Water Filtration Plant," New York, 2007–ongoing.* © *2015, Alex S. MacLean.*

filled with riparian plants.[11] Descending from the plant past the parking for DEP employees, snaking bioswales, whose necessary length dictated their curvaceous forms, reference the serpentine mounds of Native Americans, while capturing and filtering water from the parking lots. Massive bluestone boulders arc across the edge of the green roof indicate the edge of the inner plant and serve as warnings to emergency vehicles not to drive onto the roof's surface. Viewed from above, these fragmented circular forms have prehistoric echoes.

Grimshaw Architects were responsible for the architectural features on site. These include the clubhouse for the driving range and the offices of the DEP. While not yet completed, the clubhouse roof of grasses and sedums will rise up from the ground in a gentle curve that follows the arc of the plant, hugging the perimeter and providing access to the tree canopies and some of the catchment cells. At the end of the structure, an open-air classroom sits aside cell number six where visitors and school children can learn about stormwater run-off and water filtration processes. The plantings in the pools illustrate the myriad of ways that natural systems can clean our water. Organic fertilizers on the driving range further enhance water quality. Smith carefully mapped the trees before they were lost to construction, and then re-planted gums and oaks in clusters that mimicked what was lost.

Alex Ulam reviewed the project in an article in 2016, where he points out that the development of the Croton water plant has been slowed by lawsuits, corruption, and mismanagement at times. But the work of the architects at Grimshaw, together with Ken Smith's landscape vision, has transformed a potentially isolated and unfriendly water purification plant into what will be a productive and participatory landscape of recreation, education, and clean water. The "Art" in the infrastructure creates a landscape that will eventually be a good neighbor to the residents of Norwood, offering golf, shade trees, and education to the public. Referencing castle moats and ancient mounds, HaHas, natural ponds, and riparian forests, Ken Smith's camouflage works to reintroduce nature into infrastructure with purposeful inclusion.

The story of the Willamette River Water Treatment Plant in Wilsonville Oregon (Figure 9.3) has echoes of Croton, though on a smaller and much less controversial scale. The visionary City Council rejected the original plans from MWH Global for a mundane series of functioning water treatment boxes behind a chain-link fence. Instead, "the city council directed that the plant should become an asset, not a detriment, to the neighborhood."[12] The

[11]Alex Ulam, "Driving Concern: The New Mosholu Golf Driving Range Is Part of a Controversial Water Filtration Plant Project Built at the Edge of the Bucolic Van Cortland Park," *Landscape Architecture*, vol. 106, no. 7 (July 2016): p. 104.
[12]Chris Sensenig, "Willamette Water Treatment Plant—Wilsonville Oregon [EDRA/Places Awards 2004-Design]," *Places Journal*, vol. 16, no. 3 (2004). http://escholarship.org/uc/item/8013f6z7.

FIGURE 9.3 *Miller Hull Architects, "Willamette River Water Treatment Plant." Wilsonville, Oregon, 2003. © Nic Lehoux.*

architecture firm of Miller Hull Architects is responsible for the resulting design. Miller Hull divides its practice into five sectors. One of these is "Serve," which features projects ranging from public safety to infrastructure. They recently designed the West Campus Utility Plant for the University of Washington in Seattle. Sited at the entrance to the campus, this translucent white box stands sentinel proclaiming the University's commitment to sustainability. Achieving Envision Gold status for infrastructure, it is an open and educational look into the infrastructural systems of the University.

For the Willamette project, Robert Hull, once a student of Marcel Breuer, employed a series of concrete boxes separated by low stone and concrete walls, each shielding different treatment functions such as ozonation or filtration. These boxes step down the site, mimicking the water process as it moves through the system. These systems are explained in didactic panels and in the visitors' center. The inner workings of the plant are glimpsed via windows in the concrete, making accessible what is generally hidden from view. Along the eastern, public edge of the plant, the architects worked with Murase Associates Landscape Design to create a rocky stream bed with picnic tables and a green park beyond. This water feature, much like the filtration cells at Croton, serve to illustrate the filtration and aeration of water as it passes through the system. Robert Hull created a rich series of visual contrasts between the carefully detailed concrete panels with exposed vertical ridges

from the formwork which add texture, and the softening grasses, irregular stone walls, and wooden beams that frame the visitors' center. The water of the stream and the randomly scattered boulders within it, are reminders of geologic time and the importance of this key resource.

Perhaps the ultimate example of this shifting paradigm can be seen in the Solrødgård Energy, Climate and Environmental Park in Hillerød, Denmark. The client in this case is the Hillerød Utility Company. In the original guidelines calling for design submissions, the clients stipulated that "land and buildings [be] conceived and experienced as integrated parts that support an attractive energy, climate and environmental park with a clear and unambiguous design concept."[13] The goal since the project's inception is to integrate water purification, biomass and geothermal heat production, a recycling station, and test sites for solar and wind energy. Julian Weyer of C. F. Møller wrote about the early planning process, "One of the unique things about the concept, besides turning the 'necessary burden' of infrastructure into a public asset, has been our investigation of how each component can create synergies with the other pieces of the puzzle."[14] This series of green energy and waste solutions stretches across a parklike landscape with cleansing bioswales and vernal lakes and streams, thereby managing water, waste, and energy within an inviting and pastoral setting.

The project is currently under construction. The original conceptual plan was drawn up by the team at C. F. Møller. But the work has been collaborative from the start. Gottlieb Palundan is now responsible for the master plan and have designed the headquarters building for Hillerød/Forsyning in the park. The Danish firm of Henning Larssen has designed the waste water treatment plant (Figure 9.4). In contrast to the urban industrial nature of Newtown Creek, much of this new plant will be buried. The building is set seamlessly within the landscape. Its roof rises up from the ground with the appearance of being a simple topographical feature in the landscape. Only angled skylights with planted roofs and zigzagging pathways indicate something different is going on. Once upon it, the structure is understood to be bifurcated, with a pathway cutting a sunken swathe between its parts. A walk through this area features glass facades that highlight the inner workings of the waste water purification process. The roof itself is part of the landscape, an integrated public space on which people can walk or picnic. As the landscape stretches out away from the administration building, recycling center, and waste water plant, a series of paths and boardwalks provide trails for walking and biking. Fill from

[13]Hilleroed_Design_Guidline_report.pdf: https://cfmxnet.cfmoller.com/downloads/file.asp?071341 3590302000940035009524207O (google translation). Accessed July 2018.
[14]Julian Weyer, email correspondence with the author, June 21, 2018.

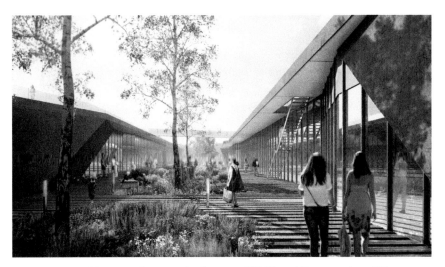

FIGURE 9.4 *Henning Larsen Architects. "Hillerød Renseanlaeg Water Treatment Plant." In progress. © Henning Larsen Architects A/S/.*

construction is used to create climbing hills and new plantings, and restored wetlands will make for rich wildlife habitats. The ambitious unity of this project, weaving energy, water, recreation, and biodiversity is remarkable and sets a new standard for the productive pastoral. It is truly a site wherein the machine sits comfortably in the garden.

10

Food, Community, and the Productive Landscape

The features of the Hillerød plant stretch out across the landscape with the recycling station, solar and wind test sites, and wastewater treatment plant tucked into or softened by the landscape of grasses, trees, and water. Through bioswales and retention ponds, stormwater from nearby homes is processed in the landscape, filtering and cleaning the water as it passes through the soils. Deep below the ground pipes carry the earth's warmth for geothermal heating and visitors learn about the process in the Visitors' Center. But the actual productivity of the land via the geothermal wells is hidden deeply below the surface. In Le Biancane Nature Park in Tuscany, Italy, trails and bike paths follow a series of geysers to Bagnore 3 geothermal energy plant designed as an "open air energy school"[1] to educate the public about how heat and electricity are produced via geothermal wells. This open-air plant is one of several in the area and is purely functional, though the landscape architect, Lucina Caravaggi of the Department of Architecture, Sapienza, University of Rome, designed the access route so as to make the plant a feature in the landscape.

Geothermal is a key energy and heat source for Iceland. The Hellisheiði Power Station near Reykjavik is the largest single-site geothermal plant in the world.[2] The role it plays in producing energy and heat for the Icelandic people is key to their success in providing 100 percent clean energy for the

[1] Alexander Richter, "Enel Officially Inaugurates Bagnore 4 Plant in Tuscany, Italy," Think Geo Energy, updated August 1, 2016, http://www.thinkgeoenergy.com/enel-officially-inaugurates-bagnore-4-plant-in-tuscany-italy/.

[2] "Home Page," GeoThermal Exhibition, ON Power, https://www.geothermalexhibition.com/. Accessed Aug. 2018.

island. The visitors' center was designed by the engineering and architecture firm of Mannvit, Verkís, Tark Architects and Landslag Architects. While the firm's main focus was on the overall engineering of the plant, the form of the visitors' center was inspired by the geology of the island,[3] with a sharply defined inverted V over the entrance, marking the plant and exhibition space out across the landscape. In both these examples, in Italy and Iceland, the productivity of the land is celebrated, and the public invited to learn about this clean energy source. They are sites and sources of civic pride and symbols of a green energy source and a country's commitment to a carbon-free future. Geothermal plants such as these are popular sources of heat and electricity in areas where the geology facilitates their use. In cases discussed above, the public is invited to explore the area and learn about power production. But the plants themselves are purely functional, and away from urban or suburban centers. Like large wind and solar farms, they are productive features in the landscape, which have yet to be approached by artists and architects and woven into a suburban or urban setting.

In contrast, agriculture is wending its way into a wide range of cityscapes in exciting and sometimes dramatic ways. As we have seen visionaries like Ebenezer Howard and Frank Lloyd Wright thoroughly integrated agricultural infrastructures into their urban plans. In the town of Todmordon in Yorkshire, England, a small band of volunteers started growing food in unusual places such as small lots in front of office buildings or in the centers of roundabouts and verges along roadways. Called the "Incredible Edible," founder Pam Warhurst described the grassroots effort during a TED talk in 2012 wherein she elaborated on how the efforts of a few residents have burgeoned into a movement and been adopted by other communities. Professors Andre Viljeon and Katrin Bohn of the University of Brighton, also in the UK have created the Continuous Productive Urban Landscape (CPUL) in which a network of green and productive spaces weave through our urban fabric, in ways similar to what Wright, le Corbusier, and Howard envisioned. Their ideas were realized in the "Middlesborough Urban Farming Project" in 2007. Bohn and Viljeon worked with DOTT07, John Thackara, David Barrie, Zest Innovation, and Debra Solomon in a wide-ranging effort to bring together the community and municipality to create a green and food producing city. Part of the project included careful mapping of ideal sites for growing different foods, as well as outreach and education. The project concluded with a large, "Meal for Middlesborough" feeding over 1,500 residents. It created a template for other communities: "The next stage in the evolution of urban agriculture is to incorporate productive gardening from the very outset of any urban design

[3]"About Us," GeoThermal Exhibition, ON Power, https://www.geothermalexhibition.com/about-us. Accessed Aug. 2018.

project. As Viljeon explains: 'We need to start thinking about food production being a part of a city's infrastructure – like roads.' "[4] Bohn, Viljeon, Thackara, and other artists working in the field envision the interweaving of productive growing spaces throughout our cities and towns, tying residents to their food sources and bringing the health and environmental benefits of agriculture to a wider public.

In the chapters above, we have looked at the need for clean water and increasingly clean energy as realized in new approaches to the infrastructures that produce them. These projects have evolved as responses to climate change, population growth, and polluted water supplies. Similar concerns are driving the revolution in food production. Industrial-scale agriculture has numerous environmental costs such as heavy use of pesticides, soil erosion, and run-off that contaminates streams and rivers. This monoculture approach impacts both the health of the soil and the population, and the use of antibiotics in meat and chicken production contributes to the development of antibiotic-resistant strains of bacteria.[5] Healthy soil can play a role in the sequestration of carbon through careful crop rotation and better agricultural practices. Breaking up our dependence on large-scale farming with an increase in independent, organic farms improves the health of the land, reduces the environmental costs of food transportation, and reconnects communities with their food supply. In addition to the environmental benefits of small-scale farming, green space in urban centers has mental health benefits as well. Olmsted foresaw this when he wrote of the need for a large park in the heart of New York City. In a recent study conducted by the University of Pennsylvania's Perlman School of Medicine, just the greening of abandoned lots in distressed neighborhoods can have a positive effect on residents' mental health. According to the study's lead author, Eugenia C. South, "The treatment of dilapidated physical environments can be an important tool for communities to address persistent mental health problems. These findings provide support to health care clinicians concerned with positively transforming the often chaotic and harmful environments that affect their patients."[6]

[4]Mark Gorgolewski, June Komisar, and Joe Nasr, *Carrot City: Creating Places for Urban Agriculture* (New York: Monacelli Press, 2011), p. 27.
[5]"Hidden Costs of Industrial Architecture," Union of Concerned Scientists: Science for a Healthy Planet and Safer World, https://www.ucsusa.org/food_and_agriculture/our-failing-food-system/industrial-agriculture/hidden-costs-of-industrial.html. Accessed August 2018.
[6]Eugenia C. South, Bernadette C. Hohl, Michelle C. Kondo, John M. MacDonald, and Charles C. Branas, "Effect of Greening Vacant Land on Mental Health of Community-Dwelling Adults: A Cluster Randomized Trial," *Jama Open Network* (July 20, 2018). https://jamanetwork.com/journals/jamanetworkopen/fullarticle/2688343. Accessed July 24, 2018.

Other studies suggest that small community organizations in cities have played a vital role in reducing violence in their neighborhoods.[7] Small-scale community gardens are part of these efforts. Designed to bring together the community, teach gardening and other skills to local youth, and grow healthy fruits and vegetables, the examples are numerous and inspiring. We will look at a few cases to illustrate the varied ways that artists, architects, and landscape architects are working with local communities to introduce a productive pastoral landscape into an urban streetscape. In 2008, Walter Hood, the landscape architect responsible for the Solar Strand at the University of Buffalo, designed a small garden in Queens called the Curtis "50 Cent" Jackson Community Garden. This is one of the many gardens and parks sponsored by the Restoration Project, founded by Bette Midler in 1995. The rapper, "50 Cent" helped fund the project with a donation of $350,000 through his foundation G-Unity. Midler has been working on such projects with the goal that "everyone who has a stake in the garden is able to use it in the way they want to: some want to grow fruits and vegetables, others want a quiet place, some want to play ball. So all these things have to be taken into consideration."[8] The area serves as both a vegetable garden and a playground space for the neighborhood. Set alongside a railroad track, the paths, the sidewalk, and arbor system mirror the railroad's linearity. Amid this organizing structure are raised and planted beds, some are rectangular and parallel the road, while others break out in whimsical shapes such as hearts, triangles, and arcing sections. These are planted with both vegetables and flowers, allowing for flexibility according to the wishes of the gardening community. Hood's overall arrangement was inspired by the Kitchen Gardens at the Chateau de Villandry.[9] A freshly painted shipping container works as the garden shed. Six tall inverted umbrella forms in striking blue play a dual role in the garden. They offer shade to children playing beneath while catching and filtering rain water into buried cisterns. This is then used to water the beds, saving the residents from hooking into the fire hydrants for irrigation.[10] The space blends productive agricultural infrastructure with history and whimsy for an urban space that functions as both a park and a garden. Weaving the needs and input from the nearby residents with his academic training, Hood created an urban landscape that invites and feeds its neighbors.

[7] Emily Badger, "The Unsung Role that Ordinary Citizens Played in the Great Crime Decline," *New York Times*, Nov. 9, 2017. https://www.nytimes.com/2017/11/09/upshot/the-unsung-role-that-ordinary-citizens-played-in-the-great-crime-decline.html. Accessed July 25, 2018.

[8] Anne Raver, "Healthy Spaces, for People and the Earth," in Home and Garden, *New York Times*, Nov. 5, 2008. https://www.nytimes.com/2008/11/06/garden/06garden.html. Accessed July 9, 2018.

[9] Gorgolewski, Komisar, and Nasr, *Carrot City,* p. 70.

[10] Raver, "Healthy Spaces, for People and the Earth."

It is difficult to characterize the work of the Sweet Water Foundation. Based in Chicago, it is the brainchild of executive director, Emmanuel Pratt. Pratt is a doctoral candidate in Urban Planning at Columbia University. He was a 2017 Loeb fellow at Harvard's Graduate School of Design and Charles Moore visiting professor at Taubman College at the University of Michigan. Pratt's fame and accolades stem from his ambitious and visionary work at the Sweet Water Foundation. Dedicated to what he calls "regenerative placemaking," he aims to

> create the platform to uncover, unleash, capture, and share the voices of the community that we know are abundant with solutions capable of creating sustained and transformational change. Amidst one reality of abandonment, exclusion, urban 'blight' or disintegration, community members will be empowered, to re-envision both personhood and place, and travel from fragmentation to possibility and wholeness within self and community.[11]

For his work in Chicago and Milwaukee he brings together community leaders, youth, architects, artists, and agricultural specialists to create new life and possibility within abandoned urban sites. Committed to reaching out into broad swathes of the community, he has recently partnered with the Smart Museum in Chicago for the Radical [Re] Constructions installation which includes a series of dinner parties with varied guests to introduce them to the positive voices and productivity of the Sweet Water community.

In 2014, the Foundation took over a three-acre site in Chicago's South side called the Perry Ave Commons (Figure 10.1). The site was home to a disused school that was razed. The Sweet Water Foundation has moved into the site, which is now home to a thriving urban farm that feeds between two hundred and three hundred people a week. But more than that, the area is becoming a cultural hub, a place of community participation, of skills training, of commerce, and the arts. Pratt talks of an abandoned warehouse that the Foundation has moved into. Here, the once neglected space is filled with thriving aquaponic plants and huge tanks of tilapia, part of Pratt's Mycella Project. Overall, the mission is to build a thriving community. Perry Ave Commons, with its neat rows of vegetables, and towering sunflowers illustrates a new agricultural paradigm in which an urban community works together to feed itself and "celebrates a social purpose while contributing to

[11] Emmanuel Pratt, "Historical Context and the Origins of the Radical (Re)construction Installation," Smart Museum of Art website, University of Chicago, updated Sept. 15, 2017. https://smartmuseum.uchicago.edu/blog/historical-context-and-origins-of-the-radical-reconstructions-installation/.

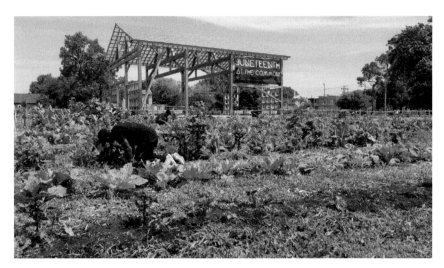

FIGURE 10.1 *Emmanuel Pratt and the Sweet Water Foundation. Perry Ave. Commons, Chicago, Illinois, 2018. Photographer, Emmanuel Pratt.*

a smarter, safer, sustainable and more ecological city."[12] While such projects seem worlds apart, Perry Ave Commons shares come key infrastructural features with projects like BIG's Amager Bakke waste-to-energy plant in Copenhagen. Both envision a new infrastructural paradigm, one that includes and invites community, and is a source of civic pride and vital production, whether through energy production or food. And both weave a pastoral productivity into the sites with their combination of beauty and bounty. The interaction between the community and infrastructure educates, informs, and integrates residents and creates positive synergies that stretch beyond the mere production of power or veggies. And it is here, perhaps, where Michael Singer and others would argue that the *art* of the project comes into play. Questioning what else a power plant or farm can be opens the floor for a myriad of questions, the answers to which open up greater and more positive paths toward change.

A relatively young architecture firm intent on both looking to history for precedents and asking probing questions about the future of food and cities is WORKac. Amale Andraos, also the dean of Columbia's Graduate School of Architecture, Planning and Preservation, and her husband, Dan Wood, are founders of the firm. In their writings such as *49 Cities* of 2015, or their more recent, *WORKac: We'll Get There When We Cross That Bridge*, they explore the historical components of cities, and the factors that shaped them.

[12]Emmanuel Pratt, "Urban Agriculture: A New Paradigm of Planning and Policy," *Engineering and Technology for a Sustainable World*, vol. 20, no. 2 (Mar./Apr. 2013): p. 21.

Their most recent book offers their design ideas and responses to many of the issues that shaped cities in the past. One of their chapters entitled, "Infoodstructure" touches on their reading of older cities' food supply and agriculture. In Andraos's words,

> You could say that our interests in these infrastructural systems – whether through urbanism or ecology-were increasingly woven together and brought into architecture. Architecture's boundaries became porous, not by blurring the skin, but literally, by collecting water from the roof and drawing it into the building, for example. Architecture became a medium to organize all of these systems and ideas as part of a larger infrastructure and ecosystem, which connected it back to its context.[13]

They have since drawn up designs for vertical farms—visionary plans where farms replace roads and productive growth climbs vertically up through the existing fabric of the city.

In 2008, they had a chance to explore these ideas in built form in the "Public Farm 1" project, built for The PS1 Contemporary Art Center in conjunction with the Museum of Modern Art. For this temporary summer pavilion, the pair were tasked with providing shade, water, and seating. Their scheme developed into a series of biodegradable cardboard tubes, raised up on taller tubes, in which a range of vegetables and herbs grew. The space below provided shade while a periscope offered views of the plantings above. Pecking chickens and chicks added the final touch to the urban farming experience. The project was fun and playful, while offering a vision of what actual urban farms can be.

Their ideas were further realized in their designs for the Edible Schoolyard projects for PS216 and PS7. Edible Schoolyards originated in Berkeley, California, under the inspiring leadership of Alice Waters. Tying healthy food and organic farming with academic curricula has meant that Edible Schoolyards have popped up across the globe. WORKac were hired to design the gardens, kitchen, and greenhouse for New York's PS216 (Figure 10.2) in Gravesend Brooklyn. While most of the space is given over to the gardens, one corner is taken up with a greenhouse, kitchen/classroom space, and a "systems wall" that houses a cistern filled with water from the adjacent roofs of the kitchen and greenhouse, a tool shed, HVAC systems, and a restroom. Each section is clearly articulated, so children can understand the various parts and their functions. In addition to a welcoming garden space with haybale seats and shady nooks, the façade of the kitchen classroom is cheerful and lively with pixelated-like shingles in floral designs inspired by Venturi and Brown's

[13]Amale Andraos, *WORKac: We'll Get There When We Cross That Bridge* (New York: Monacelli Press, 2017), p. 102.

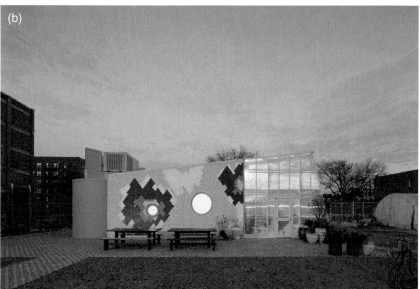

FIGURE 10.2 *a and b: WORKac, "P.S. 216 Edible Schoolyard." New York, 2009–13. © Photograph: Iwan Baan.*

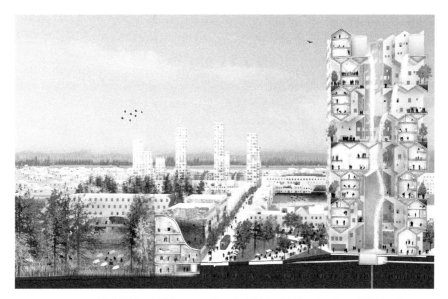

FIGURE 10.3 *WORKac, "Nature-City," 2012. © Rendering, WORKac.*

BEST showroom facade.[14] Portal windows light the kitchen area and form the flowers' centers. The systems wall is covered in pale blue rubber which adds to the playful whimsy of the whole. The spaces are designed to teach and—much like Perry Ave Commons—the architecture encourages healthy eating, and a hands-on understanding of biology, water processes, and urban agriculture.

WORKac's interest in agricultural infrastructural systems expanded in their designs for "Nature City." This was a response to the MoMA *Foreclosed: ReHousing the American Dream* exhibition of 2011. The museum invited five architecture studios to devise expansion plans for five different cities across the United States in response to the housing crisis. WORKac's project addressed the development of the suburb of Keizer, Oregon (Figure 10.3). On the outskirts of the existing town, they studied the optimum layout of buildings and infrastructure and how to best promote animal and plant diversity while creating dense and varied housing typologies. Inspired by their reflections on cities and infrastructure explored in *49 Cities*, their designs visualize a new infrastructure paradigm. In Dan Woods' words,

> We were emphasizing an idea of community through infrastructure where each house is part of a system that makes the entire city work together. No one housing type stood on its own. If one housing block processed

heat, then the steam would go to another housing type that would use it to generate power and another block would distribute it.[15]

Within this new suburban prototype, community spaces, such as the compost hill, have housing built into the artificial hillside while the composting of food wastes occurs below. The methane produced by the composting is then used for heat and electricity in the town. A tall housing block also serves as a water tower, distributing water with the help of gravity to the residents. The designs envision a blending of human-made systems such as aquaponics and fuel cell technologies together with agriculture and wide tracts of open land. Beautifully built scale models and renderings bring the ideas to life and reflect Andraos and Wood's visions of how infrastructure, once sidelined in our cities, can be integrated into a rich and diverse, and pastoral, suburban environment.

Many other architects, landscape architects, designers, and artists are imaging a world wherein agricultural infrastructures are seamlessly woven into the built fabric of our cities and towns. In the book, *Carrot City: Creating Places for Urban Agriculture*, the authors discuss built projects such as Middlesborough and Curtis '50 Cent' Jackson Community Garden, and visionary projects such as "Pig City" by MVRDV Architects wherein a whimsical world of high-rise towers sustains a pig farm, or the "Center for Urban Agriculture" by Mithun Architects which blends solar panel cladding, rich biodiversity, and food production into a multistory urban structure. Similarly, Anna Yudina's book, *Garden City: Supergreen Buildings, Urban Skyscapes and the New Planted Space* documents projects both built and unbuilt that explore the fusing of architecture and agriculture.[16] In one example, Kono Designs created a new headquarters for Pasona Inc., a staffing agency based in Tokyo. Here, they quite literally incorporate food production into the architectural spaces. For example, "a rice paddy and broccoli field can be found in the main lobby; pumpkins grow in the reception area; a canopy of tomatoes hangs above the conference tables ... while beans sprout in the drawers that are smartly tucked under the meeting room benches."[17] Such a fusion of work, architecture, and agriculture represents a major shift in how we think about all three and illustrates the potential of rethinking where our infrastructural systems are found and how we relate to and interact with them.

In such projects, the traditional boundaries between an urban culture, a pastoral middle ground, and the wilderness break down. In "Pasona HQ" or

[15]Ibid., p. 154.
[16]Anna Yudina, *Garden City: Supergreen Buildings, Urban Skyscapes and the New Planted Space* (New York: Thames and Hudson, 2017), p. 190.
[17]Ibid., p. 190.

WORKac's "Nature City," the productivity of traditional pastoralism is intimately connected to the urban fabric, bringing the benefits of healthy fresh food and a low-carbon or no-carbon infrastructure into the everyday lives of residents or employees. Such integration promotes interaction with and understanding of the systems that sustain us.

The examples discussed above have been largely urban in their focus. But as mentioned earlier, twentieth-century farming practices have evolved into monocultural entities, often on an industrial scale and with an interest in rapid and large scale production. The result is a degraded landscape of overgrazing, soil erosion, polluted waterways, and a lack of biodiversity. Farming has seldom been the purview or interest of landscape architects, who, as we have seen, work in largely urban or suburban environments. But the firm of Nelson Byrd Woltz is seeking to change that paradigm. Both Warren Byrd and Susan Nelson are retired, and Thomas Woltz now heads the firm. Woltz was a student of Warren Byrd while at the University of Virginia where he earned a masters in Landscape Architecture. From Byrd he learned about systems thinking, how all parts of the landscape work together. He also took classes from William McDonough, whose ideas put forth in *Cradle to Cradle* with Michael Braungart have had a profound impact on the way we think about industrial production. McDonough argues for closed-loop systems in which waste is a productive part of the lifecycle of both natural and human-made objects. McDonough taught Woltz that environmentally conscious design, be it a carpet or a building, can be both beautiful and productive within a closed-loop system of manufacturing. Woltz grew up on a farm and thus both his academic training and childhood have influenced the way he approaches designing a landscape.

Nelson Byrd Woltz is based out of Charlottesville, Virginia, with an office in New York City. They are, like many landscape architects, concerned and involved with urban parks, rooftop gardens, and collegiate master plans. But part of their practice includes a Conservation Agriculture Studio that focuses on regenerative and restorative designs for productive farmland. Led by Woltz, the studio seeks to remedy problems that plague farms such as polluted run-off and over-grazing. Woltz's interest in designing and restoring agricultural landscapes is rooted in history but is novel in its approach. As Elizabeth Meyers points out in her essay about Woltz and the Farm,

> For centuries, landscape architects have referenced the agricultural landscape and mined its planted types and geometric patterns for design tactics and tropes. But few landscape architects have consciously taken on the shaping, transformation, and reformation of actual rural agricultural landscapes, in the manner currently practiced by NBW. Their vision for a collaborative practice involving landowners, conservation biologists, landscape ecologists, soil scientists, and farm managers has the potential

to create regional landscape mosaics of more productive crops and herds, regenerative ecosystems, and healthier watersheds.[18]

As we have seen in the first half of this book, the pastoral landscape typology of the English landscape park had a profound impact on Olmsted and his designs for Central Park. And Olmsted's ideas went on to influence the design of our suburbs and parks for at least half a century. But as translated into suburban cul-de-sacs and urban parks, the productivity of those pastoral landscapes was abandoned. Food and energy production became unsightly and parks and gardens were feasts for the eyes and spirit but no more. Woltz and his team at NBW are interested in reclaiming that productivity while creating healthier crops, soils, animals, and water.

Their goals are realized in several projects examined here. The first is Seven Ponds Farm in Virginia. Begun in 1997, Woltz has worked with the current landowner to restore a sixty hectares farm. Cattle had grazed this land for 75 years and the result was an unhealthy landscape. "From the beginning, the goal of this landscape transformation was to maximize biodiversity while restoring a degraded agricultural landscape."[19]Problems on the property included erosion from overgrazing, invasive plant species, and suburban development. They were solved by a long-term commitment to the land, by restoring streambeds, conducting regular, controlled burns to minimize invasive species' growth, and the planting of over ten thousand trees. Wildflower meadows, grasslands, and forests are slowly evolving. Via a series of constructed pools, rain water runoff has been slowed as it reaches the streams. The project continues to evolve and has become an inviting ecological preserve where visitors enjoy a pastoral, bucolic and restored landscape.

In their work for Overlook Farm in Waverly, Pennsylvania, begun in 2012, NBW has done similar restoration work. Overlook Farm was originally laid out by the Olmsted firm in 1901. Always a working farm, NBW's Conservation Agricultural Studio has worked closely with ecologists from the Roosevelt Wildlife Station in Syracuse, New York, using the Biological Baseline Survey (BioBlitz) to assess the property. They have also relied on the original Olmsted brother's plans to construct a master plan to restore the landscape and develop sustainable farming on the site.

When working on such projects, Woltz is concerned with both the ecological health of the land, its agricultural output and its beauty. In his work at Orongo Station in New Zealand (Figure 10.4), his goals have been realized

[18]Elizabeth Meyer, "Part IV: Farm: Multifunctional Beauties," in *Nelson Byrd Woltz: Garden/Park/Community/Farm*, ed. Stephen Orr with Warren T. Byrd, Jr. and Thomas L. Woltz (New York: Princeton Architectural Press, 2013), pp. 171–2.

[19]Myla F. J. Aronson and Steven N. Handel, "Designing a Grassland Estate, Cultivating Biodiversity," *Ecological Restoration* (June 2013): p. 212.

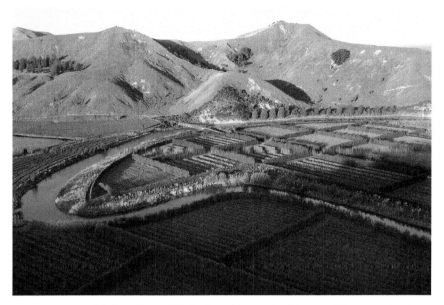

FIGURE 10.4 *Nelson Byrd Woltz Landscape Architects, "Orongo Station Citrus Fields and Bridge." Poverty Bay, New Zealand, 2002–12. © Nelson Byrd Woltz Landscape Architects.*

on a grand scale. This is a 3,000-acre sheep farm set on the northern tip of the north island of the country. Originally a temperate rain forest, the land had been slowly cleared since humans arrived on the island in the thirteenth century. Woltz has worked with the property owner, local Maori tribes, and a team of ecologists to restore the landscape. They have planted five hundred thousand trees to reestablish the conditions of the lost rain forest, re-created wetlands, and even fenced off one perimeter and, working with ornithologists and biologists, have restored the site, protecting it from invasive mammals and encouraging the recovery of native reptiles and birds including the tuatara and the sooty petrel. An area of sixty-four acres surrounded by steep slopes is now home to a restored wetland.

> The result was a boldly graphic design of arced water bodies, streams, channels, and islands that drain from several hundred acres. The desire was not to replicate nature but to use scientific data as a basis for artful landscape architecture, constructing a functioning wetland that – while clearly a work of artifice rather than nature – provides vital ecological services to the area.[20]

[20]Meyer, "Part IV: Farm: Orongo Station," in *Garden/Park/Community/Farm,* p. 192.

Near the owners' home and guest house, the Earthworks Garden references ancient Maori traditions, while creating a contemporary statement.

Few municipalities or private individuals have the resources of Woltz's client to undertake such landscape architecture. But what Woltz's work here and elsewhere in his farming projects illustrates is a conscious and elegant welding of the productive agricultural landscape with culture, history, and sustainability. In an interview, Woltz cautions that "it's crucial to remember the importance of place and that there is nothing more 'beautiful' than 'high functionality.' "[21] It is that blending of the functional with the beautiful that marks out his work and the works examined in this study. In his review of the project, Mick Abbott, director of Landscope DesignLab based at Lincoln University in Aotearoa, New Zealand, appreciates the work done at Orongo Station. His main issue with the project is the private nature of the commission. He calls for a landscape architecture that "reimagines the property as an open, virus-like experiment"[22] that spreads its beneficial productivity beyond property boundaries. Abbott challenges Woltz and other landscape architects to "design productive landscapes in which increased and enduring profits are realized because of, and not despite, a partnered and substantive increase in ecological value and diversity."[23] In Orongo Station, Woltz reintroduces the pastoral paradigm of productive beauty. Extending this paradigm across the wider landscape promises to re-connect art, agricultural infrastructure, and beauty and unite communities.

[21]Megan Backhouse, "Thomas Woltz, Landscape Architect, on How Horticulture Might Just Save the World," *Sydney Morning Herald*, Mar. 13, 2017. https://www.smh.com.au/lifestyle/thomas-woltz-landscape-architect-on-how-horticulture-might-just-save-the-world-20170310-guvoiw.html. Accessed June 18, 2018.
[22]Mick Abbott. "The Sustaining Beauty of Productive Landscapes," in *Journal of Landscape Architecture*, vol. 13, no. 2 (2018): p. 13.
[23]Ibid., p. 11.

Conclusion: Reimagining the Pastoral Paradigm for the Twenty-First Century

We began this book with a look at Dutch landscape paintings of the mid- to late seventeenth century and highlighted the connections between landscape, infrastructure, and prosperity in the Netherlands. Artists such as Ruisdael created iconic images of windmills, bleaching fields, and cows to celebrate industries and infrastructure systems that were key to the wealth of the Netherlands. In our discussion of landscape design and paintings of the eighteenth century, we quoted Tom Williamson's work on the economics of the landscape park. In his essay he highlights the ways in which the great landscape parks contributed to the prosperity and wealth of the landowner and subsequently the nation as a whole. Part of the pleasure of the landscape as viewed by the aristocratic landowner was the careful management of his land to be both productive and beautiful, pastoral and georgic, passive yet active. It was more than just the sight of his estate that mattered—it was the health of the forests, sheep, and cattle; the pastures where they grazed; and the lakes from which they drank. Well-managed estates were prosperous, while those run poorly were not. As this ideal landscape merged with the popular picturesque, and as revenues came from new industries and the railroad, the productivity of the estate grew less important to the landowner. Throughout the nineteenth century, landscapes from noble estates to public parks were separated from the productive systems. The aesthetics of the pastoral landscape remained (and still remains) important. Without financial imperatives, care of that landscape's health—be it a state park or front lawn—is less important than how it looks. But the pastoral paradigm identified in these

pages may be a crucial element as we move toward greener infrastructure systems. As Joan Iverson Nassauer points out, "The pleasure of aesthetic attention can draw people to attend to the ecological quality of the landscape."[1]

Elizabeth Meyer reiterated the need for aesthetically beautiful landscapes in her article, "Sustaining Beauty. The Performance of Appearance: A Manifesto in Three Parts," published in 2008. She argues,

> that will take more than ecologically regenerative designs for culture to be sustainable, that what is needed are designed landscapes that provoke those who experience them to become more aware of how their actions affect the environment, and to care enough to make changes. This involves considering the role of aesthetic environmental experiences, such as beauty, in re-centering human consciousness from an egocentric to a more bio-centric perspective.[2]

Whether beauty is the ideal means of engagement is up for dispute, as many will argue against its subjective nature. What is less variable is the need to engage the public, to entice and invite visitors and residents into productive landscapes, be they agricultural or otherwise.

The pastoral tradition, even when watered down in a suburban street, or distilled into a modern landscape, still has a seductive claim on us. John Stilgoe explores that phenomenon in his book *What Is Landscape*, wherein he discusses language, visual tropes, and historic events to trace our attraction to this pastoral tradition. In his words,

> in the seeming traditional but always ever so slightly evolving rural landscape, especially that of England, perhaps New England, certainly in picture books aimed at the very young, flourish the deepest of values, understandings of peace and plenty (or at least enough for everyone in famines) and order, and of aesthetics too.[3]

In the twenty-first century, the health of our landscapes, water, and air will determine our prosperity in the future, just as careful management of their estates determined the English aristocracy's in the eighteenth century. For democratic societies, ecological health is dependent on a well-educated and informed public that understands the potential impacts of power generation,

[1] Joan Iverson Nassauer, "Cultural Sustainability: Aligning Aesthetics and Ecology," in *Placing Nature: Culture and Landscape Ecology*, ed. Joan Nassauer (Washington, DC: Island Press, 1997), p. 82.

[2] Elizabeth K. Meyer, "Sustaining Beauty. The Performance of Appearance. A Manifesto in Three Parts," *Journal of Landscape Architecture*, vol. 3, no. 1 (2008): p. 3.

[3] John R. Stilgoe, *What Is Landscape*. (Cambridge, MA: MIT Press. 2015), p. 162.

water purification, or beneficial agriculture. In his introduction to the collected essays in "Uncommon Ground: Rethinking the Human Place in Nature," William Cronon notes that it is crucial that we confront "the task of rethinking and reconstructing human relationships with the natural world to make them more just and accountable."[4] We cannot fix what we do not understand to be broken.

Cronon was discussing this relationship in the context of environmental groups whose focus in the twentieth century was based on a mythic construct of pristine nature, untouched by humans. Yet, as Michael Singer grew to understand from his retreat into the Vermont woods, wherever we as humans go, we manipulate and construct nature. Thus, it is through understanding and education that we can be better accountable for the health of the natural world, for our role in it and our own health as a species.

In the 1991 landmark First People of Color Environmental Leadership Summit held in Washington, DC, leaders compiled seventeen "Principles of Environmental Justice." Given that people of color are disproportionately affected by pollution from power plants, landfills, and toxic waste sites, a platform from which to raise awareness and vocalize concerns about such injustice has been invaluable. Of the seventeen principles, two stand out in the context of this volume. Principle 12 explains that "environmental justice affirms the need for urban and rural ecological policies to clean up and rebuild our cities and rural areas in balance with nature, honoring the cultural integrity of all our communities and providing fair access for all to the full range of resources."[5] And Principle 16 "calls for the education of present and future generations which emphasizes social and environmental issues based on our experience and an appreciation of our diverse cultural perspectives."[6] Integral to these calls for environmental justice is respect for and input from local communities and educational programs designed to meet people within their cultural environment. For Nassauer, Cronon, and Di Chiro, education, fairness, respect, and accountability figure largely in the quest for environmental health and justice.

So what role does infrastructure play in this? Schwarzer points out that "during the tumultuous evolution and expansion of infrastructural systems in the modern era, the scale and mechanization of nodes exploded beyond the purview of architecture and urbanity."[7] As these large systems that provided

[4]William Cronon, "Introduction: In Search of Nature," in *Uncommon Ground: Rethinking the Human Place in Nature*, ed. William Cronon (New York: W. W. Norton, 1996), p. 26.
[5]Giovanna Di Chiro, "Nature as Community: The Convergence of Environment and Social Justice," in *Uncommon Ground: Rethinking the Human Place in Nature*, ed. William Cronon (New York: W. W. Norton, 1996), p. 309.
[6]Ibid.
[7]Schwarzer, "The Conceptual Roots of Infrastructure," p. 58.

growing populations with water, electricity, and food expanded, the scale of such systems meant they had to be built outside of urban centers. More often than not, they were housed—as we saw in the case of the sewage plant under Riverbank Park, or the industrial site of Newtown Creek Wastewater treatment plant—in close proximity to poorer neighborhoods, often populated by people of color. But the examples focused on in this study were designed to mitigate the worst effects of such systems, with new technologies that reduced emissions, odor, water pollution, or herbicide use. Almost all were designed with input from the communities they affect, and all are designed to educate the visitor about the processes going on on-site.

Common to these projects is the role of art in their design. Bringing an artist, architect, or landscape architect into the project introduces new questions about use, efficiency, and site that hadn't been voiced when the projects began. Design professionals such as those discussed in this book play a vital role in connecting the engineering and infrastructural system with the community it abuts. In ways not unlike the landscape artists of the nineteenth century who sought the means to integrate the "machine into the garden," the architects, landscape architects, and artists discussed here question the engineering and agricultural status quo and bring a broader, social element to the table. This, in turn, yields projects that not only represent greener energy production, organic farming methods, and the treatment of clean water. They are also projects that are inviting, that describe and elucidate the systems involved, and that introduce the complexity of energy production, waste, and agriculture. Emerson called on the artist to weave the new technologies of progress into art, thereby framing it in ways nineteenth-century viewers could appreciate. He believed that art "can help to overcome the dislocating effect of change by making available for society's emulation works that are, in effect, ideal symbolic reconstructions of reality. Thus the painter of pastoral landscapes exemplifies the possibility of reconciling the new machine power with the natural order."[8] In the nineteenth century, whether it was George Inness's *Lakawanna Valley* or Turner's *Rain, Steam and Speed*, the artist was tasked with reconciling nature and progressive technologies, albeit with waning success.

As we move further into the twenty-first century, artists and designers are once again involved in such a reconciliation. Their contributions create spaces that blend the dualities of nature and technology and result in a productive pastoralism. In a sense, this is a didactic pastoralism that educates and informs, welcomes, and entertains. In the *Architectural Design* volume dedicated to the question of architecture and the pastoral, editor Mark Titman,

[8]Leo Marx, "Does Pastoralism Have a Future?," *Studies in the History of Art*, vol. 36, Symposium Papers XX: The Pastoral Landscape (Washington, DC: The National Gallery of Art, 1992), p. 218.

argued that "pastoralism allows architects to explore human-centered green issues that interpret and commodify nature for the higher aim of urbanites delight, self- and spiritual realization. In the future, each time we build we could use the abovementioned index to convert from being designers to being playful custodians; to enhance the liveliness of a building and city."[9] While the architects, landscape architects, and artists discussed have not always been playful in their designs, play and recreation do have an important role in the projects covered, from Walter Hood's "Curtis '50 Cent' Jackson Park, to BIG's ski slope and hiking trails on the top and sides of the Amager Bakke power station. In these examples, recreation brings people of varying ages and races into contact with the infrastructural system. That contact sets up a mutual exchange between the plant (or farm) and the visitor. By inviting people into the productive realm, and teaching them about the processes therein, the design helps position the public to better hold the plant and its owners accountable. Such projects require a new transparency than what we usually expect from our infrastructure. Re-wedding productive infrastructures with a pastoral and inclusive nature can help "educate desire" in Marx's words, shifting our expectations of what both nature and infrastructure can be. The result is increasingly an "altered relation to the natural"[10] wherein the productivity of human systems works together once again with nature. The art of design provides the medium through which to realize this new infrastructural paradigm.

The idea for this book came from small town's turmoil over a proposed solar farm on an old landfill. Below the surface, old cars, kitchen appliances, and the detritus of lives past breakdown and rot. Above, surrounded by expensive homes, is a pastoral landscape of meadow and birds. It was this pastoral view that homeowners fought to maintain. After a law suit, the town abandoned the plan. Such reaction, albeit on a small scale, highlights the difficulties involved in reintroducing infrastructure systems into our landscapes, be they suburban or urban. One cannot help but wonder if the examples set by the architects, landscape architects, and artists outlined above might have yielded different results in Amherst. If the neighbors had been consulted first, and introduced to the concept; if they had felt a stake in the process and helped create something of which they could be proud, might the outcome have been different? If the proposed chain link fence had been replaced by undulating hedgerows, offering more diverse bird habitat, might the neighbors have welcomed it? Infrastructural systems that powered society were once a celebrated and crucial part of our pastoral view, as captured on canvas and

[9]Mark Titman, "Dualism Is Dead: Long Live the Pastoral," *Architectural Design: The New Pastoralism: Landscape into Architecture*, vol. 83, no. 3 (May/June 2013): p. 18.
[10]Marx, "Does Pastoralism Have a Future?," p. 223.

built into landscapes. The role of artists, architects, and designers is once more to integrate our productive systems into our daily lives, thereby making the producers accountable and the users involved with the processes of energy, water, and food production. The pastoral paradigm can help us change our views and celebrate that which sustains us.

Bibliography

Abbott, Mick. "The Sustaining Beauty of Productive Landscapes." *Journal of Landscape Architecture*. Vol. 13, No. 2 (December 2018): 8–19.

Abel, Mickey. "Water as the Philosophical and Organizational Basis for an 'Urban' Community Plan: The Case of Maillezais Abbey." In *Medieval Urban Planning: The Monastery and Beyond*. 8–45. Edited by Mickey Abel. Newcastle upon Tyne: Cambridge Scholars, 2017.

Adams, Ann Jensen. "Competing Communities in the 'Great Bog of Europe': Identity and Seventeenth Century Dutch Landscape Painting." In *Landscape and Power*. 35–76. Edited by W. J. T. Mitchell. Chicago, IL: University of Chicago Press, 1994.

Addison, Joseph. *Essays in Criticism and Literary Theory*. Edited by John Loftis. Northbrook, IL: AHM, 1975.

Alofsin, Anthony. "Broadacre City—Ideal and Nemesis." *American Art*. Vol. 25, No. 2 (Summer 2011): 21–5.

Alpers, Svetlana. *The Art of Describing: Dutch Art in the Seventeenth Century*. Chicago, IL: University of Chicago Press, 1983.

Anderson, Nancy K. "The Kiss of Enterprise: The Western Landscape as Symbol and Resource." In *The West as America: Re-Interpreting Images of the Frontier 1820–1920*. 237–83. Edited by William Truettner. Published in conjunction with the exhibition of the same title, organized by the National Museum of American Art, Smithsonian Institution, and presented at the National Museum of American Art, Washington, DC, March 15–July 7, 1991; the Denver Art Museum, August 3–October 13, 1991; the Saint Louis Art Museum, November 9, 1991–January 12, 1992. Washington, DC: The National Museum of American Art and the Smithsonian Institution Press, 1991.

Andraos, Amale. *WORKac: We'll Get There When We Cross That Bridge*. New York: Monacelli Press, 2017.

Appleton, Jay. *The Experience of Landscape*. London: John Wiley, 1975.

Aronson, Myla F. J., and Steven N. Handel. "Designing a Grassland Estate, Cultivating Biodiversity." *Ecological Restoration* (June 2013): 212–16.

Auping, Michael. *Common Ground: Five Artists in the Florida Landscape, Hamish Fulton, Helen and Newton Harrison, Michael Singer, Alan Sonfist*. Sarasota, FL: John and Mabel Ringling Museum of Art, 1982.

Backhouse, Megan. "Thomas Woltz, Landscape Architect, on How Horticulture Might Just Save the World." *Sydney Morning Herald*. March 13, 2017. https://www.smh.com.au/lifestyle/thomas-woltz-landscape-architect-on-how-horticulture-might-just-save-the-world-20170310-guvoiw.html. Accessed June 18, 2018.

Bacon, Mardges. "Le Corbusier and Postwar America: The TVA and *béton brute*." *Journal of the Society of Architectural Historians*. Vol. 74, No. 1 (March 3, 2015): 13–40.

Badger, Emily. "The Unsung Role That Ordinary Citizens Played in the Great Crime Decline." *New York Times*. November 9, 2017. https://www.nytimes.com/2017/11/09/upshot/the-unsung-role-that-ordinary-citizens-played-in-the-great-crime-decline.html.

Barringer, Tim, and Oliver Fairclough. *Pastures Green & Dark Satanic Mills: The British Passion for Landscape*. Published in conjunction with the exhibition of the same title, organized by the American Federation of the Arts and Amgueddfa Cymru-National Museum Wales. New York: American Federation of the Arts in Association with D Giles Limited, 2014.

Beecher, Henry Ward. *Star Papers: Or, Experiences of Art and Nature*. New York: J. C. Derby; Boston: Philips, Sampson; Cincinnati: H. W. Derby, 1855.

Bellamy, Edward. *Looking Backward: 2000–1887*. Edited by Stanley Appelbaum (general) and Thomas Crofts (volume). Mineola, NY: Dover Thrift Editions, 1996.

Bergdoll, Barry. "Foreward." In *Public Natures: Evolutionary Infrastructure*. 6–7 Edited by Marion Weiss and Michael A. Manfredi. New York: Princeton Architectural Press, 2015.

Bergman, Bettina. "Exploring the Grove: Pastoral Space on Roman Walls." *Studies in the History of Art*. Vol. 36, Symposium Papers XX: The Pastoral Landscape (National Gallery of Art, 1992): 20–46.

Bermingham, Ann. *Landscape and Ideology: The English Rustic Tradition, 1740–1860*. Berkeley: University of California Press, 1986.

Berstein, Fred. "Beauty in Garbage: Naka Incineration Plant by Yoshio Tanaguchi." *ArchNewsNow.com*. November 9, 2004. http://www.archnewsnow.com/features/Feature152.htm. Accessed July 10, 2018

Blake, William. "And Did Those Feet." In *Norton Anthology of English Literature*. 85–6. Vol. 2, 6th edition. Edited by M. H. Abrahms. New York: W.W Norton, 1993.

Boetzkes, Amanda. *The Ethics of Earth Art*. Minneapolis: University of Minnesota Press, 2010.

Bonehill, John, and Stephen Daniels. " 'Real Views from Nature in this Country': Paul Sandby, Estate Portraiture and British Landscape Art." *The British Art Journal*. Vol. 10, No. 1 (Spring/Summer 2009): 72–7.

Boomgaard, Peter. "Technologies of a Trading Empire: Dutch Introduction of Water- and Windmills in Early Modern Asia 1650s-1800." *History and Technology*. Vol. 24, No. 1 (March 2008): 41–59.

Branch, Mark Alden. "Water Shed: A Water Purification Plant and Park by Steven Holl and Michael Van Valkenburgh is a Model of Sustainable Infrastructure." *Architecture*. Vol. 94, No. 10 (October 2005): 32–41.

Braudel, Fernand. *The Wheels of Commerce: Civilization and Capitalism, 15th-18th Century*. Vol. 2. New York: Harper & Row, 1979.

Brown, David, and Tom Williamson. *Lancelot Brown and the Capability Men: Landscape Revolution in Eighteenth-Century England*. London: Reaktion Books, 2016.

Brown, Hillary. *Next Generation Infrastructure: Principles for Post-Industrial Public Works*. Washington, Covelo and London: Island Press, 2014.

Bruyn, Joshua. "Toward a Scriptural Reading of Seventeenth-Century Dutch Landscape Paintings." In *Masters of 17th Century Dutch Landscape Painting*. 84–103. Edited by Peter Sutton. Philadelphia: University of Pennsylvania Press, 1987.

Burns, Sarah. *Pastoral Inventions: Rural Life in Nineteenth-Century American Art and Culture*. (Philadelphia, PA: Temple University Press. 1989).

Burns, Sarah. "Revitalizing the 'Painted-Out' North: Winslow Homer, Manly Health, and New England Regionalism in Turn-of-the-Century America." *American Art*. Vol. 9, No. 2 (Summer 1995): 20–37.

Calhoun, Blue. *The Pastoral Vision of William Morris: The Earthly Paradise*. Athens: University of Georgia Press, 1975.

Carlyle, Thomas. *A Carlyle Reader: Selections from the Writings of Thomas Carlyle*. Edited by G. B. Tennyson. Cambridge: Cambridge University Press, 1984.

Carr, Ethan. *Wilderness by Design: Landscape Architecture and the National Park Service*. Lincoln: University of Nebraska Press, 1998.

Carroll, David. "Pollution, Defilement and the Art of Decomposition." In *Ruskin and Environment: The Storm-Cloud of the Nineteenth Century*. 58–75. Edited by Michael Wheeler. Manchester: Manchester University Press, 1995.

Carson, Rachel. *Silent Spring*. 40th edition. Boston, MA: A Mariner Book: Houghton Mifflin, 2002.

Chapman, Michael, and John Roberts. "Industrial Organisms: Sigfried Gideon and the Humanisation of Industry in Alvar Aalto's Sunila Factory Plant." *Fabrications*. Vol. 24, No. 1 (2014): 72–91.

Cole, Thomas. "Essay on American Scenery." In *The Native Landscape Reader*. 27–36. Edited by Robert E. Grese. Amherst: University of Massachusetts Press, 2011.

Colquhoun, Kate. *The Busiest Man in England: A Life of Joseph Paxton: Gardner, Architect and Victorian Visionary*. Boston: David R. Godine, 2006.

Colquhoun, Kate. *A Thing in Disguise: The Visionary Life of Joseph Paxton*. London: Fourth Estate, 2003.

Cosgrove, Denis, and Stephen Daniels, eds. *The Iconography of Landscape: Essays on the Symbolic Representation, Design and Use of Past Environments*. Cambridge Studies in Historical Geography 9. Cambridge: Cambridge University Press, 1988.

Crandell, Gina. *Nature Pictorialized: "The View" in Landscape History*. Baltimore, MD: Johns Hopkins University Press, 1993.

Cronon, William, ed. *Uncommon Ground: Rethinking the Human Place in Nature*. New York: W. W. Norton, 1996.

Cronon, William. "Introduction: In Search of Nature." In *Uncommon Ground: Rethinking the Human Place in Nature*. 23–68. Edited by William Cronon. New York: W. W. Norton, 1996.

Curtis, William J. R. *Le Corbusier: Ideas and Forms*. New York: Phaidon Press, 2015.

Daniels, Stephen. *Fields of Vision: Landscape Imagery and National Identity in England and the United States*. Princeton, NJ: Princeton University Press, 1993.

Daniels, Stephen. "Landscaping for a Manufacturer: Humphry Repton's Commission for Benjamin Goot at Armley in 1809–10." *Journal of Historical Geography.* Vol. 7, No. 4 (October 1981): 379–96.

Di Chiro, Giovanna. "Nature as Community: The Convergence of Environment and Social Justice." In *Uncommon Ground: Rethinking the Human Place in Nature.* 298–320. Edited by William Cronon. New York: W. W. Norton, 1996.

Emerson, Ralph Waldo. *The Essential Writings of Ralph Waldo Emerson.* Edited by Brooks Atkinson. New York: The Modern Library, 2000.

Fabricant, Carole. "The Aesthetics and Politics of Landscape in the Eighteenth Century." In *Studies in Eighteenth-Century British Art and Aesthetics.* Edited by Ralph Cohen. 49–81. Berkeley: University of California Press, 1985.

Fergusson, Peter. "Alumnae Valley, Wellesley College: Redefining the Campus Landscape." In *Michael Van Valkenburgh Associates: Reconstructing Urban Landscapes.* 136–63. Edited by Anita Berrizbeitia. New Haven, CT: Yale University Press, 2009.

Foister, Susan. "Young Gainsborough and the English Taste for Dutch Landscape." *Apollo Magazine.* Vol. 146 (August 1997): 3–11.

Forgey, Benjamin. "Art Out of Nature Which Is about Nothing but Nature." *Smithsonian Magazine* (January 1978): 62–9.

Frampton, Kenneth. "In Search of the Modern Landscape." In *Denatured Visions: Landscape and Culture in the 20th Century.* 42–61. Edited by Stuart Wrede and William Howard Adams. New York: Museum of Modern Art with Harry N. Abrams, 1991.

Gibson, Walter. *Pleasant Places: The Rustic Landscape form Bruegel to Ruisdael.* Berkeley: University of California Press, 2000.

Gilpin, William. *Three Essays: On Picturesque Beauty; on Picturesque Travel; and on Sketching Landscape: To Which Is Added a Poem, on Landscape Painting.* Cambridge: Chadwyck-Healey, 1999.

Gorgolewski, Mark, June Komisar, and Joe Nasr. *Carrot City: Creating Places for Urban Agriculture.* New York: Monacelli Press, 2011.

Gottlieb Paludan Architects. *Energy and Utilities.* Translated by Birgit Ducasse. Copenhagen: Gottlieb Paludan Architects A/S, 2017.

Halperin, David. *Before Pastoral: Theocritus and the Ancient Tradition of Bucolic Poetry.* New Haven, CT: Yale University Press, 1983.

Hanley, Keith. "The Discourse of Natural Beauty." In *Ruskin and Environment: The Storm-Cloud of the Nineteenth Century.* 10–37. Edited by Michael Wheeler. Manchester: Manchester University Press, 1995.

Hauck, Thomas, and Daniel Czechowski. "Green Functionalism: A Brief Sketch of Its History and Ideas in the United States and Germany." In *Revising Green Infrastructure: Concepts between Nature and Design.* 3–28. Edited by Czechowski Hauck and Georg Hausladen. Boca Raton, FL: CRC Press, 2015.

Heathorn, Stephen. "Aesthetic Politics and Heritage Nostalgia: Electrical Generating Superstations in the London Cityscape since 1927." *London Journal.* Vol. 38, No. 2 (July 2013): 125–50.

Howard, Ebenezer. *Garden Cities of Tomorrow.* Edited by F. J. Osborn with an introduction by Lewis Mumford. London: Faber & Faber, 1945.

Hunt, John Dixon. *Gardens and the Picturesque: Studies in the History of Landscape Architecture.* Cambridge, MA: MIT Press, 1992.

Jefferson, Thomas. *Notes on the State of Virginia*. Baltimore, MD: W. Pechin. 1800.

Klaus, Susan L. *A Modern Arcadia: Frederick Law Olmsted Jr. and the Plan for Forest Hills Gardens*. Amherst: University of Massachusetts Press, in association with Library of American Landscape History, 2002.

Klingender, Francis D. *Art and the Industrial Revolution*. Edited and revised by Arthur Elton. Chatham: W & J Mackay, 1968.

Kornhauser, Elizabeth Mankin, and Tim Barringer. *Thomas Cole's Journey: Atlantic Crossings*. With Dorothy Mahon, Christopher Riopelle, and Shannon Vittoria. Published in conjunction with the exhibition of the same title, organized and presented by the Metropolitan Museum of Art, New York, January 30–May 13, 2018 and the National Gallery, London, June 11–October 7, 2018. New York: Metropolitan Museum of Art. New Haven, CT: Yale University Press, 2018.

Ling, Peter. "Thomas Jefferson and the Environment." *History Today*. Vol. 54, No. 1 (January 2004): 48–53.

Linn, Charles. "Building Types Study 711: Parks and Recreational Facilities: Paradise Lost and Found." *Architectural Record*. Vol. 181, No. 11 (November 1993): 108–17.

Mabie, Hamilton Wright. *Essays on Nature and Culture*. New York: Dodd, Mead, 1896.

Macy, Christine. "The Architects' Office of the Tennessee Valley Authority." In *The Tennessee Valley Authority: Design and Persuasion*. 26–51. Edited by Tim Culvahouse. New York: Princeton Architectural Press, 2007.

Mannell, Steven. "From Indifferent Shell to Total Environment: The Design Evolution of Toronto's Victoria Park Water Works, 1913–1936." *Journal of the Society for the Study of Architecture in Canada*. Vol. 37, No. 2 (January 2012): 53–73.

Marks, Arthur. "Palladianism on the Schuylkill: The Work of Frederick Graff at Fairmount." *Proceedings of the American Philosophical Society*. Vol. 154, No. 2 (June 2010): 201–57.

Marsh, Jan. *Back to the Land: The Pastoral Impulse in England, from 1880 to 1914*. London: Quartet Books, 1982.

Marx, Leo. "Does Pastoralism Have a Future?" *Studies in the History of Art*. Vol. 36, Symposium papers XX: The Pastoral Landscape (National Gallery of Art, 1992): 208–25.

Marx, Leo. *The Machine in the Garden: Technology and the Pastoral Ideal in America*. 2nd edition. Oxford: Oxford University Press, 2000.

McClelland, James, and Lynn Miller. *City in a Park: A History of Philadelphia's Fairmount Park System*. Philadelphia, PA: Temple University Press, 2016.

Meunier, John. "A Model for the De-Centralized City: An Interview with Cornelia Brierly." In *Frank Lloyd Wright: The Phoenix Papers. Volume 1: Broadacre City*. 2–10. Edited by K. Paul Zygas. Tucson: Arizona University Press, 1994.

Meyer, Elizabeth. "Part IV: Farm." In *Nelson Byrd Woltz: Garden/Park/Community/Farm*. 170–220. Edited by Stephen Orr with Warren T. Byrd, Jr. and Thomas L. Woltz. New York: Princeton Architectural Press, 2013.

Meyer, Elizabeth. "Sustaining Beauty. The Performance of Appearance: A Manifesto in Three Parts." *Journal of Landscape Architecture* (Spring 2008): 6–23.

Miller, Angela. *The Empire of the Eye: Landscape Representation and American Cultural Politics, 1825–1875*. Ithaca, NY: Cornell University Press, 1993.

Milroy, Elizabeth. *The Grid and the River: Philadelphia's Green Places, 1682–1876*. University Park: Pennsylvania State University Press, 2016.

Moffett, Marian. "Noble Structures Set in Handsome Parks: Public Architecture of the TVA." *Modulus*. No. 17 (January 1984): 74–83.

Moggridge, Hal. "Notes on Kent's Garden at Rousham." *Journal of Garden History*. Vol. 6, No. 3 (July 1986): 187–226.

Monoian, Elizabeth, and Robert Ferry. *Powering Places: Santa Monica. Land Art Generator Initiative*. Munich: Prestel Verlag, 2016.

Morris, William. "The Beauty of Life. Delivered before the Birmingham Society of the Arts and School of Design, February 19, 1880." In *The Collected Works of William Morris*. 51–80. Introduction by his daughter May Morris. Vol. 22. New York: Russell & Russell, 1966.

Morris, William. *A Factory as It Might Be*. Nottingham: Mushroom Bookshop, 1994.

Morris, William. "The Lesser Arts." In *The Collected Works of William Morris*. 3–27. Vol. 23 Introduction by May Morris. New York: Russell & Russell, 1966.

Morris, William. "Useful Work versus Useless Toil." In *The Collected Works of William Morris*. 98–121. Vol. 23. Introduction by his daughter May Morris. New York: Russell & Russell, 1966.

Mumford, Lewis. "The Skyline: The Architecture of Power." *The New Yorker Magazine* (June 7, 1941): 60.

Muschamp, Herbert. "Architecture View: When Art Becomes a Public Spectacle." *New York Times*. Sunday, August 29, 1993.

Myrone, Martin, ed. *John Martin: Apocalypse*. Published in conjunction with the exhibition of the same title, organized and presented by Tate Britain, September 21, 2011–January 15, 2012. London: Tate Publishing, 2011.

Nassauer, Joan Iverson. "Cultural Sustainability: Aligning Aesthetics and Ecology." In *Placing Nature: Culture and Landscape Ecology*. 65–84. Edited by Joan Nassauer. Washington, DC: Island Press, 1997.

New York City Department of Environmental Protection. *The Newtown Creek Nature Walk*, Flyer. http://www.nyc.gov/html/dep/pdf/newtown_creek_nature_walk_flyer.pdf. Accessed August 2018.

Nichols, Frederick Doveton, and Ralph E. Griswold. *Thomas Jefferson: Landscape Architect*. Charlottesville: University of Virginia Press, 1978.

Novak, Barbara. *Nature and Culture: American Landscape and Painting, 1825–1875*. 3rd edition. Oxford: Oxford University Press, 2007.

Olcott, Richard. "An Architecture of Change: Newtown Creek Wastewater Treatment Plant." *Oz*. Vol. 34 (2012): 52–7. https://doi.org/10.4148/2378-5853.1505. Accessed June 16, 2018.

Olmsted Jr., Frederick Law, and Theodora Kimball. *Frederick Law Olmsted, Landscape Architect 1822–1903*. New York: G. P. Putnam's Sons, 1928.

Olmsted, Frederick Law. *Essential Texts*. Edited by Robert Twombly. New York: W. W. Norton, 2010.

Olmsted, Frederick Law. *Walks and Talks of an American Farmer in England*. New York: G. P. Putnam's Sons, 1852.

Perkins, Diane. "Tate Aquistition: Two Landscapes by Lambert." *British Art Journal*. Vol. 1, No. 2 (Spring 2000): 87–8.

Pratt, Emmanuel. "Urban Agriculture: A New Paradigm of Planning and Policy." *Engineering and Technology for a Sustainable World*. Vol. 20, No. 2 (March/April 2013): 21.

Pugin, Augustus Welby Northmore. *Contrasts: Or, a Parallel between the Noble Edifices of the Middle Ages, and Corresponding Buildings of the Present Day; Shewing the Present Decay of Taste*. 2nd edition. Leicester: Leicester University Press, 1971.

Raver, Anne. "Healthy Spaces, for People and the Earth," in Home and Garden, *New York Times*, November 5, 2008. https://www.nytimes.com/2008/11/06/garden/06garden.html. Accessed July 9, 2018.

Richards, Jeffery. "The Role of the Railways." In *Ruskin and Environment: The Storm-Cloud of the Nineteenth Century*. 123–43. Edited by Michael Wheeler. Manchester: Manchester University Press, 1995.

Rosenthal, Michael, Christina Payne, and Scott Wilcox, eds. *Prospects for the Nation: Recent Essays in British Landscape 1750–1880*. Studies in British Art 4. New Haven: Yale University Press, 1997.

Ruskin, John. The Storm Cloud of the 19th Century: Two Lectures Delivered at the London Institution, February 4 and 11, 1884. New York: John Wiley, 1884. https://play.google.com/store/books/details?id=iR1FAAAAYAAJ&rdid=book-iR1FAAAAYAAJ&rdot=1. Accessed March 20, 2018.

Ruskin, John. *Modern Painters*. Edited and abridged by David Barrie. New York: Alfred A. Knopf, 1987.

Sayre, Laura B. "Locating the Georgic: From the Ferme Ornée to the Model Farm." *Studies in the History of Gardens and Designed Landscapes*. Vol. 22, No. 3 (July 2002): 167–92.

Schama, Simon. "Dutch Landscapes: Culture as Foreground." In *Masters of 17th Century Dutch Landscape Painting*. 64–83. Edited by Peter Sutton. Philadelphia: University of Pennsylvania Press, 1987.

Schama, Simon. *Landscape and Memory*. New York: Vintage Books, 1996.

Schulyer, David. *Apostle of Taste: Andrew Jackson Downing 1815–1852*. Amherst, MA: Library of American Landscape History, 2015.

Schwarzer, Mitchell. "The Conceptual Roots of Infrastructure." In *Intelligent Infrastructure: Zip Cars, Invisible Networks, and Urban Transformation*. 39–62. Edited by T. F. Tierney. Charlottesville: University of Virginia Press, 2016.

Scott, Edith Hope. *Ruskin's Guild of St. George*. London: Methuen, 1931.

Sensenig, Chris. "Willamette Water Treatment Plant—Wilsonville Oregon [EDRA/Places Awards 2004-Design]." *Places Journal*. Vol. 16, No. 3 (2004). http://escholarship.org/uc/item/8013f6z7. Accessed July 17, 2018.

Seward, Anna. *The Poetical Works of Anna Seward, with Extracts from Her Literary Correspondence*. Vol. 2. Edited by Walter Scott. Edinburgh: James Ballantyne, 1810. Reprinted New York: AMS Press, 1974.

Singer, Michael, Ramon Cruz, and Jason Bregman. *Infrastructure and Community: How Can We Live with What Sustains Us?* New York: Environmental Defense Fund and Michael Singer Studio, 2007.

Slessor, Catherine. "Energy in the Landscape: Turning a Solar Array on a US Campus into Land Art." *Architectural Review*. Vol. 228 (October 2010): 38.

Slive, Seymour. *Jacob van Ruisdael: Master of Landscape*. Published in conjunction with the exhibition of the same title, organized by the Royal

Academy of Arts and presented at Los Angeles County Museum of Art, June 26–September 18, 2005; Philadelphia Museum of Art, October 23, 2005–February 5, 2006; Royal Academy of Arts, London, February 25–June 4, 2006. London: Royal Academy of Arts; New Haven and London: Yale University Press, 2005.

Solkin, David H. *Art in Britain 1660–1815*. New Haven, CT: Yale University Press and the Paul Mellon Centre for Studies in British Art, 2015.

South, Eugenia C., Bernadette C. Hohl, Michelle C. Kondo, John M. MacDonald, and Charles C. Branas. "Effect of Greening Vacant Land on Mental Health of Community-Dwelling Adults: A Cluster Randomized Trial." *Jama Network Open* (July 20, 2018). https://jamanetwork.com/journals/jamanetworkopen/fullarticle/2688343. Accessed July 24, 2018.

Staley, Allen, and Christopher Newall. *Pre-Raphaelite Vision: Truth to Nature.* Published in conjunction with the exhibition of the same title organized and presented by Tate Britain, London, February 12–May 3, 2004; Alte Nationalgalerie, Berlin, June 12–September 19, 2004; Fundació "la Caixa," Madrid, October 6, 2004–January 9, 2005. London: Tate Publishing, 2004.

Stechow, Wolfgang. *Dutch Landscape Painting of the Seventeenth Century.* National Gallery of Art Kress Foundation Studies in the History of European Art. London: Phaidon, 1966.

Stilgoe, John R. *What Is Landscape?* Cambridge, MA: MIT Press. 2015.

Stone-Ferrier, Linda. "Views of Haarlem: A Reconsideration of Ruisdael and Rembrandt." *Art Bulletin.* Vol. 67, No. 3 (September 1985): 417–36.

Sutton, Peter, ed. *Masters of 17th Century Dutch Landscape Painting.* Philadelphia: University of Pennsylvania Press, 1987.

Titman, Mark. "Dualism Is Dead: Long Live the Pastoral." *Architectural Design: The New Pastoralism: Landscape into Architecture.* Vol. 83, No. 3 (May/June 2013): 14–20.

Troyen, Carol. "Retreat to Arcadia: American Landscape and the America Art-Union." *The American Art Journal,* Vol. 23, No. 1 (1991): 20–37.

Tunnard, Christopher, and John Dixon Hunt. *Gardens in the Modern Landscape: A Facsimile of the Revised 1948 Edition.* Philadelphia: University of Pennsylvania Press, 2014. https://ebookcentral.proquest.com/lib/UMA/detail.action?docID=3442396 (ProQuest). Accessed May 15, 2018.

Ulam, Alex. "Driving Concern: The New Mosholu Golf Driving Range Is Part of a Controversial Water Filtration Plant Project Built at the Edge of the Bucolic Van Cortland Park." *Landscape Architecture.* Vol. 106, No. 7 (July 2016): 104–19.

Van Hellemondt, Imke, and Bruno Notteboom. "Sustaining Beauty and Beyond." *Journal of Landscape Architecture.* Vol. 13, No. 2 (2018): 4–7.

Virgil. *The Georgics: A Poem of the Land.* Translated and edited by Kimberly Johnson. London: Penguin Classics, 2010.

Washburn, Alexandros. "Civic Virtue by Design." *Metropolis Magazine.* September 5, 2007. https://www.metropolismag.com/cities/civic-virtue-by-design/.

Whately, Thomas. *Observations on Modern Gardening: An Eighteenth-Century Study of the English Landscape Garden.* Introduction and Commentary by Michael Symes. Woodbridge, Suffolk: The Boydell Press, 2016.

Whitman, Walt. "Passage to India." In *God's New Israel: Religious Interpretations of American Destiny*. 141. Edited by Conrad Cherry. Chapel Hill: University of North Carolina Press, 1998.

"Whitney Water Purification Facility and Park," Steven Holl Architects, http://www.stevenholl.com/projects/whitney-water-facility?. Accessed August 2018.

Williamson, Tom. *Polite Landscapes: Gardens and Society in Eighteenth-Century England*. Baltimore, MD: Johns Hopkins University Press, 1995.

Wordsworth, William. *The Prelude: 1805*. Edited by James Engell and Michael D. Raymond. Boston: David R. Godine, 2016.

Wrede, Stuart and William Howard Adams, eds. *Denatured Visions: Landscape and Culture in the Twentieth Century*. New York: The Museum of Modern Art with Harry N. Abrams, 1991.

Wright, Frank Lloyd. *The Living City*. New York: Horizon Press, 1958.

Wulf, Andrea. "Man and Nature: George Perkins Marsh and Alexander von Humboldt." *Geographical Review*. Vol. 107, No. 4 (October 2017): 593–607.

Yudina, Anna. *Garden City: Supergreen Buildings, Urban Skyscapes and the New Planted Space*. New York: Thames and Hudson, 2017.

Zafran, Eric, ed. *Fantasy and Faith: The Art of Gustave Doré*. With Robert Rosenblum and Lisa Small. New York: Dahesh Museum of Art; New Haven, CT: Yale University Press, 2007.

Index